ADORNING THE WORLD

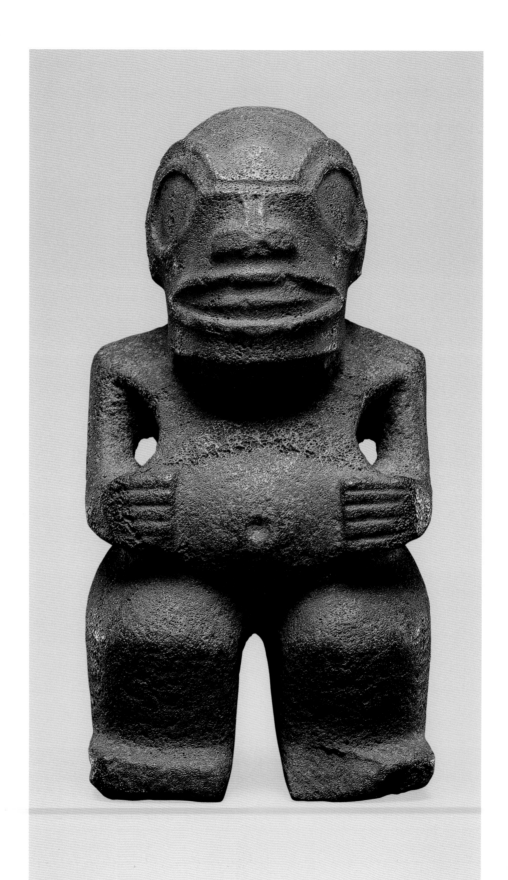

ADORNING THE WORLD
ART OF THE MARQUESAS ISLANDS

ERIC KJELLGREN

with

CAROL S. IVORY

THE METROPOLITAN MUSEUM OF ART, NEW YORK
YALE UNIVERSITY PRESS, NEW HAVEN AND LONDON

This volume is published in conjunction with the exhibition "Adorning the World: Art of the Marquesas Islands," held at The Metropolitan Museum of Art, New York, from May 10, 2005, to January 15, 2006.

The exhibition is made possible by Air Tahiti Nui and Tahiti Tourisme.
——— www.nyctotahitinonstop.com ———

Additional support has been provided by The Andrew W. Mellon Foundation.

Published by The Metropolitan Museum of Art, New York
John P. O'Neill, Editor in Chief
Emily March Walter, Senior Editor
Robert Weisberg, Designer
Douglas J. Malicki, Production Manager
Jean Wagner, Bibliographic Editor
Map designed by Anandaroop Roy

Color separations by Professional Graphics, Inc., Rockford, Illinois
Printed and bound by CS Graphics PTE Ltd., Singapore
Typeset in Granjon
Printed on 150 gsm R-400

Library of Congress Cataloging-in-Publication Data

Kjellgren, Eric.
 Adorning the world : art of the Marquesas Islands / Eric Kjellgren with Carol S. Ivory.
 p. cm.
 Catalog of an exhibition at the Metropolitan Museum of Art, New York, May 10, 2005–Jan. 15, 2006.
 Includes bibliographical references and index.
 ISBN 1-58839-146-9 (pbk.) — ISBN 0-300-10712-9 (Yale University Press)
 1. Art, Marquesan—Exhibitions. I. Ivory, Carol S. II. Metropolitan Museum of Art (New York, N.Y.) III. Title.
 N7411.M3K44 2005
 745'.089'9942—dc22 2005000844

Cover: Wilhelm Gottlieb Tilesius von Tilenau (1769–1857), *An Inhabitant of the Island of Nukahiwa,* 1813. The New York Public Library, Astor, Lenox, and Tilden Foundations (cat. no. 21)

Frontispiece: Figure. 19th century or earlier. Indiana University Art Museum, Bloomington (cat. no. 2)

Contents

Sponsors' Statement

Air Tahiti Nui and Tahiti Tourisme are pleased to cosponsor "Adorning the World: Art of the Marquesas Islands" at The Metropolitan Museum of Art. The exhibition brings together a unique assemblage of sculpture and decorative art representing the finest achievements of Marquesan artists from the late eighteenth to the late nineteenth century.

The remote isles of French Polynesia, including the Marquesas, Bora-Bora, Moorea, Tahiti, and Taha'a, have long attracted artists, writers, and adventurers. Paul Gauguin, Herman Melville, Robert Louis Stevenson, and Jack London were all specifically inspired by their experiences in the rugged, mysterious islands of the Marquesas archipelago.

The year 2005 is an important one for Air Tahiti Nui and Tahiti Tourisme. It is our privilege to help make possible the presentation of these outstanding works from French Polynesia. In so doing, we hope to invite a broader public to experience the rich and varied cultures of our islands.

Al Keahi
Managing Director
Tahiti Tourisme
North America

Nelson Levy
Chief Operating Officer
Air Tahiti Nui

www.nyctotahitinonstop.com

STATEMENT FROM THE MARQUESAN PEOPLE

It is a great honor for me to thank, in the name of the Marquesan people, The Metropolitan Museum of Art and its director, Philippe de Montebello, for presenting "Adorning the World: Art of the Marquesas Islands." To Eric Kjellgren, the Evelyn A. J. Hall and John A. Friede Associate Curator of Oceanic Art, who conceived and organized the exhibition, I am particularly indebted for his efforts to foster a greater appreciation of the creativity and productivity of the artists of the Marquesan archipelago. More than an exhibition will take place when "Adorning the World" opens in New York, the premier city of the United States. The exhibition will represent one of the most important moments in the history of the islands themselves and will introduce a larger public to the artistic achievements of our ancestors. Marquesan artists have always been inspired by nature and have drawn on the long traditions of our culture.

It is heartening to know that the achievements of our artists, isolated as the islands are in the vast Pacific, have attracted the special attention of the Metropolitan Museum. To all those individuals who have made this exhibition possible, we offer our warmest thanks. This recognition of the treasures of our culture is a source of pride to the Marquesan people and earns our deep gratitude.

Toti Te'ikiehu'upoko
Director, Académie Marquisienne
President, Fédération Culturelle
Motu Haka des Îles Marquises
Hakahau, Ua Pou, Marquesas Islands

LENDERS TO THE EXHIBITION

American Museum of Natural History,
New York
 Department of Library Services 20, 27
 Division of Anthropology 1, 42, 71, 76

Bernice P. Bishop Museum, Honolulu 14, 15,
16, 33, 34

Collection of Mark and Carolyn Blackburn,
Kamuela, Hawai'i 3, 4, 5, 8, 9, 10, 13, 19, 37, 41,
44, 46, 47, 48, 53, 54, 57, 60, 62, 63, 65, 66, 72, 73,
75, 78

The Field Museum, Chicago 35, 49

Leo and Lillian Fortess Collection 69

Collection of Monah and Alan Gettner 11

Hawaiian Mission Children's Society Library,
Mission Houses Museum, Honolulu 23, 24,
25, 26

Indiana University Art Museum, Bloomington
2, 6, 30

The Israel Museum, Jerusalem
 Department for the Arts of Africa, Oceania,
 and the Americas 68

The Metropolitan Museum of Art, New York
28, 31, 40, 50, 52, 55, 59, 74, 77

The New York Public Library
 General Research Library 21
 Rare Books Division 18, 22

Peabody Essex Museum, Salem, Massachusetts
12, 17, 32, 51, 64

Peabody Museum of Archaeology and Ethnology,
Harvard University, Cambridge, Massachusetts 36

Private Collection 56

The University of Pennsylvania Museum of
Archaeology and Anthropology, Philadelphia
7, 38, 39, 43, 45, 58, 61, 70

Collection of Raymond and Laura Wielgus
29, 67

DIRECTOR'S FOREWORD

It is a privilege for The Metropolitan Museum of Art to present for the first time in an art museum works from a remarkable artistic tradition that, while long admired by scholars, artists, and writers, has heretofore been unfamiliar to a wider audience. Known for their elegant stylization of the human form and the variety and sophistication of their decorative arts, the artists of the Marquesan archipelago were among the most accomplished in the Pacific. On viewing the works in the exhibition "Adorning the World: Art of the Marquesas Islands," one is struck by the novelty and richness of Marquesan artistic expression. In this context, it is interesting to note that the imagery of these remote islands also had a direct influence on one of the most important artists in the Western canon, Paul Gauguin.

The unique visual qualities of Marquesan art that Gauguin admired more than a century ago endure. In the ornaments and functional objects they made and in the sacred images of their ancestral deities, Marquesan artists infused their work with the vitality of a centuries-old tradition. Made to honor divine beings, accentuate the beauty of the human body, and embellish both sacred and secular objects, their art encompassed and enhanced all aspects of life.

The Marquesans were renowned, in particular, for their decorative arts. Their work is fashioned in a diversity of materials and forms that range from delicate ivory ornaments to luxuriant featherwork and imposing figural sculpture in wood and stone. The human body was an important focus for Marquesan artistic expression. Adorned with finely crafted accessories, intricate tattoos, and elaborate coiffures, on festive occasions the Marquesans were themselves one of the islands' most striking art forms. It was this distinctive visual aesthetic that captured the imagination of Western artists and explorers whose compelling portraits also appear in the exhibition.

"Adorning the World: Art of the Marquesas Islands" presents a select group of Marquesan works drawn from the holdings of more than a dozen museums, libraries, and private collections, as well as from the Metropolitan's own collection of Oceanic art. To the individual and institutional lenders, we are indebted for so graciously offering to part temporarily with many of their most treasured and important works, a substantial number of which are here presented to the public for the first time.

Much of the Marquesan art in the Metropolitan Museum was initially acquired by Nelson A. Rockefeller, who bequeathed his private collection of the arts of Africa, Oceania, and the Americas to the Museum in 1979. The Museum's Marquesan holdings were later enriched by works included in an important gift of Oceanic works from Evelyn A. J. Hall.

For lending his knowledge and expertise to the organization of the exhibition and the writing of the catalogue, I extend my thanks to Eric Kjellgren, the Evelyn A. J. Hall and John A. Friede Associate Curator of Oceanic Art. I wish also to thank Carol S. Ivory, Professor and Chair, Department of Fine Arts, Washington State University, Pullman, for her contributions to the catalogue. Together, the authors place the artistic traditions of the Marquesas within their historical and cultural context and give insights into their distinctive visual imagery.

To all those individuals and organizations that have contributed to bringing this project to fruition, I express my deepest gratitude.

The Metropolitan Museum would like to thank Air Tahiti Nui and Tahiti Tourisme for their generous support of this important exhibition. We are also grateful to The Andrew W. Mellon Foundation for their valuable contribution toward the realization of this project.

Philippe de Montebello
Director
The Metropolitan Museum of Art

ACKNOWLEDGMENTS

"Adorning the World: Art of the Marquesas Islands" would not have been possible without the efforts of many people both within and outside the Metropolitan Museum. I want, especially, to thank Carol S. Ivory, for her contributions to the catalogue and for sharing with me her knowledge of and enthusiasm for Marquesan art. I wish also to thank Toti Te'ikiehu'upoko for his gracious statement on behalf of the Marquesan people. I express my gratitude to Air Tahiti Nui and Tahiti Tourisme and to The Andrew W. Mellon Foundation for their sponsorship of the exhibition.

My appreciation goes to my colleagues in museums and institutions beyond the Metropolitan who allowed me to study their collections and generously agreed to lend some of their most prized works to the exhibition: Enid Schildkrout, Paul Beelitz, Tom Baione, and Kristen Mabel at the American Museum of Natural History, New York; Christina Hellmich at the Peabody Essex Museum, Salem; Adria Katz and Juana Dahlan at The University of Pennsylvania Museum of Archaeology and Anthropology, Philadelphia; Betty Kam at the Bernice P. Bishop Museum, Honolulu; Diane Pelrine and Anita Bracalente at the Indiana University Art Museum, Bloomington; Kimberlee Kihleng and Marilyn Reppun at the Mission Houses Museum, Honolulu; Stewart Bodner, Michael Inman, Elizabeth Diefendorf, and Roseann Panebianco at the New York Public Library; John Terrell and Dorren Martin-Ross at The Field Museum, Chicago; Martin Wright and Dorit Shafir in the Department for the Arts of Africa, Oceania, and the Americas, and Hank Vandoornik at the Israel Museum, Jerusalem; and Rubie Watson and Genevieve Fisher at the Peabody Museum of Archaeology and Ethnology, Harvard University, Cambridge, Massachusetts.

A number of private collectors also generously consented to lend some of their finest Marquesan objects. I express my particular gratitude to Mark and Carolyn Blackburn, not only for lending numerous works but also for providing assistance with many aspects of the exhibition and catalogue. I would like to thank Raymond and Laura Wielgus, Leo and Lillian Fortess, Monah and Alan Gettner, and one anonymous lender, without whose loans the quality of the exhibition would be greatly diminished. Thanks are also due to Faith-dorian and Martin Wright for their help in securing the loan of the canoe model, which their family has recently given to the Israel Museum.

At the Metropolitan Museum, I thank Philippe de Montebello, Director, for his steadfast support. Within the Department of the Arts of Africa, Oceania, and the Americas I express my gratitude first and foremost to Julie Jones, Curator in Charge, without whose knowledge, advice, and guidance this exhibition would not have been possible. I am also indebted to my other colleagues in the department, especially Victoria Vanzandt-Southwell, Hillit Zwick, and Amy Chen for their help in handling the logistics of the exhibition and catalogue. I thank Christine Giuntini for her assistance in the conservation of and mount designs for many of the most fragile works and Heidi King for her help with translation. I am grateful to Ross Day, Joy Garnett, and Erica Hauser of the Robert Goldwater Library for obtaining many difficult-to-locate references on Marquesan art and culture.

The continuing dedication to excellence on the part of the staff of the Editorial Department, under the guidance of John P. O'Neill, Editor in Chief, is reflected in this catalogue. I would like, especially, to extend my thanks to my editor, Emily March Walter, whose tireless devotion to perfecting the text is matched by an enthusiasm that makes it a pleasure to work with her. I am grateful to Peter Antony, Chief Production Manager, and, particularly, to Douglas Malicki for the catalogue's production. I also want to express my appreciation to Robert Weisberg for all his efforts with the catalogue

design. Many thanks are due to Jean Wagner for her careful work as bibliographer. Anandaroop Roy produced the map of the Marquesan archipelago.

Eileen Travell, in the Photograph Studio, did the original photography of many works in the exhibition. Colta Ives, Curator, and Constance McPhee, Department of Drawings and Prints, located and allowed me to reproduce the print *Christ on the Cross*. And Mark and Carolyn Blackburn and Loed and Mia van Bussel offered their permission to include in the catalogue previously unpublished photographs from their collections.

Numerous members of other departments within the Metropolitan provided vital assistance with the exhibition. In particular I wish to acknowledge Dan Kershaw, Exhibition Designer, Emil Micha, Clint Coller, and Richard Lichte, Design Department; Nina Maruca, Registrar's Office; Ellen Howe, Jeffrey Perhacs, Alexandra Walcott, Frederick Sager, and Jenna Wainwright, Objects Conservation; Naomi Takafuchi, Communications; and Andrea Kann, Eti Bonn-Muller, and Rosayn Anderson, Development.

Carol S. Ivory extends her thanks to all who have shared with her their knowledge and love of Marquesan history, culture, and art. She is especially indebted to the following people, whose research and experience enriched her contributions to this catalogue: Heidy Baumgartner, Pascal Erhel Hatuuku, Kimberlee Kihleng, and Marilyn Reppun at the Mission Houses Museum, Catherine and the late Christian Kervella, Débora and the late Lucien Ro'o Kimitete, Msgr. Hervé-Marie Le Cléac'h, Sidsel Millerstrom, Marie-Noëlle and Pierre Ottino-Garanger, Robert C. Suggs, and Toti Te'ikiehu'upoko. For their continued support of her research, she especially thanks CPTM/Aranui and Robin Wright.

To these individuals and to all those who contributed in so many ways, both large and small, to the success of this project, I extend my heartfelt thanks.

Eric Kjellgren

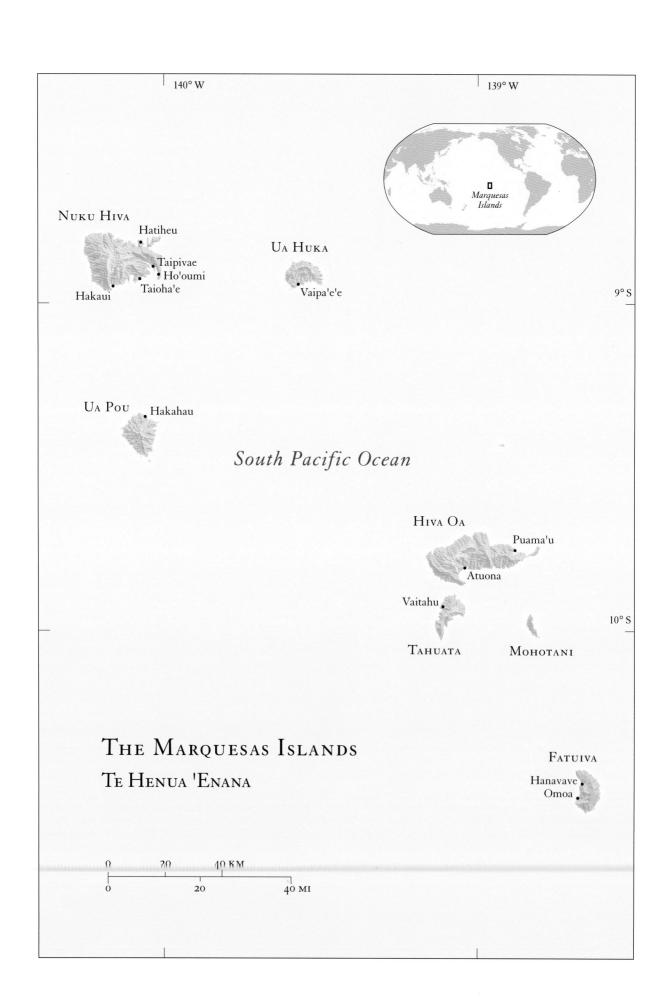

140° W 139° W

Marquesas Islands

NUKU HIVA

Hatiheu

Taipivae

Ho'oumi

Hakaui Taioha'e

UA HUKA

Vaipa'e'e

9° S

UA POU Hakahau

South Pacific Ocean

HIVA OA

Puama'u

Atuona

Vaitahu

10° S

TAHUATA MOHOTANI

THE MARQUESAS ISLANDS

TE HENUA 'ENANA

FATUIVA

Hanavave
Omoa

0 20 40 KM

0 20 40 MI

Adorning the World

Art of the Marquesas Islands

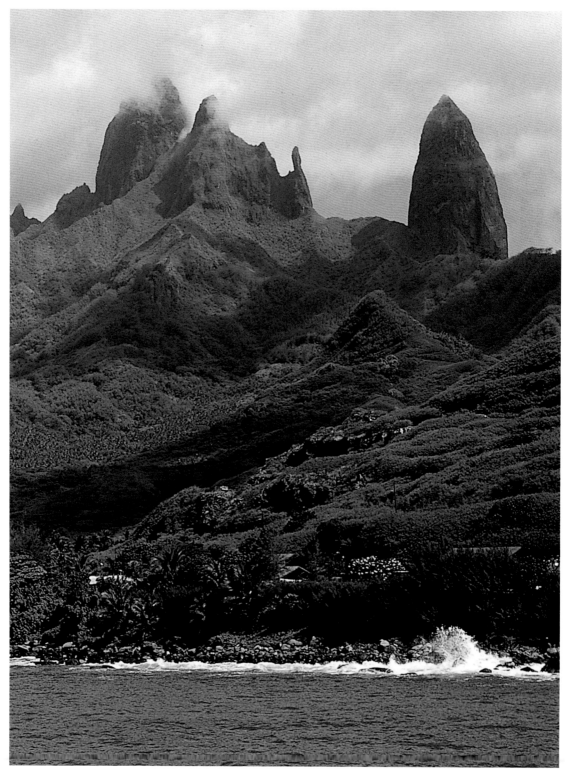

Figure 1. View of the island of Ua Pou, showing the mountainous topography typical of the Marquesas Islands.

Adorning the World

Eric Kjellgren

*The Marquesas! What strange visions of outlandish things does the very
name spirit up! . . . I felt an irresistible curiosity to see those islands which
the olden voyagers had so glowingly described.*
 —*Herman Melville*[1]

The Marquesas Islands, which lie some eight hundred miles north-
east of Tahiti, were first revealed to the wider world when the
Spanish explorer Alvaro de Mendaña de Neira (1542?–1595) acciden-
tally encountered the archipelago in 1595. After a brief but violent
sojourn, Mendaña, longing to press on to the Solomon Islands, where
he hoped to establish a colony and discover the fabled riches of the
biblical King Solomon, left the islands with little but a name, christen-
ing them Las Marquesas de Mendoza.[2] The people of the islands, who
have come to be known as Marquesans, call themselves Te 'Enana[3]
and refer today to their homeland as Te Henua 'Enana (fig. 1).[4]
Subsequently visited by numerous explorers, naval expeditions,
whalers, and merchant vessels, the Marquesas did not come to the
attention of a broader Western audience until the latter half of the
nineteenth century. It was then that they attained a degree of literary
celebrity as the setting for Herman Melville's first novel, *Typee*. In our
time, the Marquesas are perhaps best known as the final home and
resting place of Paul Gauguin, who sought refuge in the archipelago
when even Tahiti proved too civilized for his personal vision of para-
dise. An avid admirer of Marquesan art, Gauguin incorporated
images inspired by Marquesan sculpture and designs into many of his
own works. But long before they captivated the imagination of
Melville and Gauguin, the Marquesas were already a world adorned.
It is the Marquesans who are the original, and enduring, artists of the
archipelago. As Gauguin once marveled, Marquesan artists possessed
"an unheard of sense of decoration" in all they create.[5] Virtually every
type of object they used—from the sacred figures of gods and ancestors to
the most mundane items—could be, and frequently was, embellished.

1. Melville (1846) 1964: 17.
2. Later explorers and writers shortened this name simply to Marquesas. Mendaña named the islands in honor of his patron, Don García Hurtado de Mendoza, marquis de Cañete, the viceroy of Peru; Dening 1980: 11.
3. The people of the Marquesas speak Marquesan, a language with two regional variants: a northern dialect (spoken on the islands of Nuku Hiva, Ua Pou, and Ua Huka) and a southern dialect (spoken on Hiva Oa, Tahuata, and Fatuiva). In many instances, the words in the two dialects are identical. Where the two differ, the catalogue text uses the northern version, noting the southern form when the word or phrase first appears in the text. The spellings of Marquesan words follow Dordillon (1904) 1999. The southern form of *Te 'Enana* is *Te 'Enata*. The term *Te 'Enana* means "The People."
4. In the southern dialect: Te Fenua 'Enata. Although this name is used by Marquesans to refer to their homeland today, Dening (1980: 14) notes that, while all the islands and their subdivisions were individually named, there may have been no Marquesan term for the archipelago as a whole prior to European contact. Te Henua 'Enana means "The Land of the People."
5. Quoted in Rotschi 1995: 92–93, translation mine.
6. In the southern dialect: *tuhuna.*
7. E. Handy 1923: 143.

Made to honor supernatural beings, adorn the human body, and decorate the objects employed in daily life, art in the islands pervaded virtually every aspect of the sacred and secular world. Marquesan art is characterized by its elegant stylization of the human image and ornate surface decoration. It encompasses a diversity of forms and materials, from massive images of wood and stone to intimately scaled personal ornaments in ivory and bone, colorful featherwork, and tattoo.

Marquesan artists have long been admired for the refinement and sculptural power of their human figures, or *tiki,* originally erected at sacred ceremonial sites, or *me'ae,* or used in acts of private devotion. In combination with the islands' distinctive zoned geometric designs, the *tiki* is the leitmotif of Marquesan art. With its wide, goggle-like eyes, stylized limbs, and robust body, the *tiki,* often reduced simply to the head or eyes, appears in nearly every art form, from large *me'ae* figures hewn from rough volcanic rock (fig. 13) to fan handles (cat. nos. 50–53), bowls (cat. nos. 74, 75), and ear ornaments (cat. nos. 40–48). Throughout Marquesan art, the *tiki* image is worked and reworked, with consummate skill and ingenuity.

Marquesan artists found perhaps their supreme expression in the richness and variety of their decorative arts, which often incorporated complex anthropomorphic and geometric motifs. Beginning in the late nineteenth century, the surfaces of Marquesan works became increasingly ornate as the wide availability of metal tools obtained from the West, combined with a growing external market for Marquesan "curiosities," sparked an efflorescence of Marquesan wood carving.

In addition to sculpture and decorative art, the human body also was a central focus for artistic expression. Marquesan tattooing was the most extensive and aesthetically sophisticated in the Pacific. Lavishly tattooed, meticulously coiffured, and adorned with superbly crafted ornaments, the Marquesans themselves became living works of art (cat. nos. 17–27).

During the eighteenth and nineteenth centuries, when the works presented here were made, art in the Marquesas was not conceived in the Western sense, as an activity undertaken purely, or primarily, for aesthetic enjoyment. Instead, it was intended to be functional. The objects that we admire as art once served to embellish the homes, ceremonial sites, and bodies of Te 'Enana and to act as intermediaries between humans and the supernatural powers that sustained the universe.

Individuals who possessed exceptional intellectual, physical, or artistic talent were acknowledged and honored as experts, or *tuhuka,*[6] and their services were highly sought after.[7] There were *tuhuka* for nearly every occupation, from the recitation of chants and genealogies to performing arts, architecture, tattoo, sculpture, and the making of ornaments. *Tuhuka* were highly specialized, each typically devoting his or her skills to performing a single activity or producing a single type of

object.[8] The act of artistic creation was itself sacred, or *tapu*. Many art forms were under the patronage of specific deities, and the recitation of appropriate chants and magical incantations was as crucial to the creative process as the physical labor involved.[9] Paid in food, barkcloth, ornaments, and other goods, some *tuhuka,* such as tattooists and ear ornament makers, were essentially professional artists.[10]

As in nearly all Pacific artistic traditions, men and women in the Marquesas practiced different art forms. Men were carvers and worked in hard materials such as stone, wood, bone, ivory, and shell. Women made textiles and worked in fiber, producing barkcloth, or *tapa* (a paper-like textile made from the inner bark of the paper mulberry tree or other species), as well as mats, fan blades, and cordage. Both male and female master artists were recognized as *tuhuka,* and a number of objects such as fans, whose carved handles would have been made by men and blades by women (cat. nos. 50, 51, 53), combined the skills of both sexes.

Culturally and genetically, the Marquesans are Polynesians, one of thirty-six closely related peoples whose ancestors discovered and settled the islands of the central and eastern Pacific. They share a common ancestry with other Polynesian groups, including Tahitians, Hawaiians, Samoans, Rapa Nui (Easter Islanders), and the Māori of Aotearoa (New Zealand). In terms of the enormous distances they traveled and the small size and remoteness of the islands they discovered and colonized, the Polynesians were the finest sailors in the ancient world. Employing a complex system of navigation based on the stars, the form and rhythm of ocean swells, cloud formations, and the flight patterns of seabirds, Polynesian seafarers established communities on nearly every inhabitable island within the immense region known as the Polynesian triangle, bounded by Aotearoa, Hawai'i, and Rapa Nui.

All Polynesian peoples are believed to be descended from a single ancestral culture, which archaeologists refer to as Lapita. Originating in an as yet undetermined homeland in Island Southeast Asia, the Lapita peoples first began to migrate eastward into the Pacific around 1500 B.C. Along with the plants, animals, and tools they needed to survive, the Lapita settlers brought with them distinctive artistic traditions, including pottery, tattoo, and figurative sculpture. Characterized by intricate bounded geometric designs that, at times, incorporate stylized human images (see fig. 14), Lapita art is the common ancestor of all Polynesian artistic traditions. Today, its artistic legacy is evident in places as widely separated as Samoa, Hawai'i, Aotearoa, and the Marquesas.

Dispersing rapidly across the large and closely spaced islands of the western Pacific, the Lapita peoples reached the previously uninhabited archipelagos of Fiji, Tonga, and Samoa by 1000 B.C. Here, these early voyagers apparently paused in their explorations for several centuries. Their culture, however, continued to change and diversify, and by the

8. Handy (ibid.: 145) presents an extensive, though undoubtedly partial, list of the various types of *tuhuka,* including makers of images, mats, food pounders, bowls, drums, hair ornaments, staffs, and other art forms.
9. Ibid.: 146–47.
10. Ibid.: 145; Porter (1815) 1986: 294.

11. The history of Lapita and Polynesian settlement presented here is based on Kirch (2000: 207–45).

12. Kirch (ibid.: 232, 257, table 7.2) and Pierre and Marie-Noëlle Ottino-Garanger (1995: 18–19) summarize and discuss the dating of the initial settlement of the Marquesas, which is based on carbon 14 results obtained from a number of early archaeological sites. Estimates range from 200 B.C. to A.D. 300, although some recent theories posit that the islands may have been settled as late as A.D. 700 (Atholl Anderson, personal communication, 2004).

13. Geographically, the Marquesan archipelago is situated between latitudes 7°50' and 10°35' south and longitudes 138°25' and 140°50' west; E. Handy 1923: 6.

14. Many East Polynesian peoples, such as the Rapa Nui, have oral traditions that describe the arrival of such canoes from homelands to the west. However, Handy (1923: 251) states that the Marquesans had no tradition of their islands having been settled from elsewhere. Instead, surviving creation accounts state that humans first originated in the Marquesan archipelago.

15. Ibid.: 181–84.

16. In the southern dialect: 'ena.

17. In many areas of Polynesia, there is some debate as to whether coconut palms were already present on the islands when humans arrived or were introduced by the first settlers.

middle of the first millennium B.C., the descendants of the Lapita peoples developed the first recognizably Polynesian cultures. Between roughly 200 B.C. and A.D. 1, what were now Polynesian navigators began to explore and colonize the immense and largely landless expanses of the eastern Pacific.[11] One of the first new lands they found were the Marquesas. There is considerable debate as to when the Marquesans' Polynesian ancestors arrived, but current evidence suggests that the islands were initially settled sometime between 200 B.C. and A.D. 100.[12]

Formed from the summits of extinct volcanoes that rise from the ocean floor, the Marquesas Islands stretch in a narrow chain south of the equator in the eastern Pacific.[13] The archipelago comprises six main islands, Nuku Hiva, Ua Huka, Ua Pou, Hiva Oa, Tahuata, and Fatuiva, as well as a number of smaller islets and rocks. From the time the islands first emerged from the sea, the forces of erosion have sculpted the smooth contours of the original volcanoes into some of the most dramatic landscapes in the Pacific. Lacking the broad coastal plains and fringing coral reefs of other Pacific islands, the Marquesas consist primarily of deep, narrow valleys radiating from a central peak or peaks like the spokes of an enormous, irregular wheel and separated from each other by steep mountain ridges. This unusual topography shaped the culture and identity of the people that reached their shores.

The earliest settlers likely arrived in large double-hulled sailing canoes capable of carrying all the people, animals, plants, and equipment necessary to establish a permanent settlement in the lush and densely forested islands.[14] Like those of other Polynesians, the ancestors of the Marquesans were agriculturalists and brought with them their staple crops—taro, bananas, sugarcane, and breadfruit.[15] Breadfruit, known as *mei*, flourished in the islands as nowhere else in the Pacific, becoming the Marquesans' primary food. It was typically eaten in the form of *popoi*, a paste prepared by mashing the breadfruit flesh with heavy stone pounders, known as *ke'a tuki popoi* (cat. nos. 72, 73).

Apart from food crops, the settlers also brought other plants. These included *kava* (whose root provides a mildly narcotic drink), turmeric (*'eka*),[16] the source of a yellow or orange pigment used to dye barkcloth (*tapa*) and adorn the body, as well as gourds (*hue mao'i*) and, possibly, coconuts (*ehi*),[17] which were used to make bowls and other vessels (cat. nos. 75, 77). The thick husks of coconuts also provided *keikaha* (coconut-husk fiber), from which the Marquesans made cordage used for a multitude of purposes, including decorative suspension nets, or *koko* (cat. no. 77), and architectural lashings. Perhaps the most significant import was the paper mulberry tree, or *ute,* the most important of several tree species whose inner bark was processed to make the barkcloth used in clothing (cat. nos. 21, 26), headdresses (cat. nos. 17, 18), effigies (cat. no. 14), and other objects.

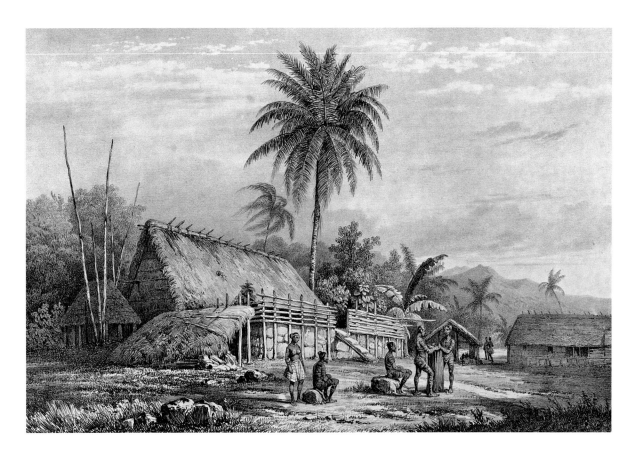

The first canoes also carried three domestic animals, pigs, dogs, and chickens, as well as rats. By the time Europeans reached the islands, dogs appear to have died out, but the other species thrived.[18] As elsewhere in Polynesia pigs, or *pua'a,* were valued as a prestige food and as sacrificial offerings. Though occasionally eaten, chickens, and specifically roosters, or *moa vahana,* were raised primarily for their plumage, which was used to make dramatic feather headdresses worn at feasts and ceremonies (cat. nos. 32, 33). So great was the demand for their feathers that one explorer noted that roosters in the Marquesas walked about "from time to time, plucked quite bare."[19]

In addition to the plants, animals, and objects necessary for survival, the settlers arrived with intellectual and artistic traditions that profoundly shaped the development of Marquesan culture. As Polynesians, they would already have practiced wood and stone carving, barkcloth making, and tattoo. The first colonists also brought and later manufactured pottery, a distant echo of their Lapita origins, but its use soon died out.[20]

From the beginning, Marquesan society followed the classic Polynesian model and was ruled by a hereditary nobility composed of chiefs (*haka'iki*) who were believed to be the most direct descendants of the gods (*etua*). The chiefs held secular and religious authority over the commoners, *mata'eina'a* (also *mata'einana*), who constituted the majority of the population. The islands' powerful prophetic priests, or

Figure 2. Louis Le Breton (1818–1866), *Cases des Naturels a Nouka-Hiva*, 1846. Originally sketched in Taioha'e, Nuku Hiva, in 1838, Le Breton's village scene depicts the distinctive stone platforms (*paepae*) that formed the foundations of houses and other structures.

18. Beaglehole 1961: 374 n. 4;
 Dening 1980: 46–47.
19. Langsdorff 1813, vol. 1: 176.
20. Kirch 2000: 258.

21. In the southern dialect: *tuhuna o'ono.*
22. Lavondès 1995: 31; E. Handy 1923: 45; Dening 1980: 50.
23. Lavondès 1995: 31; E. Handy 1923: 44.
24. E. Handy 1923: 49; Porter (1815) 1986: 359. Lavondès 1995: 31.
25. Lisiansky (1814) 1968: 66; Langsdorff 1813, vol. 1: 118–20; Krusenstern 1813: 155.
26. An exception to this was the island of Ua Pou, the entirety of which was under the control of a single *haka'iki;* E. Handy 1923: 35.
27. Lavondès 1995: 31.

tau'a, and ritual specialists, *tuhuka o'oko,*[21] were drawn primarily from chiefly families. In contrast to some regions of Polynesia, such as Hawai'i, where chiefs held near absolute authority, Marquesan *haka'iki,* although recognized as the traditional leaders of society, had little inherent political power. Instead, each was dependent on his, or in some instances her, personal charisma, eloquence, and leadership abilities to earn the respect and obedience of the *mata'eina'a.*[22]

The *haka'iki* initiated and controlled communal activities and resources, including feasts (*koina*), warfare, and the breadfruit harvest, and owned public spaces such as the ceremonial plazas, or *tohua.*[23] Although they typically had servants and lived in larger dwellings than *mata'eina'a,* Marquesan chiefs mixed freely with commoners and performed ordinary tasks.[24] As early European observers noted with some surprise, in daily life there were few outward signs to distinguish the *haka'iki* from their subjects except that chiefs, as a group, were more intricately and extensively tattooed (cat. no. 22).[25] On festive occasions, however, the status of the *haka'iki* became more apparent in the number and quality of their ornaments and the accessories they carried, some of which, like the staffs known as *tokotoko pio'o* (cat. nos. 57, 58), appear to have been restricted to members of the chiefly class.

The political organization of the Marquesas was defined, in large part, by the islands' mountainous landscape. Each of the deeply carved valleys was typically home to a single autonomous group, which, although composed of both chiefs and commoners, was known collectively as a *mata'eina'a.* The *mata'eina'a* was led by one or more *haka'iki,* whose political power and influence did not extend beyond the valley.[26] Individual *mata'eina'a* were usually named after a specific ancestor.[27] In some cases, more than one *mata'eina'a* inhabited the same valley and no single chief had control of the entire area. Although luxury items such as *'eka* (turmeric), ornaments, and other objects were exchanged within and between islands, every valley was essentially self-sufficient. The beaches at the mouths of the valleys gave access to the sea for fishing, travel, and obtaining materials such as turtleshell, pearlshell, or *uhi,* and the large marine snails required for shell trumpets (cat. no. 63). The relatively flat valley floors provided space for houses, breadfruit trees, and other crops, while forested areas on the steeply sloping sides were a source of wood and the precious feathers of wild birds.

Marquesan houses were not usually concentrated in a single village but were instead built at intervals along the entire length of the valley floor. Constructed from wood, bamboo, and thatch, they were erected on raised stone platforms, or *paepae* (fig. 2). Public spaces like *tohua* were typically situated closer to the mouth of the valley, while sacred sites, such as *me'ae* and the homes of the prophetic priests, or *tau'a,* were secluded in the narrow hinterlands at the back.

In most cases, relationships between the *mata'eina'a* were hostile. The people of each valley were typically in a continuous, though small-scale, state of war with their neighbors. When *mata'eina'a* in adjacent or nearby valleys formed alliances, it was often to unite against a common enemy rather than to achieve a lasting peace. Although wars of conquest were occasionally waged, particularly during the postcontact period, the primary goal of most conflicts was not to defeat the enemy but to kill or capture a victim.[28] Marquesans fought both to avenge earlier killings or insults and to obtain human sacrifices, or *heana*.[29] Some religious observances required that human sacrifice be offered as part of the rites. On such occasions, the *tau'a* would call upon the community to provide a *heana*, and a military expedition would be mounted to obtain one from a neighboring valley.[30]

The identity and social standing of most Marquesan men were largely determined by their achievements as warriors. Although war parties were dispatched by the *haka'iki*, the actual fighting was done almost exclusively by the *toa*, a class of semiprofessional warriors second only to the chiefs and *tau'a* in their secular authority.[31] Many *toa* carried the decorated skulls of their victims as evidence of their martial prowess (cat. nos. 20, 21). Bodies of enemies taken in vengeance were usually offered as sacrifices at the *me'ae* or, at times, consumed at feasts, which were typically limited to the elite.[32] Many Marquesans owned and used *ivi po'o*, ornaments fashioned from the bones of slain enemies (cat. nos. 6–13).

Whether fought for revenge, *heana*, or a combination of factors, Marquesan warfare consisted primarily of brief skirmishes. These took the form of both pitched battles, which were often held on the ridges that separated the valleys, and more stealthy raids on the dwellings of the enemy. In some instances, hostilities might last on and off for weeks or months before a single life was lost.[33]

Announced well in advance, pitched battles in the Marquesas were a dress occasion. *Toa* went into such battles adorned in their finest and most treasured ornaments. In some instances, *haka'iki* also lent their own adornments to *toa* to wear while they fought.[34] Intended to inspire fear and awe, a warrior's regalia often included imposing feather headdresses (cat. nos. 32, 33) and dense embellishments of human hair worn about the shoulders, waist, and limbs (see fig. 20) that undulated wildly as he ran, creating the impression of great ferocity and speed.[35] Capt. David Porter, who visited the islands in 1813, described the elaborate battle dress of the Marquesan *toa*:

> *I had seen several of their warriors since I had arrived, many of them highly ornamented with plumes, formed of the feathers of cocks and man-of-war [frigate] birds, and with the long tail feathers of the tropic bird; large tufts of hair were tied around their waists, their ancles, and their*

28. Dening 1980: 24.
29. E. Handy 1923: 127.
30. Robarts (1974: 77–85) provides a detailed account of one such incident from the island of Hiva Oa, describing the call of a *tau'a* for a *heana* and the war that ensued in order to obtain one.
31. E. Handy 1923: 36, 133.
32. Ibid.: 124.
33. Porter (1815) 1986: 329.
34. Robarts 1974: 25.
35. E. Handy 1923: 127–29.

Figure 3. Portraits of Marquesans from Taioha'e valley on Nuku Hiva made by artists from Dumont d'Urville's expedition of 1838 showing the rich variety of Marquesan ornaments and tattoo. Left to right: a warrior with a composite headdress and wood ear ornaments (*kouhau*), Patini (a high-ranking female chief), and a tattooed man wearing what is likely an ivory ear ornament (*hakakai*).

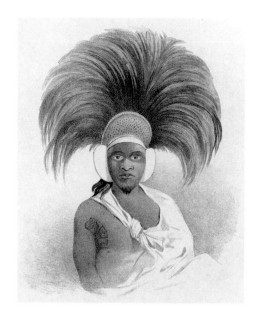

loins: a cloak, sometimes of red cloth,[36] but more frequently of a white paper cloth . . . thrown not inelegantly over the shoulders, with large round or oval ornaments in their ears, formed of whales' teeth, ivory, or a kind of soft and light wood, whitened with chalk; from their neck suspended a whale's tooth, or highly polished shell, and round their loins several turns of the stronger kind of papercloth, the end of which hangs before in the manner of an apron: this with a black and highly polished spear of about twelve feet in length, or a club richly carved, and borne on the shoulders, constitutes the dress and equipment of a native warrior, whose body is highly and elegantly ornamented by tattooing, executed in a manner to excite our admiration.[37]

In addition to the clubs and spears noted by Porter, Marquesans also used slings to hurl stones from a distance with deadly accuracy.[38] The finest and most prestigious weapons were the exquisitely carved hardwood war clubs known as *'u'u* (cat. nos. 54–56). Carried both in battle and in daily life, a finely crafted *'u'u* was the mark of a Marquesan warrior. Beyond the *'u'u,* a *toa*'s accessories might include a shell trumpet, or *putoka* (cat. no. 63), used to rally forces and coordinate the movements of warriors in combat. Standing on the battlefield, with their densely tattooed bodies arrayed in lavish regalia and armed with *'u'u* and other weapons, Marquesan *toa* were, quite literally, dressed to kill.

This delight in personal ornamentation extended far beyond the *toa* and their chiefly sponsors. Even the lowest ranking commoners sought to embellish themselves as extensively and elegantly as circumstances allowed. Nearly all adult Marquesans were tattooed. The process of tattooing, known as *patu 'i te tiki* or *patu 'i te ti'i,* began in adolescence and continued throughout an individual's life.[39] Women's tattoos were generally restricted to vertical lines on the lips and small motifs behind the ear, together with more extensive designs on the arms, legs, and shoulders.[40] But men, such as chiefs and warriors, who could afford the time and expense involved and withstand the pain of having their entire bodies decorated were, as one eighteenth-century explorer observed, "tattow'd from head to foot in the prettyest manner that can be conceiv'd."[41] Indeed, some older men were so extensively tattooed that their skins, naturally light brown in color, appeared almost black.[42]

36. Porter is likely referring here to the red trade cloth obtained from European and American sailors.
37. Porter (1815) 1986: 311–12.
38. Ibid.: 328.
39. For a more detailed discussion of Marquesan tattooing, see cat. nos. 19–22.
40. Linton 1923: 417.
41. This observation was made by Charles Clerke, who visited the islands in 1774 as a member of Capt. James Cook's expedition. Beaglehole 1961: 374 n. 5.
42. Forster (1777) 2000, vol. 1: 329.

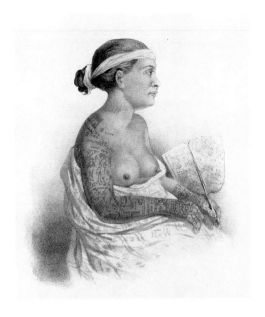
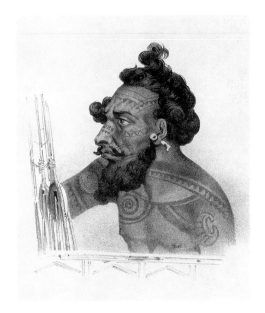

At once fascinated and repelled by the practice, early explorers marveled at the ingenuity and complexity of Marquesan tattooing. Porter's description of tattooed chiefs expresses this ambivalent admiration:

When the eye is once familiarised with men ornamented after this manner, we perceive a richness in the skin of an old man highly tattooed comparable to that which we perceive in a highly wrought piece of old mahogany: for, on a minute examination, may be discovered innumerable lines curved, straight, and irregular, drawn with the utmost correctness, taste and symmetry. . . . in a short time we are induced to think that tattooing is as necessary an ornament for a native of those islands as clothing is for an European. The neatness and beauty with which this species of ornament is finished, served greatly to surprise us. . . ."[43]

Marquesan tattooing was the work of *tuhuka,* who were often full-time specialists.[44] Tattoos were created using fine-toothed comblike blades made from human or bird bone attached to handles to form implements resembling miniature garden hoes. The teeth of the comb were dipped in black pigment made from soot or finely crushed charcoal mixed with water and held against the skin. The *tuhuka* then struck the top of the comb sharply with a small stick to insert the pigment.[45] Like other art forms, the act of tattooing was sacred—presided over by specific deities and accompanied by ritual and restriction. Because the process was both expensive and extremely painful, *tuhuka* usually worked on only a small area of the client's body in any given session.[46]

Owing, in large measure, to the magnificence of their tattooing and the islands' subtropical climate, Marquesans needed few clothes. Men wore loincloths, or *hami* (cat. nos. 21, 23), while women wore short skirts known as *ka'eu* (cat. no. 26).[47] In some cases, women were also attired in shawl-like garments and headcloths, wound like a turban over their hair.[48] Early European portraits of Marquesans at times

43. Porter (1815) 1986: 294.
44. Langsdorff 1813, vol. 1: 117; E. Handy 1923: 145; Porter (1815) 1986: 294.
45. Linton 1923: 417–18.
46. W. Handy 1922: 11–12.
47. Thomson (1841) 1980: 25; E. Handy 1923: 279.
48. Thomson (1841) 1980: 25.

49. An exception to this are the elaborately decorated surfaces of the barkcloth effigies (cat. no. 14).
50. Thomson (1841) 1980: 18.
51. Forster (1777) 2000, vol. 1: 332.
52. E. Handy 1923: 61, 87.
53. Linton 1923: 424; Ivory 1990: 164.

show men wearing draped headcloths as well as capes (cat. nos. 17, 18, 24). Before the introduction of Western trade cloth, all Marquesan clothing was made from *tapa* (barkcloth), which, in contrast to the elaborate ornamentation seen in other Marquesan art forms, was nearly always unadorned.[49] Coarser varieties, such as the light brown form made from the bark of the breadfruit tree, or *mei,* were used for everyday clothing. The finer white barkcloth derived from the paper mulberry, or *ute,* was used for men's loincloths and for garments worn on special occasions. Some head cloths made from *ute* were reportedly as fine and delicate as lace.[50] A reddish brown barkcloth known as *hiapo,* made from the young banyan trees (*aoa*), was considered sacred and was used to make the loincloths for the *haka'iki,* as well as the capes and robes worn by warriors and minor priests. Darker cloaks made from the bark of older banyans were worn by the *tau'a.*

If Marquesan garments were relatively simple, as one early explorer aptly observed, "the number of ornaments might be said to supply the want of cloathing."[51] While, apart from their tattoos, most Marquesans wore few ornaments on a daily basis, on festive occasions both men and women decked themselves out in all their finery (fig. 3). Festivals, ceremonies, and other public gatherings were the center of Marquesan social life. The primary venue both for the performing arts and for the conspicuous display of personal ornaments and tattoo, festivals were held to commemorate nearly every significant occurrence in the community. These included the elevation of ancestors to the status of *etua* and important events in the lives of the *haka'iki,* as well as celebrations of the breadfruit harvest or victory in battle. Festivals typically took place on the *tohua* (ceremonial plazas), where hundreds, or even thousands, of people gathered to witness rituals or events such as stilt-walking competitions and performances by the *ka'ioi,* a semiprofessional class of performers composed of young men and women.

At festivals and other dress occasions, Marquesans adorned themselves with an astonishing variety of ornaments. The simplest and most ephemeral were natural objects such as flowers and leaves plucked for the occasion and discarded after use. The most elaborate included forms such as composite headdresses (cat. no. 32), porpoise-tooth crowns (cat. nos. 36, 37), and bone and ivory ear ornaments (cat. nos. 40–48). These ornaments required days or weeks to make and were often passed down as heirlooms. Like all significant personal possessions, treasured ornaments were given individual names.[52] Although some types, like the larger variety of ivory ear ornaments, or *hakakai* (cat. no. 40), appear to have been restricted to members of one sex, most ornaments could be worn by either men or women.[53] Whether gathered to witness or participate in festivals, feasts, or battle, Marquesans adorned their bodies with a splendor and complexity unsurpassed in Polynesia.

This love of ornament extended beyond the body to the surrounding world. While many of the objects the Marquesans fashioned were unadorned, *tuhuka* frequently embellished even the most mundane tools and utensils. Explorers in the late eighteenth and early nineteenth centuries described carved wood bowls, whose designs included images of humans, birds, and fish, as well as vessels suspended in ornamental nets, or *koko*, accented with ornaments of human bone (cat. no. 77).[54] Beginning in the late nineteenth century, Marquesan works became increasingly ornate, and objects made during this period are the most lavish and intricate expressions of Marquesan decorative carving. As Gauguin, who was more familiar with works in this later style, observed: "Give [a Marquesan] an object . . . [and] he will succeed—the whole harmoniously—in leaving not a single shocking or incongruous empty space."[55] During this era and, to a large extent, into the present day, Marquesan *tuhuka* exhibit a virtual horror vacui, adorning almost any type of surface with patterns of often astounding complexity.

The designs on Marquesan objects are similar, in many instances identical, to those that appear in tattoo, and there has been some debate on the nature of the relationship between surface ornament and tattoo motifs. One early-twentieth-century scholar proposed that the carved surfaces of bowls served as the original inspiration for Marquesan tattoo.[56] Contemporary researchers, by contrast, have argued that, as the most ornate bowls and objects are of relatively late date, it was instead tattooing that provided the inspiration for surface ornamentation.[57] However, it seems more likely that, rather than one art form having given rise to the other, tattoo and surface ornamentation represent two different expressions derived from a shared set of artistic conventions.

Among the richly varied geometric patterns in Marquesan decorative art are a number of figurative motifs, including humans, lizards (cat. nos. 60, 62), birds, turtles (cat. no. 54), and fish. Of these, by far the most widespread and significant are the human images, or *tiki,* which appear on virtually all three-dimensional objects, decorated surfaces, and tattoos. Marquesan *tuhuka* seem, at times, to have reveled in the act of subtly incorporating *tiki* into the most complex geometric compositions. The human figure, however, was more than a decorative motif. Even in mundane contexts, it retained sacred associations, whose meanings were intimately linked to Marquesan religious beliefs.

Like other Polynesian peoples, the Marquesans were polytheistic. Their cosmology encompassed a diversity of supernatural beings, or *etua*, from the gods and goddesses who created the universe to those responsible for different aspects of the natural world and human activities, such as agriculture and war. More specialized *etua* served as

54. Crook 1800: 80–81; Fleurieu 1801: 122; Langsdorff 1813, vol. 1: 172; Robarts 1974: 279.
55. Quotation in Rotschi 1995: 92, translation mine.
56. Linton 1923: 355–76.
57. Ivory 1990; Ivory 1993.

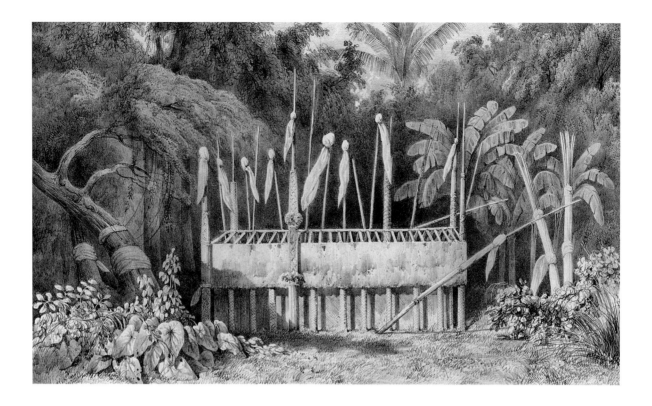

Figure 4. The *me'ae* of a chief in Taioha'e, Nuku Hiva, as recorded by Louis Le Breton (1818–1866) in 1838. The *me'ae* incorporates an elaborate ceremonial structure with prominent vertical poles adorned with ball-like bundles of barkcloth (*tapa*). Large pieces of barkcloth are also tied around the trunks of some of the surrounding trees.

58. E. Handy 1923: 244; Dening 1980: 60.
59. E. Handy 1923: 244.
60. A fuller account of this tradition is given in the essay by Carol S. Ivory in this volume.
61. Dening 1980: 57.
62. E. Handy 1923: 148.

patron deities for specific aspects of nature and human endeavor—from tattooing and canoe building to breadfruit harvesting, fishing, and the curing of sickness.[58] The power of some *etua* extended throughout the archipelago and the universe. The influence of most, however, was more localized. Within the individual valleys, each *mata'eina'a* recognized and honored its own particular *etua,* whose powers sustained and protected the fertility and well-being of their specific community.

In the broadest sense, all Marquesan deities were ancestral.[59] According to one oral tradition, the primordial beings Tiki and Hina-tu-na-one gave rise to the first Marquesans, whose descendants became the founding ancestors of families and *mata'eina'a*.[60] Along with more distant ancestors, prominent chiefs, priests, or *tuhuka* who had recently died (or were, in some cases, still living) were also venerated as *etua.* The most powerful *etua,* such as creator beings, were largely remote from the sphere of daily life.[61] Seldom directly worshipped, they are not known to have been depicted in Marquesan art or embodied in any material object.[62] Instead, all Marquesan *me'ae,* priests, ceremonies, and their related art forms were dedicated to *etua* associated with specific *mata'eina'a* and chiefly families. Thus, although Marquesans shared many deities and oral traditions in common, the divine beings honored in their ceremonies were, to a large extent, local.

Etua were the ultimate source of supernatural power, or *mana,* which could be manifest in people, places, and both natural and man-

made objects. *Haka'iki,* considered the most direct descendants of the ancestral deities, inherently had more *mana* than commoners, and they imparted it to the ornaments and implements they used. Because of their close association with *etua,* priests, sacred sites, and religious paraphernalia were also heavily imbued with *mana.* The nature of *mana* was, in some ways, analogous to that of electricity in industrial societies. While its energy sustained the health and prosperity of the community, it was also potentially dangerous. If individuals or objects with little *mana* came in contact with people or things that were highly charged, the resulting transfer of sacred power could be lethal to the former and defiling to the latter.

Individuals, places, activities, and objects with large amounts of *mana* were designated as sacred, or *tapu.* By extension, the term *tapu* also served as a warning that contact with that person or thing was dangerous and therefore restricted or forbidden. *Tapu* varied in their strength and intensity. *Haka'iki,* priests, and *tuhuka* were more *tapu* than commoners, as were their homes and possessions, but not to such an extent that members of different social ranks could not interact in daily life. Men, as a rule, were more *tapu* than women, although female chiefs held sacred status. The head was the most *tapu* part of the body and, particularly in the case of the *haka'iki,* was not to be touched by others.[63] Some *tapu* designations were temporary, declared by chiefs or priests to protect crops and other resources from overexploitation or preserve them for use in feasts and ceremonies. Most *tapu,* however, were permanent, such as those which governed all things associated with the *me'ae.*

Me'ae were the most important sacred sites in the Marquesas and the primary centers of religious life. The *mata'eina'a* of each valley had one or more *me'ae,* where rituals were performed and offerings and prayers to local *etua* were presented. *Me'ae* often served as burial grounds for prominent individuals, some of whom were themselves venerated as ancestral deities.[64] While the plan of individual *me'ae* varied, nearly all of them incorporated one or more stone platforms, or *paepae,* on which structures or images were erected either permanently or in connection with specific ceremonies. Striking expressions of Marquesan architecture, the *me'ae* were frequently adorned with carvings, barkcloth, and other embellishments (fig. 4).

In some *me'ae,* the resident *etua* were represented by one or more large stone or wood *tiki,* erected on the *paepae* (see fig. 13 and cat. no. 1). In others, their powers were embodied in non-representational forms such as natural objects or bundles of barkcloth, which were often regarded as more powerful than the anthropomorphic images. When Porter visited a *me'ae,* for example, he described a number of *tiki* figures but noted that the "greatest of all gods" took a very different form:

63. Ibid.: 257–58; Lavondès 1995: 31.
64. E. Handy 1923: 115.

65. Porter (1815) 1986: 412. Similar barkcloth bundles can be seen attached to the poles of the *me'ae* in figure 4.

66. Lavondès 1995: 31–32; Dening 1980: 166.

67. Lavondès 1995: 32.

68. In the southern dialect: *tuhuna 'o'ono*.

69. Lavondès 1995: 32.

70. E. Handy (1923: 9–10) estimated the total population at contact at between 50,000 and 100,000. Dening (1980: 239) believes that the population in 1798 was approximately 90,000. Rallu (1995: 76), by contrast, claims that the population during roughly the same era was only 40,000 to 50,000.

71. Dening 1980: 239; Rallu 1995: 79. The current population of the islands is roughly 8,700 with another 10,000 living in Tahiti and elsewhere in the Society Islands.

They brought him [the god] out on the branch of the cocoa-nut tree, when I was surprised to find him only a parcel of paper cloth [barkcloth] secured to a piece of a spear about four feet long; it in some measure resembled a child in swaddling cloths, and the part intended to represent the head had a number of strips of cloth hanging from it about a foot in length.[65]

Like other important activities, religious rites were performed by specialists. By far the most significant and powerful spiritual figures in Marquesan society were the prophetic priests, or *tau'a*. The *tau'a* formed a direct supernatural link between the *etua* and the community, and their persons, dwellings, and possessions were all highly *tapu*. When it became necessary to communicate with the *etua* or as the inspiration struck them, the *tau'a* would enter a trancelike state during which the ancestral divinities spoke directly through them to express their will and desires. Some prominent *tau'a* were considered to be *etua* in their own right.[66] At once honored and feared, *tau'a* were the ultimate authorities in the religious sphere, and their secular power was second only to that of the ruling *haka'iki*. Acting on behalf of the *etua*, the *tau'a* presided over major sacrificial rituals and oversaw some funerary rites.[67] Other religious observances were the responsibility of *tuhuka 'o'oko*,[68] less powerful priests who lacked the prophetic gifts of the *tau'a*. Experts in religious lore and ritual protocol, *tuhuka 'o'oko* organized both public and private ceremonies. In a society without written language, they also served as the keepers of genealogies and oral traditions.[69]

It was this complex and aesthetically sophisticated people, the inheritors of a cultural and artistic legacy fifteen centuries in the making, that Mendaña and his party encountered in 1595. Although the next European vessel would not reach their shores until nearly two centuries later, Mendaña's "discovery" of the islands would ultimately lead to what, in the Pacific, was an all too familiar cycle of colonization, missionization, and disease that would have a profound impact on Marquesan culture.

In the absence of reliable information, it is impossible to know with any certainty how many Marquesans were living in the archipelago when the earliest explorers arrived. Estimates range from forty to one hundred thousand people, distributed among the six regularly inhabited islands.[70] By the 1860s, as the result of a series of epidemics as well as social disruption and violence, there were ten thousand, and, by the mid-1920s, only about two thousand.[71]

Marquesans lived in an oral culture whose traditions resided in the collective memories of its people. The decimation of the population combined with the zealous efforts of missionaries, who by the 1860s had converted virtually all the islands' inhabitants to Christianity, caused many customs and art forms to die out or become severely diminished. Yet, despite the devastating effects of Western contact, Marquesan art, language, and culture endured, and over the past

thirty years, many art forms have been experiencing a renaissance.

Our knowledge of Marquesan art and culture as it existed in the precontact and early historical periods is based on the observations of Westerners who, for a variety of reasons, sought to understand and describe the islands and their people. Although necessarily shaped by the perspectives and biases of those who recorded it, much of this information was obtained through direct observation or from the Marquesans themselves. Thus, while imperfect, their accounts offer what is often the only window on a largely vanished world.

From the beginning, Marquesan culture was a source of fascination to Western visitors. The earliest descriptions of Marquesan art are those of Mendaña's pilot, Pedro Fernandez de Quirós (d. 1615), who wrote a history of the ill-fated Spanish expedition following his commander's death.[72] Quirós described the Marquesans' elaborate tattooing, as well as a *me'ae* with several wood *tiki*.[73]

After this brief initial encounter, Europeans did not visit the Marquesas again until 1774. It was then that the British explorer Capt. James Cook (1728–1779), whose three voyages to the Pacific were responsible for first revealing many of its arts and cultures to the West, made a brief stop at Vaitahu, on Tahuata, the same harbor where Mendaña had anchored. After nearly two centuries without Western contact, the lavishly tattooed Marquesans clambered aboard Cook's ships "to be gazed at, and to gaze."[74] The expedition's artist, William Hodges (1744–1797), created the earliest European depictions of the islands and their people (cat. nos. 17, 18). Cook and other members of his expedition also wrote detailed descriptions of their encounters and brought the first collections of Marquesan objects back to Europe.[75]

Cook's rediscovery of the islands marked the beginning of regular contact with the West. In 1791, the American Joseph Ingraham (1745–1800) and, two months later, the French explorer Étienne Marchand (1755–1793) became the first outsiders to sight the northern islands of the Marquesan archipelago, including Nuku Hiva, Ua Huka, and Ua Pou.[76] They were soon followed by other explorers as well as the earliest merchant vessels. The Marquesas' first beachcomber,[77] Edward Robarts (1771–1832?), and the first missionary, William Pascoe Crook (1775–1846), both of whom wrote extensive accounts of their experiences, also arrived in the 1790s.[78]

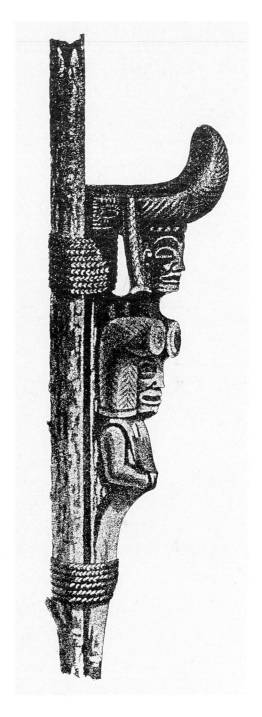

Figure 5. Marquesan stilt (*vaeake*), including a portion of the pole and the carved stilt step (*tapuvae*) illustrated by Capt. David Porter (1780–1843) in 1815. A similar stilt step appears in cat. no. 66.

72. See Quirós 1904. Originally from Portugal, Quirós was born Pedro Fernandes de Queirós and later moved to Spain, where the spelling of his name was changed to Pedro Fernandez de Quirós.

73. Ibid.: 50, 52, 61.

74. Forster (1777) 2000: 330.

75. See Beaglehole 1961, vol. 1; Kaeppler 1978: 165–68.

76. The observations of Marchand and his officers were later edited by Charles Pierre Claret, compte de Fleurieu (1738–1810), who published them in 1801.

77. The term "beachcomber" refers to Western sailors who deserted their vessels and took up residence among the Marquesans and other Pacific Island peoples.

78. Crook 1800; Robarts 1974. For a detailed and highly readable history of the encounters between Marquesans and the West from 1774 to 1880, see Dening 1980.

79. Between 1797 and 1817, some fifty vessels are known to have visited the archipelago and a total of thirty-one beachcombers lived among the Marquesans for varying lengths of time; Dening 1974: 28.

80. Ibid.

81. Ivory 1990: 98–99. See Krusenstern 1813; Lisiansky (1814) 1968; and Langsdorff 1813.

82. For a detailed account of Porter's activities on Nuku Hiva, see Dening 1980: 26–31.

In the early decades of the nineteenth century, European and American vessels began to arrive in ever greater numbers.[79] Whaling ships were regular callers as were traders seeking sandalwood, a fragrant timber that grew in abundance in the islands. Most visitors stopped at Taioha'e on Nuku Hiva or Vaitahu on Tahuata, which provided the best anchorages.[80] As a result, the majority of early Western images and descriptions of Marquesan culture are based on the *mata'eina'a* of these two valleys.

The most extensive accounts of Marquesan art and culture from this period are those by the members of the 1804 Russian expedition under Capt. Adam Johann von Krusenstern (1770–1846). Krusenstern's ships, the *Nadezda* and the *Neva,* anchored for nearly two weeks at Taioha'e. During this time, assisted by Robarts and the French beachcomber Jean-Baptiste Cabri (1780–1822), Krusenstern as well as the *Neva*'s captain, Urey Lisiansky (1773–1837), and the German scientist Georg Heinrich von Langsdorff (1774–1852) compiled detailed descriptions of Nuku Hivan customs and artistic traditions.[81] Perhaps the most enduring legacy of Krusenstern's visit are the striking portraits of tattooed Marquesans made by Wilhelm Gottlieb Tilesius von Tilenau (1769–1857), one of the artists who accompanied the expedition (cat. nos. 19–21).

The War of 1812 between the United States and Great Britain, whose battles were waged thousands of miles away, had unexpected repercussions for the Marquesas. In 1813, an American naval officer, Capt. David Porter (1780–1843), was dispatched to the Pacific in an effort to harass the British whaling fleet. During the course of this mission, Porter brought the two vessels under his command, along with three captured British whaling ships, to Taioha'e. There, he established a settlement and fort and conducted several military campaigns, including two against the people of nearby Taipivai.[82] In the midst of all these activities, Porter somehow found time to write a lengthy description of his exploits, which includes substantial information on Marquesan art and customs. In his published book, Porter illustrated a number of Marquesan objects, among them a stilt, or *vaeake* (fig. 5), whose stilt step is similar in form to one of the examples presented here (cat. no. 66). In response to Porter's actions, the British sent the HMS *Briton* to the islands in 1814. The *Briton*'s voyage was chronicled by Lt. John Shillibeer (1792–1860), whose account is notable primarily for the author's portrait of Patuki, a magnificently tattooed *haka'iki* whom he befriended in Taioha'e (cat. no. 22).

A more refined series of images of the Marquesans and their land was made by Louis Le Breton (1818–1866) and the other artists who accompanied the French explorer Jules-Sébastien-César Dumont d'Urville (1790–1842) to the islands in 1838 (see figs. 2, 3, 4 and cat. no. 27). The same year also marked the first visit of the French admiral Abel Aubert

Dupetit-Thouars (1793–1864), who returned in 1842 to negotiate the formal annexation of the archipelago by France and is known to have collected a number of Marquesan objects (including cat. nos. 8, 37, 46–48). The islands have been under French authority ever since and today form part of the larger Pacific territory known as French Polynesia.[83]

Following annexation, missionary activity in the Marquesas greatly increased. The efforts of earlier missionaries, such as Crook and the Americans Richard Armstrong (1805–1860) and Clarissa Chapman Armstrong (1805–1891; cat. nos. 23–26), had been largely unsuccessful. Eventually, however, French Catholic missionaries were able to convert the entire population. Ironically, while they sought to suppress

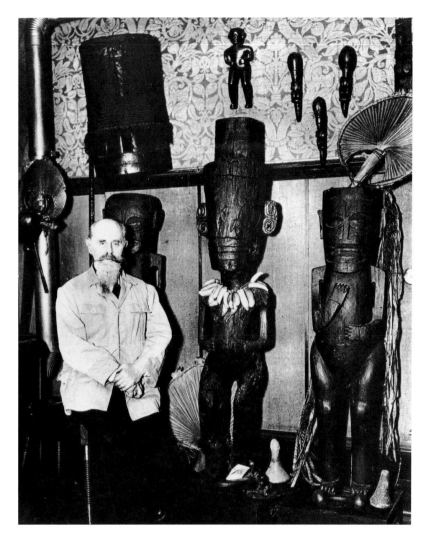

Figure 6. The pioneering scholar of Marquesan art Karl von den Steinen (1855–1929) posing with large *tiki* and other Marquesan works. Date and photographer unknown. Collection of Loed and Mia van Bussel, Amsterdam

many of the practices they encountered, some also wrote extensive studies of Marquesan language and culture. These include the works of Gérauld Chaulet (1830–1912), Siméon Delmas (1862–1939), and Mathias Graçia (1801–1876), as well as Ildephonse-René Dordillon (1808–1888), who compiled the definitive dictionary and grammar of the Marquesan language.[84]

After over a century of more general accounts, the first scholar to take an interest specifically in Marquesan art was the German physician Karl von den Steinen (1855–1929; fig. 6). After spending years examining collections of Marquesan art in the West, Steinen finally traveled to the islands in 1897 where he made extensive studies of the imagery and significance of many Marquesan art forms, and collected both objects and oral traditions.[85] Steinen's monumental three-volume study, *Die Marquesaner und ihre Kunst,* remains the most comprehensive survey of Marquesan art.[86] The information obtained by Steinen was augmented in 1920 by members of the Bayard Dominick Expedition, organized by the Bernice P. Bishop Museum in Honolulu. The expedition included the anthropologist Edward Smith Craighill

83. French Polynesia, officially classified as a " French overseas territory" (*pays d'outremer*) of France, also encompasses the Society Islands (including Tahiti) and the Tuamotu, Austral, and Gambier Islands (including Mangareva).
84. See Delmas 1927; Graçia 1843; and Dordillon (1904) 1999.
85. Dening 1980: 278.
86. See Steinen 1925–28.

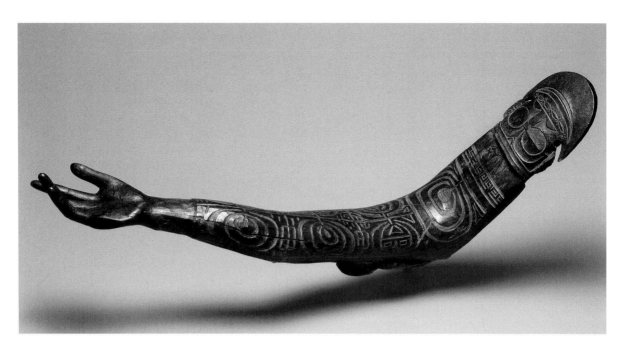

Figure 7. Carving of a tat-
tooed arm collected by Robert
Louis Stevenson (1850–1894).
Wood, length 24 in. (61 cm).
Peabody Essex Museum,
Salem, Massachusetts

Handy (1892–1980) and his wife, the artist Willowdean Handy (1889–
1965), as well as the archaeologist Ralph Linton (1893–1953), whose
numerous published works contain extensive discussions of the
islands' diverse art forms.[87]

Beyond the more pragmatic and intellectual concerns of explorers,
missionaries, and scholars, the Marquesas have long held an irresistible
allure for romantics attempting not to promote but to escape Western
civilization. From the early beachcombers to the tourists who visit
their shores today, these remote islands have been a touchstone for
those seeking adventure, or refuge, in the South Pacific.

The most renowned of the beachcombers was Herman Melville
(1819–1891). Unhappy with conditions aboard the American whaler
Acushnet, on which he had shipped as a sailor, he jumped ship when it
anchored at Taioha'e, on Nuku Hiva, in 1842.[88] In all, Melville spent a
month on the island, dividing his time between Taioha'e and the nearby
valley of Taipivai.[89] His experiences on Nuku Hiva formed the basis of
his first book, *Typee* (1846). Set almost entirely in Taipivai (whose name
he rendered as Typee), the book was billed as a true account of the
author's adventures and sold briskly, establishing Melville's reputation as
an author. In fact, until the early twentieth century, Melville was best
known as the author of *Typee* rather than *Moby-Dick*.[90] Originally pres-
ented as nonfiction, the book is actually a semi-autobiographical novel
in which Melville supplemented his own observations with informa-
tion drawn from Cook, Porter, and other sources and extended the
period of his sojourn from one to four months.[91] Replete with exotic
images of the Marquesans and their islands, from the fair maiden
Fayaway to secretive cannibal feasts, *Typee* embodies the romanti-
cized vision of the South Pacific that continues to this day.

87. See E. Handy 1923 and 1929;
 W. Handy 1922; and Linton
 1923 and 1925.
88. In 1992, a monument was
 erected in Taioha'e to com-
 memorate the 150th anniver-
 sary of Melville's arrival. It
 represents what is perhaps
 the world's only monument
 to a deserting sailor.
89. Hayford 1964: 314.
90. Ibid.: 309.
91. Dening 1974: 1.

After Melville first fixed them in the Western imagination, the Marquesas became a destination for adventurous writers throughout the nineteenth and early twentieth centuries. The first to arrive, in 1872, was another sailor, Louis-Marie-Julien Viaud, who later wrote under the pseudonym Pierre Loti (1850–1923). In his book *Le Mariage de Loti* (1878), he mourns the devastating impact of Western contact on the Marquesan people. He was followed in 1888 by Robert Louis Stevenson (1850–1894), who traveled extensively in the Pacific in the hope that the mild, tropical climate would improve his declining health.[92] Stevenson spent more than a month in the Marquesas and devoted the first section of his book *In the South Seas* (1896) to the archipelago. While he mentions Melville, whom he hails as one of only two writers to have "touched the South Seas with any genius," and, later, Loti,[93] of whom he held a lower opinion, *In the South Seas* is essentially a travelogue describing his encounters with the islands and their inhabitants, both French and Marquesan. While there, Stevenson acquired a number of Marquesan artworks, including a dramatic life-sized carving of a tattooed arm (fig. 7).

The most enthusiastic writer to stop at the islands was Jack London (1876–1916), for whom the journey was less a visit than a personal literary pilgrimage. "When I was a little boy," he wrote, "I read a book . . . Herman Melville's 'Typee'; and many long hours I dreamed over its pages. Nor was it all dreaming. I resolved there and then . . . that when I had gained strength and years, I too, would voyage to Typee."[94] London realized his youthful ambition in 1907, when he arrived at Nuku Hiva aboard his private yacht, the *Snark*. After an arduous journey overland from Taioha'e, he at last reached Taipivai, where he was, perhaps inevitably, disappointed. In contrast to the lively and exotic world described in *Typee* (the details of which were frequently embellished by Melville's imagination), London found the valley largely empty and overgrown, its once legendary warriors now peaceful and ailing from introduced diseases.

In the years that followed, the allure of the Marquesas would inspire new generations of romantics, including the Scandinavian adventurers Thor Heyerdahl (1914–2002) and Bengt Danielsson (1921–1997) and the Belgian singer Jacques Brel (1929–1978), who spent much of the last years of his life on Hiva Oa and lies buried near that island's most famous resident, Paul Gauguin.

Paul Gauguin (1848–1903) remains by far the most renowned of all those who sought refuge in the Marquesas. Both literally and figuratively, the islands were the final stop in Gauguin's obsessive quest to find, and lead, what he described as a simple, "savage" life free of the confines of Western civilization. Disillusioned with Tahiti, which he found both too civilized and too expensive, Gauguin arrived in the

92. Stevenson eventually settled in Samoa, where he died in 1894.
93. Stevenson (1900) 1986: 26, 58. The other author whose Pacific writings Stevenson praised was the American Charles Warren Stoddard (1843–1909), whose literary reputation has not proved as enduring as Melville's.
94. London 1911: 137–38.

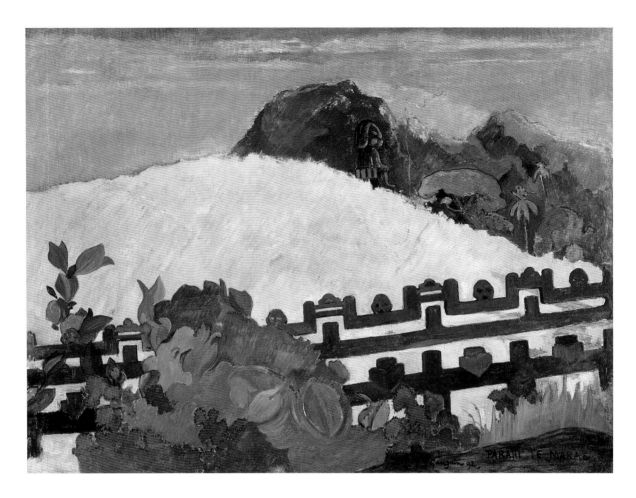

Figure 8. Paul Gauguin (1848–1903), *Parahi Te Marae* (*There Is the Marae*), 1892. Oil on canvas, 26 x 35 in. (66 x 88.9 cm). Philadelphia Museum of Art, Gift of Mr. and Mrs. Rodolphe Meyer de Schauensee, 1980

95. Rotschi 1995: 88.
96. Quotation given in ibid.: 88, translation mine.
97. Ibid.: 88–89.
98. See Varnedoe 1984: 192–93 and Rotschi 1995: 88–89.
99. Rotschi 1995: 89, 91.
100. Varnedoe 1984: 192.
101. See ibid.: 195, 198, 203.
102. Ives and Stein 2002: 138, 141. The bronze version of *Oviri* that adorns the grave today is a later copy, placed there in 1973. The original, a ceramic figure Gauguin produced in 1894 during a visit to France, is now in the Musée d'Orsay, Paris.

Marquesas in 1901 and settled in Atuona valley, on the island of Hiva Oa.[95] There he hoped to make a fresh start in both his life and his work. "I believe that in the Marquesas," he wrote to his friend the painter Georges-Daniel de Monfried (1856–1929), "with the facility that one has for obtaining models . . . and with landscapes still to be discovered—in brief, with elements that are completely new and more savage, I will make beautiful things. . . . My paintings of Brittany have become like *eau de Cologne* because of Tahiti; Tahiti will become *eau de Cologne* because of the Marquesas."[96] Ironically, much of the tranquil, unhurried life that Gauguin sought and found in the Marquesas was the result not of the absence but the impact of the West. Pacified by the French colonial authorities and depopulated by introduced diseases, the peaceful, sparsely settled islands Gauguin encountered had already been radically transformed.

Gauguin, however, had been fascinated and inspired by Marquesan art long before he settled in the archipelago. While it is unclear how much opportunity he had to see Marquesan works before he arrived in the Pacific, he is known to have brought photographs of tattooed Marquesans with him to Tahiti in 1891. Once there, he was able to examine and draw Marquesan objects in the collections of colonial officials and others who had visited or been stationed in the islands.[97]

He also acquired Marquesan works himself (cat. no. 73). Gauguin made sketches of several types of objects, including *pu taiana* (bone ear ornaments; cat. nos. 42–48), and tried his hand at decorating wood platters and vessels with *tiki* and other Marquesan motifs.[98]

Gauguin also assimilated Marquesan imagery into his own artistic language, incorporating elements inspired by Marquesan prototypes into his paintings, prints, watercolors, and sculpture.[99] The unusual fence that encircles the sacred site and *tiki* in his 1892 canvas *Parahi Te Marae* (*There Is the Marae*), for example, is inspired by Marquesan *pu taiana*, while the temple figure itself resembles the small *tiki* on the ends of *hakakai* (cat. no. 41).[100] His 1891–92 sculpture *Wood Cylinder with Christ on the Cross* and the later print based on it (fig. 9) transform the head of a Marquesan *'u'u* club into the cross itself.[101] The unusual radiating design at the top of this image, known as the *tiki* star motif, appears on many late-nineteenth-century *'u'u* as well as on the turtleshell overlays of *uhikana* headdresses (cat. nos. 28, 29). Surprisingly, Marquesan influences appear more frequently in the works Gauguin made during his years in Tahiti than in those he created after he settled in the Marquesas. For the renewed vigor in his life and art, which he, in failing health even as he arrived, had hoped to find in the Marquesas, went largely unrealized. Gauguin died on Hiva Oa in 1903 and is buried in Atuona. His grave was adorned, at his request, with his sculpture *Oviri* (*Savage*), whose features were inspired by Marquesan *tiki*.[102]

Around the time of Gauguin's death, Marquesan art began to attract the attention of a radically different group of artists. Marquesan works were among the African and Pacific sculptures that, in the early 1900s, served as sources of artistic inspiration for Pablo Picasso (1881–1973) and other members of the modernist movement. While the influence of Marquesan art is immediately evident in the works of Gauguin, among the modernists it is more subtle, part of a diversity of African and Pacific prototypes that contributed to the development of their often strikingly innovative approaches to the human form.[103]

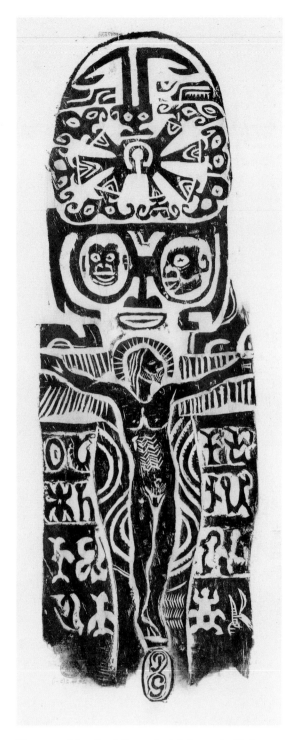

Figure 9. After Paul Gauguin (1848–1903), *Christ on the Cross*, 1926, posthumous rubbing on japan paper, taken from *Wood Cylinder with Christ on the Cross*, 1891–92, 15 ⅞ x 5 ⅜ in. (40.3 x 13.7 cm). The Metropolitan Museum of Art, New York, Harris Brisbane Dick Fund 29.10.2 (2–1)

Figure 10. Guillaume Apollinaire (1880–1918) with a Marquesan *tiki*. Photograph taken by Pablo Picasso in his studio, 1910.

Picasso's personal collection included a large Marquesan *tiki*, which appears in the well-known photograph of his friend the poet Guillaume Apollinaire, who is shown seated in Picasso's studio in 1910 (fig. 10). In what seems a very different world, the same *tiki* can also be seen in the background of a photograph taken decades later showing the now elderly Picasso accompanied by a youthful and voluptuous Brigitte Bardot.[104] In the 1950s and 1960s, Marquesan sculptures and motifs entered popular culture as part of the broader group of Pacific art forms that designers drew upon when creating "Polynesian" themed restaurants, cocktail lounges, and attractions such as Trader Vic's or the Tiki Room at Disney World.[105] Indeed, the word *tiki,* the term for an anthropomorphic image in Marquesan, Māori, and other Polynesian languages, is used in the West to refer to almost any Pacific-inspired figure in human form. The *tiki* of the restaurant and souvenir shop, however, are grotesque and artless caricatures of the works of Marquesan and other Polynesian sculptors.

Although it has had a significant influence on our own art and literature for more than one hundred and fifty years, Marquesan art remains unfamiliar to Western audiences. Long relegated to anthropological museums and collections of exotic curiosities, the creations of Marquesan *tuhuka* have only recently come to be recognized and acknowledged as works of art. Pioneered by Gauguin and the early modernists, the appreciation and exhibition of works by Marquesans and other Pacific peoples on an equal basis with those of Western artists developed gradually over the course of the twentieth century. However, it has been left to a new century, and to this exhibition, to present for the first time in an art museum an installation devoted exclusively to Marquesan works. After four centuries as the preserve of explorers, artists, and dreamers, the art of the Marquesas Islands will now adorn a wider world.

103. The influences of African and Oceanic works on the development of modern and contemporary art are explored at length in Rubin et al. 1984.
104. See Kirsten 2003: 26.
105. A fascinating and abundantly illustrated account of *tiki* and other Pacific images in popular culture is provided in Kirsten 2003.

Art and Aesthetics in the Marquesas Islands

Carol S. Ivory

The Marquesan people, Te 'Enana, were (and are today) expert artists and craftspeople who adorned their world and themselves with one of the most distinctive and sophisticated artistic styles in all of Polynesia. This style includes a complex and symbolically rich design system that is both pervasive, cutting across diverse media,[1] and persistent over time. It can be seen in the intricate and remarkable art of Marquesan tattoo and in many different types of objects made from stone, bone, wood, shell, and ivory. It continues today as well, in contemporary carving, tattoo, and barkcloth painting (fig. 11).

Marquesan designs may seem familiar to many people. They have made their way into the popular culture and, in some ways, have become widely emblematic of Polynesia, even the Pacific Islands, as a whole. Few, however, are able to identify the Marquesas as the source of this imagery or understand its rich cultural history and the complexity of meaning inherent in its motifs and patterns.

As in other Polynesian societies, there is no word in the Marquesan language for "art" in the Western sense. In his seminal Marquesan–French dictionary, published in 1904, Msgr. Ildephonse-René Dordillon, a French Catholic missionary who lived in the Marquesas from 1840 until his death in 1888, translated "art" as 'a'akakai, meaning "antiquity" or "curiosity."[2] The word "antiquity" in this context connotes an object's age and history. Indeed, finely crafted works, especially personal ornaments and prestige items, were regarded as family heirlooms and handed down over many generations, their individual histories and genealogies increasing their *mana*, or supernatural power, over time. The term "curiosity" here probably refers to an unusual object that is preserved and exhibited. This is not a customary practice for Marquesans but one with which they became familiar through their contact with Westerners.[3]

Te 'Enana have always had a strong aesthetic sense that emphasizes the appreciation of an object as beautiful (*kanahau*) or beautifully made (*ha'a kanahau*), a concept that refers to a thing that is not only skillfully crafted but also made in the proper way, by the appropriate

Figure 11. Contemporary painted barkcloth (*tapa*) from Omoa village, Fatuiva

person.[4] Among the Marquesan words meaning "skillful" or "adroit" are *ite*, a term that includes the notion that a skilled person also possesses the knowledge required for his or her craft, and *tuhuka,* which describes an individual who is clever, educated, and artistic.[5] The word *tuhuka* also denotes professionals who are experts in their chosen endeavors and, at the same time, ritual specialists, since all creative activities in the Marquesas were sacred and surrounded by prescribed ceremony. The tasks performed by *tuhuka* ranged from house and canoe building to tattooing, carving, and the performing arts, including oratory, song, dance, and other ritualized movements of the body.

These activities functioned within a broader framework of religious ceremony and status differentiation, in which the process was often more important than the final product. Such, for example, was the case with tattoo, a procedure that involved the spilling of blood, a highly *tapu* substance. For a young man of high social rank, tattooing began around the age of eighteen; by age thirty he would be fully tattooed. Langsdorff selected a thirty-year-old tattooed man to serve as the model for Tilenau's well-known image *An Inhabitant of the Island of Nukahiwa* (cat. no. 21) since, he noted, at that age a man's tattoo was most distinct. This was because, while an individual's body might already be fully tattooed, the tattooing process did not stop but continued indefinitely, with the *tuhuka patu tiki,*[6] or tattoo artist,

1. I use the term "pervasive" here in the context of the work of Warren DeBoer (1991: 144–61), as discussed in Millerstrom 1997 and Millerstrom and Edwards 1998.
2. Dordillon (1904) 1999: 22, 104.
3. Kaeppler 1978: 37.
4. Dordillon (1904) 1999: 150.
5. Ibid.: 143, 276.
6. The Marquesan word for "tattoo" is *tiki*, and for the verb "to tattoo," *patu tiki* ("to draw/design *tiki*"). See Dordillon (1904) 1999: 204. Because statues in human form are also called *tiki*, I will use tattoo, not *tiki*, to differentiate the two.
7. Langsdorff 1813, vol. 1: xiv.

placing "one figure . . . over another, till the whole becomes confused."[7] In tattooing, as in other activities, it was the process, and not the clarity of the overall design, that was of paramount importance.

Marquesan women were also tattooed, usually on the hands, ankles, and lips and behind the ears (fig. 12). Tattooing was both painful and expensive.[8] Most women could be tattooed in their own homes with little ceremony. However, for both high-ranking men and women, special houses were built for the occasion. The *tuhuka*, his assistants, and others who helped during the session had to be fed and paid. At the end of the session, a feast was held on a *paepae,* or stone platform, at the *tohua,* or public ceremonial ground, during which the new tattoos were displayed.

Despite the cost and physical suffering involved, Marquesans endured the tattooing process because tattoos were essential to many aspects of life. Men and women were tattooed to mark specific events in their lives, such as entry into adulthood, the birth of a child for a woman, or a victory in battle for a man. Men and women also underwent tattooing to make themselves more sexually attractive, and certain tattoos identified men as members of special groups that ate together at feasts, or *koina*.

The complexity of the Marquesan design system reflected the culture and worldview of Te 'Enana. Some of the carefully crafted objects made by the *tuhuka* played specific roles in religious practices. For example, figures in human form, or *tiki*, functioned to honor and please the gods (*etua*), the most important of whom were deified ancestors. Other objects signified social rank or office and were worn or displayed by chiefs (*haka'iki*) and their families, as well as other high-status individuals, such as warriors and religious specialists, on important occasions. Many objects served as markers of personal prestige, which derived both from an individual's ancestry and from his or her own abilities and achievements. Ornaments of many materials, including

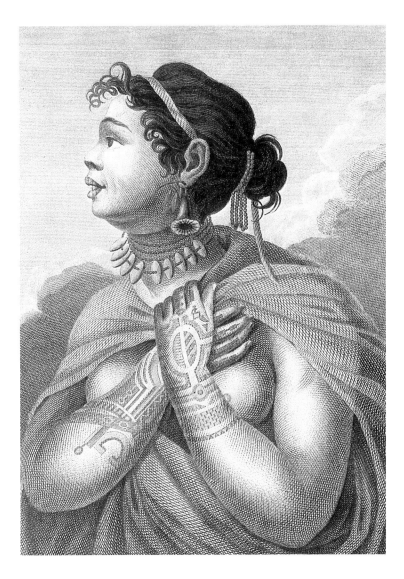

Figure 12. *Native Woman of Nukahiva Island*, engraving published in Krusenstern's atlas of 1814. The portrait shows the intricate tattooing of the hands practiced by many Marquesan women until the mid-nineteenth century.

8. The definitive work on Marquesan tattoo is that of Marie-Noëlle Ottino-Garanger and Pierre Ottino-Garanger (1998). See also Langsdorff 1813, vol. 1: xiv–xvi, 116–23 and Willowdean Handy 1922.

feathers, human hair, seeds, and teeth, were worn at major events, where participants performed songs and chants accompanied by choreographed body movements, as offerings to the gods.

TIKI: THE HUMAN BODY IN MARQUESAN ART

The central motif of Marquesan art is the human body, which either appears as a full figure or is represented by specific parts, in particular the head, face, and eyes. The body was also a medium for artistic expression: human skin, for example, served as the canvas for tattoo. It also provided materials for various art forms. Bone was used to make ear ornaments (*pu taiana*; cat. nos. 42–48) and small cylindrical ornaments (*ivi po'o*; cat. nos. 6–13). Human hair, from relatives or enemies, was attached to clubs, conch trumpets (cat. no. 63), and chiefs' staffs (cat. nos. 57, 58) as decorative tassels or pom-poms, and garlands of hair were used to adorn the body (see fig. 20). *Pavahina,* precious ornaments made from the beards of male elders, were used as plumes on headdresses (cat. no. 32) and finger ornaments. Because they were considered the most valuable of all possessions, initially *pavahina* were virtually unobtainable by Westerners and examples were not collected until the traditional culture had nearly died out in the late nineteenth century.

During the late eighteenth and early nineteenth centuries, Marquesans portrayed the human figure, or *tiki*, in a variety of materials. Some images were made to stand on the *me'ae,* or sacred ritual areas (fig. 13), usually located far up the valleys or adjacent to *tohua* (public ceremonial plazas). Full figures appeared on important objects, including stilt steps (cat. nos. 65–67), fan handles (cat. nos. 50–53), and ear ornaments (cat. nos. 40–48). Often, as on the fan handles, *tiki* are shown back-to-back, and placed one on top of another. Half figures also appear, on fan handles and on bone ornaments, or *tiki ivi po'o* (cat. nos. 6–13). The finials of stone food pounders frequently took the shape of two human heads, also depicted back-to-back (cat. nos. 72, 73).

Regardless of size or material, Marquesan *tiki* share similar stylistic characteristics. The images face frontally and have heavy, squat bodies with bent knees. The arms are held close to the body, with the hands typically resting on a rounded stomach. At times, one hand reaches up to touch the chin. In general, little attention is given to the details of hands or feet. However, the head, the most *tapu* part of the body, is oversized. In contrast to the elaborately tattooed and ornamented bodies of the Marquesans themselves, *tiki* typically have few, if any, body adornments.

Like many words in the Marquesan language, the meanings of the term *tiki* are complex and multilayered. In Marquesan art, *tiki* refers

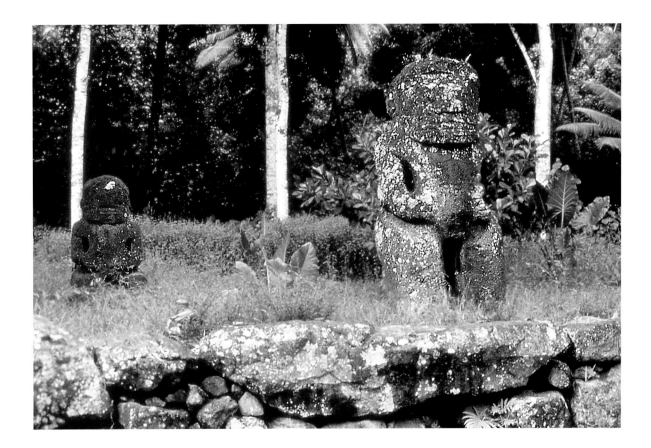

generically to all statues and designs in human form. Such *tiki* generally represented deified ancestors or sometimes gods. *Tiki* is also the term for "tattoo," and used as a verb, means to sculpt, to draw or design a motif, or to tattoo.[9] Underlying these diverse meanings are a series of relationships that link the word *tiki* directly with notions of virility, fertility, creativity, and abundance. These associations can be more clearly understood through examining Marquesan oral traditions.

The name Tiki, with a capital T, refers to a figure from Marquesan legend. There is some uncertainty as to whether Tiki is a god or a human being; he is often regarded as both.[10] In some oral traditions, he is described as "the ancestor of men," who taught them everything they know, both "good and bad."[11]

Tiki is central to the legend that describes the origins of Marquesan carving.[12] In the story, Tiki lived in Havai'i pe, one of the lower levels of Havai'i (the land of the ancestors). He was very powerful because he possessed a body, as well as the ability to create other bodies. From sand he created a wife, Hina-tu-na-one, and together they produced a son and a daughter, Te papa una and Te papa ao. The children, in turn, through an incestuous relationship, had a son and daughter, Oatea and Oatanua.[13] At this time, the world consisted only of water, so Tiki created an island for his children and grandchildren to live on. He named it Nuku Hiva. When Nuku Hiva became overpopulated,

Figure 13. Massive stone *tiki* erected on a platform at Te I'ipona *me'ae* at Puama'u, Hiva Oa. The larger figure on the right represents the *etua* Takai'i.

9. Dordillon (1904) 1999: 204.
10. Langridge and Terrell 1988: 192.
11. E. Handy 1923: 245; E. Handy 1930: 123.
12. This legend was collected on Tubuai in the Austral Islands by Robert T. Aitken, a research associate at the Bernice P. Bishop Museum, Honolulu. It is from the files of Robert Bruce Dorm, through his son Eugene. The translation was made in 1904 by F. Allen, and some of the phrasing reflects Christian influence. The original transcript, published in Handy's *Marquesan Legends* (1930), is now in the Bernice P. Bishop Museum library.

13. In another oral tradition from Nuku Hiva, Atea creates the Marquesan islands one by one to form a house for his wife, Atanua (Kaiser and Elbert 1989).

14. Langridge and Terrell 1988: 184–91.

15. E. Handy 1927: 107.

16. Suggs 1966: 144–45.

17. Suggs, personal communication, 2004.

he formed a second island, Ua Pou. The people of Nuku Hiva, believing they would never see Tiki again, decided to make a stone image of him to remember him by, and so carved the first *tiki*. As the population continued to grow, Tiki went on to create each of the Marquesas Islands in succession.

Another oral tradition that relates to *tiki* was collected by Karl von den Steinen, a German medical doctor turned ethnologist who visited the Marquesas from 1897 to 1898, learned Marquesan, and collected hundreds of Marquesan objects, which are now in the Ethnologisches Museum, Berlin-Dahlem. One legend he recorded connects *tiki* with the creation of humans.[14] In the story, an unnamed old man fashions a male *tiki* from stone. The figure comes to life as a man when its "member" is "bent right" (probably made erect). The name of the new man is Atea Nuku. The old man then carves a second figure from a breadfruit tree, which assumes the form of a woman when blood enters it, and comes to life when it is felled. The story goes on to tell how the woman, Kua Mauihia, learns the art of lovemaking from two ancient gods and subsequently gives birth to a daughter (though not by Atea Nuku). As in the legend of Tiki, sexuality, fertility, and creation are central themes.

These traditions suggest an underlying relationship between Tiki/ *tiki*, the ability to create and procreate, and human sexuality, particularly male potency. This last relationship has been explored by a number of scholars. In describing *tiki,* Handy observed that the form of *tiki,* "which is never varied, results from the fact that each [*tiki*] is actually a phallic symbol transformed into a human figure; or perhaps it should be stated the other way—that each is a human figure carved in a form suggestive of a phallus."[15]

This theory is supported by the archaeologist Robert Suggs, who has worked in the Marquesas since the 1950s and made an extensive study of Marquesan sexuality. Suggs takes the analysis further, stating that "any piece of Marquesan art work decorated with motifs deriving from the human figure has some vague sexual connotation."[16] Stones in phallic form are not uncommon in the Marquesas, and breadfruit pounders, *ke'a tuki popoi*, have handles that are distinctly phallic in shape (cat. nos. 72, 73). Contemporary Marquesan men often use the word *tiki* to refer to the penis in their conversations, which frequently include much ribald joking and sexual innuendo.[17]

On a symbolic level, then, *tiki* images may be interpreted as representations of the culture hero Tiki and his male generative force. At the same time, however, some *tiki* also commemorated specific ancestors, both male and female, while others represented legendary figures. Few *tiki* have visible genitalia, and most remain gender neutral, although identifiably male and female figures exist. Even where they are distinctly male, the genitals are usually represented rather

subtly, by a small knob. What all this suggests is that in Marquesan thought, the *tiki* image is multivalent and simultaneously references the opposing but related concepts of creativity/life/male potency and death/the ancestral world/spiritual power.

18. Gauguin 1978: 280.
19. On the Lapita cultural complex, see Kirch 1997 and Kirch 2000.
20. For a detailed analysis of Marquesan *'u'u*, see Ivory 1994.

The Face and Eyes in Marquesan Art

The heads of Marquesan *tiki* at times constitute as much as half the total height of the figure. Human faces are ubiquitous within Marquesan art. They are depicted with enormous eyes often framed by goggle-like outlines, arched eyebrows, flattened noses, and wide, horizontally compressed bandlike mouths. Face and eye motifs appear in every medium from all time periods and are perhaps the most widespread and immediately recognizable image in Marquesan art. Paul Gauguin was among the first outsiders to appreciate Marquesan aesthetics and to recognize the importance in Marquesan art of the human image in general and the face in particular. "The basis of this art," he wrote, "is the human body or face. The face especially. You're astonished to find a face where you thought there was a strange geometrical figure. Always the same thing and yet never the same thing."[18]

The origins of the Marquesan aesthetic system can be traced back to the art of the Lapita cultural complex, which dates from about 1500 B.C. to 550 B.C. and is ancestral to all contemporary Polynesian cultures.[19] Lapita art and aesthetics were marked by several distinctive characteristics. These included the placement of repeated motifs and geometric patterns within bounded zones and fields, specific rules for the ways in which different designs were combined to form larger patterns, and a strong emphasis on the human face. Also common was a kind of visual punning, in which single and double faces appear and disappear within each other. All these features can be seen in figure 14, which shows a diagram of a reconstructed fragment of Lapita pottery.

The imagery and aesthetics of Lapita art were critical to the artistic system that evolved in the Marquesas. Its legacy is perhaps most evident in the ornamentation of early-nineteenth-century war clubs, or *'u'u*, in which the representation of heads, faces, and eyes is at its most sophisticated (cat. nos. 54–56). In these remarkable objects, faces and eyes in high and low relief are combined with and superimposed on one another, resulting in a series of complex visual puns. Below the horizontal crossbar are three distinct zones of low-relief carving. These comprise two bands of abstract, geometric designs between which another set of eyes appears.[20]

The archaeological record provides little evidence of how the Lapita design system was carried from West Polynesia to the Marquesas, where it seems to have had a particularly strong aesthetic resonance.

Figure 14. Reconstruction of a Lapita face design based on vessel fragments recovered from the Nenumbo site, Reef Islands, Solomon Islands, ca. 1000–900 B.C.

21. Kaeppler 2001: 33.

One possible explanation is that it came in the form of tattoo, which was practiced by the Lapita peoples, who used similar types of comb-like tools to adorn their bodies and to make dentate-stamped designs on their pottery. Such tools were undoubtedly brought to the Marquesas by the first settlers as part of their tattooing equipment. There, the ancestral Lapita aesthetic was preserved, nurtured, and elaborated as Marquesan tattoo evolved.

We have already noted the centrality of the face and eyes in Marquesan art. As in other Polynesian cultures, among the Marquesans the head was the most *tapu* part of the body, the site of a person's *mana* (supernatural power). This fact, however, only begins to explain the significance of the face and eyes in Marquesan art. Adrienne Kaeppler has noted that Polynesian art is often characterized by "indirectness, and the intimate association of verbal and visual modes of expression," in which "many Polynesian words have hidden or veiled meanings that must be unraveled layer by layer until the metaphors on which they are based become apparent."[21] As the layered meanings surrounding the word *tiki* amply demonstrate, this association of different modes of expression is certainly true of Marquesan art, where it is impossible to understand the implications behind the designs and motifs without exploring the words related to them.

In discussing the face and eyes in Marquesan art, two words, *mata* and *ipu,* are particularly significant. Both terms are used, in part, to refer to specific motifs that appear frequently and over long time periods in Marquesan rock art, tattoo, and carved objects. Describing the importance of the human body in Hawaiian art, Kaeppler argues that "the backbone, the sacred top of the head, human hair, gourds, and

pigs were symbolically associated with Lono [the Hawaiian god of rain and agriculture] and the 'aumakua (ancestral gods) and metaphorically related to genealogy, all of which could be substituted for each other."[22] I would like to suggest that similar conceptual and metaphorical relationships existed in the Marquesas, linking the face, eye, and skull with objects (knots, nets, containers) and living creatures (turtles) and that these, in turn, referred symbolically to etua (deified ancestors) and the spirit world. These interchangeable concepts and associations were embodied in circular motifs in general and representations of the face, skull, and eyes in particular.

The Marquesan term for both face and eye is mata. The recitation of an individual's genealogy was referred to as matatetau, literally "to count or recite [tetau] faces/eyes [mata]."[23] Handy uses mata alone to refer to genealogy. The term mata 'enana (face/eye people) refers to one's relatives, ancestors, or allies, as well as to the best ("the flower, the cream") of humankind.[24] Thus, the symbolic relationship between images of the face or eye and an individual's ancestry—and, by extension, the sacred power of the ancestors—begins to become apparent. The term mata also denotes a knot or link in a net. Lengths of woven coconut-husk fiber with cords of knotted string tied to them, known as ta'o mata, were used as mnemonic devices to aid in learning genealogies.[25]

Eyes, sometimes shown with a mouth or nose, are perhaps the most widespread motif in Marquesan art. One such image is the mata komoe, which appears at the center of an engraving of Marquesan tattoo motifs published by Langsdorff in 1813 (fig. 15). Steinen associated this design with Komoe, a legendary chief, and also with what he termed the "skull-face."[26] Rocks engraved with the mata komoe motif are often found near me'ae, where the skulls of chiefs and priests were frequently placed in sacred banyan trees, or aoa, which were always located near them. The skulls of enemies were also kept as trophies of war. In Tilenau's illustration of a young Marquesan man (cat. nos. 19, 20), the subject is shown with a mata komoe motif at the center of his back and holds a trophy skull in his hand.

The word ipu denotes a container or vessel and was commonly used to refer to the small gourds or coconut-shell containers (cat. no. 75) used to hold popoi (breadfruit paste), the staple of the Marquesan diet. By extension, ipu o'o refers to the skull, the container for the brain, while an ipu mata is the eye socket. In combination with other words, ipu is used to mean a protective shield or covering, such as the shell of a crab, shrimp, or turtle.[27]

Ipu is also the name for a specific design motif that Crook described as the Marquesans' "favorite mark," which he thought resembled "a lagoon island—an incomplete circle, with which they fill up vacancies in every part of the body."[28] Langsdorff noted that in Marquesan

22. Kaeppler 1988: 167–68.
23. Dordillon (1904) 1999: 179, 180; E. Handy 1923: 342. Dordillon here uses the French term parent, which can, as in English, mean mother or father, but also denotes relatives in general and, in a broader sense, one's ancestors. See Larousse 1993: 371.
24. E. Handy 1923: 342; Dordillon (1904) 1999: 179.
25. E. Handy 1923: 342.
26. Steinen 1925–28, vol. 1: 125.
27. Dordillon (1904) 1999: 143.
28. Crook 1800: 18.

29. Langsdorff 1813, vol. 1: xvi.
30. See Steinen 1925–28, vol. 2: 167–72 for an analysis of *uhikana* designs.
31. See Rolett 1986.
32. Ibid.: 84.
33. See Ivory 2001.

tattoo, this design (fig. 15, lower right) appeared only on the thighs and the underside of the arms (see cat. no. 21 and fig. 7).[29] These are places that may have been considered vulnerable, especially in battle, when the arm was raised to hurl a stone from a slingshot or to wield a club. Placing the *ipu* motif in these areas may have been seen as affording the wearer a measure of supernatural protection.

Another example of the *ipu* design appears on the openwork turtleshell disks that form part of *uhikana* headdresses (fig. 16). Carved in pairs, the *ipu* suggest eyes, which, in turn, recall the *mata komoe* motif.[30] A simplified version of the *ipu* also appears in the low-relief bands on '*u'u* clubs, while another variant appears on the bodies of barkcloth effigies (cat. no. 14).

Turtles (*honu*) were one of several marine species, also including sharks and rays, that had sacrificial and sacred ramifications. Like deified ancestors, turtles were believed to have the ability to cross between two worlds.[31] Turtles were associated with funerary sacrifices, where their flesh was a *tapu* food reserved for the elite. They served as substitutes for human sacrifices, or *heana*, after the practice was prohibited in the nineteenth century.[32] The protective shell of the turtle (*honu ipu*) was the source of the keratinous plates, or turtle-shell, used especially in ornaments intended for the head, which were usually adorned with *ipu* or *tiki* designs (cat. nos. 28–31). In this context, it seems reasonable to suggest that a symbolic relationship existed between turtles and turtleshell and the related notions of skull/container, face/eyes, and ancestors/genealogy. It follows that all these phenomena may have been able to stand in for one another metaphorically and symbolically, forming a web of interrelated meanings. If so, this could explain the central and all-pervasive presence of faces and eyes,

Figure 15. Engraving of Marquesan tattoo motifs published by Langsdorff in 1813 in his account of his visit to the Marquesas as a member of Krusenstern's expedition of 1804.

in the form of *mata komoe* and related motifs in Marquesan art.

CHANGE IN MARQUESAN ART

The majority of the works in this catalogue were made before the mid-nineteenth century. They are representative of objects that were integral to Marquesan life and reflect aesthetic and societal concerns central to the culture before the great changes that occurred during the first half of the century. Sadly, very few fine historical objects like those seen here remain in the archipelago today, displayed in small local museums or kept in private family collections. The rest had left the islands by the late nineteenth century, having been traded, sold, given to,

Figure 16. An early *uhikana* headdress showing the *ipu* (container) motifs typical of *uhikana* described and collected in the late eighteenth and early nineteenth centuries. Peabody Essex Museum, Salem, Massachusetts

or taken by, explorers, missionaries, government officials, tourists, and anthropologists. In addition, much knowledge about these early art forms was lost over the course of the nineteenth century as a result of conversion to Christianity, the prohibition of traditional practices, chaotic periods of internal strife, and the death of tens of thousands of Marquesans from introduced diseases.

Despite these traumatic events, Marquesan art did not die out but was instead transformed.[33] Beginning in the late nineteenth century, a new yet still unmistakably Marquesan artistic style emerged. The development of this new style seems to have been spurred primarily by changing economic conditions, including the development of a small "souvenir" market for itinerant visitors and the growing population of Tahiti, which created a similar "curio" market there. The main characteristic of this style, seen primarily in wood carving, was the ornamentation of the entire surface of an object with low-relief patterns derived from tattoo designs (cat. nos. 61, 62, 68, 76). Although similar in form to earlier Marquesan works, objects made during this period were generally smaller and made from softer, lighter woods that were easier to carve. They included war clubs, canoe paddles, model canoes (cat. no. 68), and bowls (cat. no. 76).

Made primarily for sale, such objects became an important part of what was a very limited economic base in the Marquesas at the time. Their production was an essential element in the perpetuation of the indigenous culture, and they provided a way for a new and viable Marquesan aesthetic to develop during a period of economic and social upheaval. Once considered degenerate tourist art, many

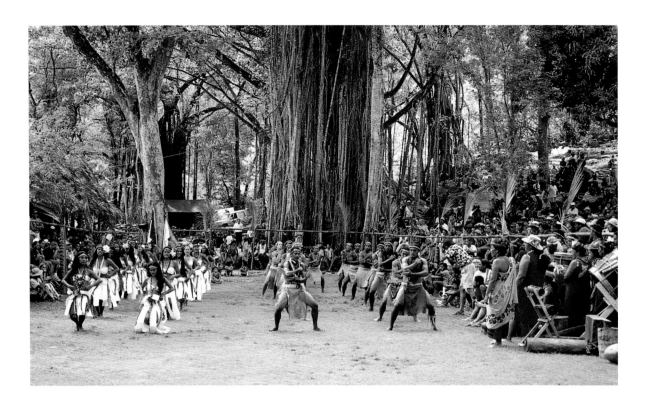

Figure 17. Dance troupe from Fatuiva, performing at Tohua Koueva in Taioha'e, Nuku Hiva, December 1999.

objects from this period are in fact beautifully crafted and highlight the creativity and resilience of Marquesan artists as they adapted to a new reality. It was this late-nineteenth-century style that became the standard and accepted model for twentieth-century Marquesan carvers, as well as the style popularized in Polynesian-themed restaurants in foreign countries thousands of miles away. It persisted, little changed, for most of the twentieth century, as Marquesan art struggled to survive.

A dramatic renaissance of Marquesan culture, however, began in the mid-1970s.[34] Since then, a variety of Marquesan art forms, some old and some new, both performing and visual, have emerged. Under the impetus of the much-loved and now retired Catholic bishop of the islands, Msgr. Hervé-Marie Lecléac'h, and cultural leaders including René Uki Haiti, Toti Te'ikiehu'upoko, and Lucien Ro'o Kimitete, the arts in the Marquesas have been revitalized. Beginning in 1978, Motu Haka, a cultural organization with branches on all six inhabited islands, has fostered and supported the arts through research, educational projects, and arts festivals (fig. 17). Museums and education centers now exist or are being built on every island, encouraging local interest in Marquesan history and culture. Contemporary artists are researching the past and reviving the early-nineteenth-century art style and at the same time innovating, making *tiki,* for example, whose features, while more naturalistic than those of earlier styles, remain imbued with Marquesan tradition.

Since 1987, six interisland festivals of the arts have been held in the archipelago.[35] The overarching goal of the festivals is described in

34. See Ivory 2002.
35. Ivory, forthcoming.

Marquesan as *matava'a* ("to wake up the eyes") of the people, especially the youth, to the importance and vitality of their history and culture. These festivals have had a profound impact on both the performing and visual arts—encouraging local interim festivals, providing opportunities for competition winners to travel to Europe and the United States, and establishing models for young Marquesans to emulate. As a result of this renewed interest in art and culture, new *tohua* (ceremonial grounds) have been built and ancient ones restored.

Many art forms are thriving today in Te Henua 'Enana. Marquesan tattoo designs can be seen throughout French Polynesia and are a particular mark of identity and pride for the Marquesan people. Contemporary sculpture, crafted from a variety of media including wood, animal bone, and coconut shell, is flourishing. Stone *tiki* adorn renovated *tohua* (fig. 18), while wood images, along with low-relief carvings employing traditional designs, decorate public buildings. Carved objects are also made for sale to visitors, both locally and for the external market in Tahiti (fig. 19). *Tapa* is used in making costumes, especially for dance performances at festivals, and for small painted pieces to sell.

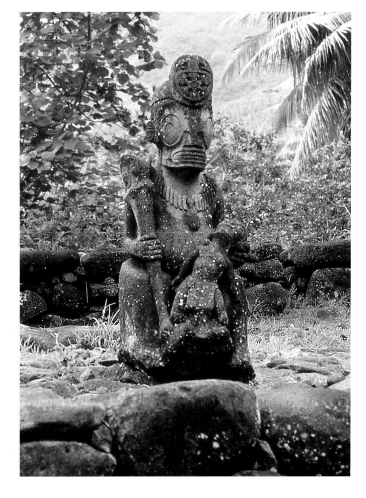

Figure 18. Contemporary stone *tiki* by René Uki Haiti and Severin Kahee Taupotini erected at Tohua Hikokua in Hatiheu, Nuku Hiva.

In many valleys, local artisans have formed cooperative associations and constructed *artisanats,* buildings in which they sell their work, mainly to people visiting the islands aboard the *Aranui 3,* a freighter–cruise ship that carries up to 180 passengers and arrives every three weeks, providing a reliable internal market. At the same time, artists have become increasingly sophisticated about the need to market their work beyond the limited sales opportunities provided by the *Aranui* passengers. In the mid-1990s, they formed Te Tuhuka o Te Henua 'Enana (The Artists of the Marquesas Islands), an association of artisans from all six islands. The association has four main goals: to provide opportunities for artists from the Marquesas to meet in Tahiti (which is logistically easier than meeting in the islands themselves); to work together to promote the sale of Marquesan products in Tahiti and, potentially, in markets beyond French Polynesia; to raise awareness of the association within and beyond the Marquesas; and to demonstrate to young people that

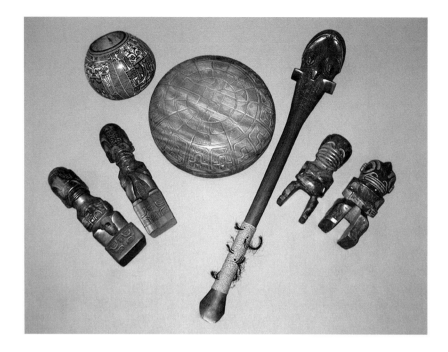

Figure 19. Carvings by contemporary Marquesan artists. Left to right: two *tiki* by Hara Ah Scha, *ipu ehi* (coconut bowl) by Charles Seigel, wood bowl and *'u'u* club by Anihoka Tepea, *tiki* by Rico Tauira, and *tiki* by Anihoka Tepea. Photograph, 2004

36. Christian Kervella, personal communication, 2000.

they can make a living as artists without leaving their homeland, which many must now do to find work.[36] While it has thus far proved difficult and expensive to establish new markets beyond Tahiti, the organization has met with success in some of its other goals. In the past several years, more young Marquesans seem interested in learning carving and other traditional arts, either from artists within their families or at the vocational high schools operating on several of the islands.

In this age of increasing globalization, the Marquesas, though still remote, are no longer isolated. Daily plane service from Tahiti, the increasingly popular *Aranui 3*, satellite television, mobile phones, and the Internet now link Te Henua 'Enana to the rest of the world. As Toti Te'ikiehu'upoko's statement in this catalogue affirms, Marquesans today take pride in their culture and the unique identity it gives them both within and beyond French Polynesia and are actively seeking ways to engage and prosper within a global context without sacrificing their distinctive cultural heritage. Art will surely play a central role in this endeavor, and the Marquesan people will continue to adorn and enrich not only their own world but also the larger one we share.

CATALOGUE

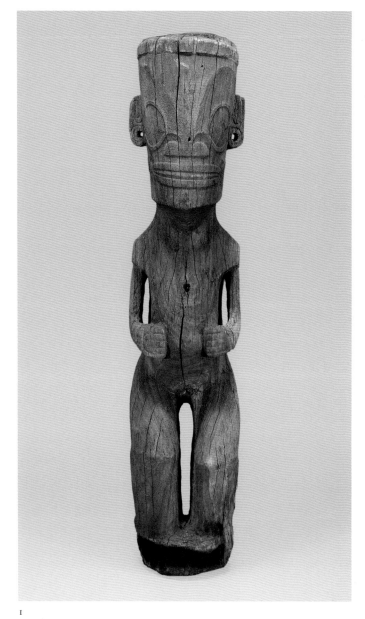

1

1. Figure (*tiki*)

19th century
Wood
Height 40½ in. (103 cm)
American Museum of Natural History, New York

The most imposing Marquesan wood sculptures are the large *tiki,* or human images, which, together with similar images in stone (fig. 13), originally stood on the *me'ae,* ritual sites that also served, in some instances, as burial places for prominent individuals. The centers of spiritual life, *me'ae* typically included a number of *paepae* (stone platforms), on which structures were erected for important ceremonies. Many *me'ae* also had one or more large *tiki* figures, which were generally positioned on the highest platform or at the rear or uphill side of the consecrated area.[1]

Tiki represented *etua,* deified ancestors whose supernatural powers sustained and protected the community.[2] During both public and private observances, Marquesans presented the *etua* with food and other offerings. In some cases, the *tiki* themselves appear to have served as offering platforms. Describing one *me'ae,* Edward Robarts, a British sailor who lived in the islands from 1798 to 1806, noted: "There is a rough image fixt in the ground at the moria [*me'ae*]. On the head of this log of wood is put a small part of every thing sent. This no one eats, being held sacred."[3] This secondary function of the images may explain why the heads of a number of examples, such as the present work, are flat in contrast to the rounded heads of stone figures (cat. nos. 2–5) and other *tiki.*[4]

As with other art forms, the creation of human images was the work of specialists, or *tuhuka. Tiki* carvers were known as *tuhuka ta'ai tiki.*[5] When sculpting a figure, the *tuhuka* first marked out the rough proportions and then worked from the base upward, beginning with the legs and ending with the head. In carving the facial features, the artist began with the mouth. The eyes, the most supernaturally powerful element of the face, were completed last.[6] Each *tiki* was either male or female, although the sex of the images, when marked at all, is only subtly indicated.[7]

The large wood figures represent the *tiki* image in its purest form. The fundamental design element in Marquesan sculpture, the *tiki* image is repeated and reworked in a diversity of art forms including bone ornaments, stilt steps, paddle finials, and fan handles. In their conception of the human

1. E. Handy 1923: 236.
2. Ibid.: 236, 248; Linton 1925: 346; Panoff et al. 1995: 132.
3. Robarts 1974: 57. Crook (1800: 43) also described stone "pillars," some in the form of human images, on top of which flat stones were placed to hold offerings.
4. Such flat heads are also seen in the bone ornaments (cat. nos. 6–13), although, in the ornaments, the form may have been dictated by the hollow cylindrical nature of the bones from which they are carved rather than by aesthetic factors.

form, Marquesan *tiki,* with their strictly frontal orientation, slightly bent knees, arms extending down the sides, and hands resting on rounded stomachs, reflect their common artistic ancestry with other East Polynesian sculptural traditions such as those of Tahiti or Rapa Nui (Easter Island). The figures' enlarged heads, which constitute one-third to one-half the total height, are also typical of Polynesian sculpture. Surprisingly, in contrast to the extensively tattooed artists who made them, the bodies of Marquesan *tiki* are frequently unadorned, though some are shown with ornaments or isolated tattoo motifs.

E K

5. E. Handy 1923: 144.
6. Linton 1925: 71.
7. Ibid.: 72.

STONE FIGURES (*tiki ke'a*)

2. Figure

19th century or earlier
Stone
Height 6 ¼ in. (15.7 cm)
Indiana University Art Museum,
Bloomington, Raymond and Laura
Wielgus Collection

3. Figure

19th century or earlier
Stone
Height 5 ⅝ in. (14.3 cm)
Collection of Mark and Carolyn
Blackburn, Kamuela, Hawai'i

4. Figure

19th century or earlier
Stone
Height 4 ⅝ in. (11.7 cm)
Collection of Mark and Carolyn
Blackburn, Kamuela, Hawai'i

5. Double Figure

19th century or earlier
Stone
Height 4 in. (10.2 cm)
Collection of Mark and Carolyn
Blackburn, Kamuela, Hawai'i

With their robust, boldly contoured bodies and serene facial expressions, the small stone figures, or *tiki ke'a,* of the Marquesas have a sculptural power that belies their modest scale. Marquesan stone sculpture was highly developed. Artists made both freestanding human images and architectural carvings, which were incorporated into the massive stone platforms of *me'ae* (sacred ritual sites) or the houses of high-ranking individuals. As elsewhere in the archipelago, the dominant image in Marquesan stonework was the human form, or *tiki.*

Freestanding *tiki ke'a* appear to have been of two distinct types. The first consisted of small portable images, such as the present works, that range from roughly four to eight inches in height. The second type comprised the monumental stone images erected on the *me'ae.* Some *me'ae* images, such as those at Puama'u on the island of Hiva Oa (fig. 13), stand more than eight feet high. Like their wood counterparts (cat. no. 1), large stone *tiki* were permanent features of the *me'ae,* where they were a focus of rites performed on behalf of the community.

By contrast, the smaller *tiki ke'a* appear to have been used during acts of private devotion. To ensure the success of important or hazardous undertakings, individuals or small groups would bring such figures to the *me'ae,*

1. E. Handy 1923: 238; Linton 1923: 345. Steinen (1925–28, vol. 2: 86) illustrates a small stone *tiki* found on a *me'ae* at Puama'u, which is likely an example of such a votive offering.
2. Linton 1923: 345.

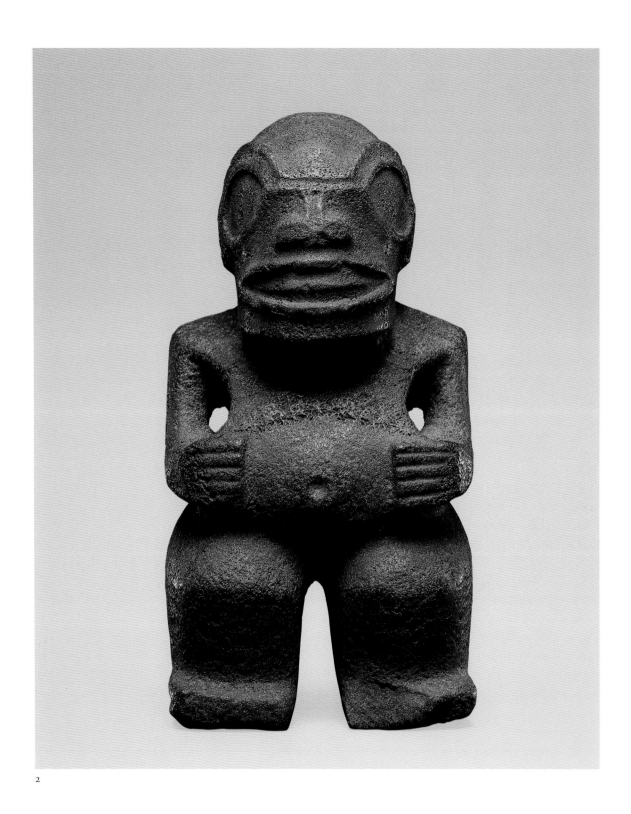

2

where they were presented as offerings to the resident *etua*.[1] Such *tiki ke'a* were also reportedly used as sacred images by fishermen and in curing sickness, although precisely how they were employed is unclear.[2]

Like virtually all Marquesan art forms, the small stone figures were made by specialists, or *tuhuka*. The carvers worked primarily in basalt, a dense volcanic rock whose slight porosity imparts a subtle corrugation to the surface. In some instances, the back of the head is equipped with a pierced stone lug,

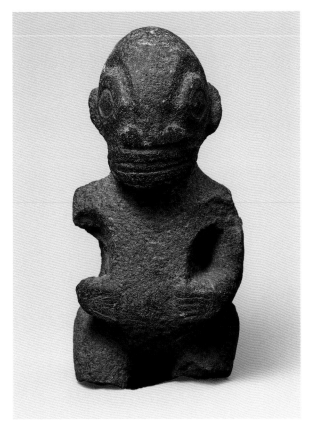

3

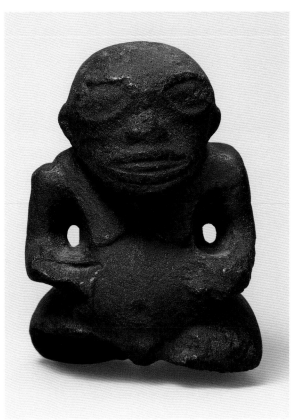

4

which may have allowed the figures to be suspended around the neck of participants during rituals or hung from trees or posts at the *me'ae,* in the manner of other offerings. Many *tiki ke'a* have extensive damage (cat nos. 3, 4), particularly to the lower portion of the body, indicating that they may have fallen from a considerable height. Such damage may have occurred when the cordage used to suspend the figures rotted, causing them to drop to the hard stone pavement of the *me'ae. Tiki ke'a* occur primarily as single images, but, in rare instances, they take the form of double figures joined at the head and buttocks (cat no. 5). While the significance of this unusual imagery is unknown, it is likely that both the double and single *tiki ke'a* served similar functions.

EK

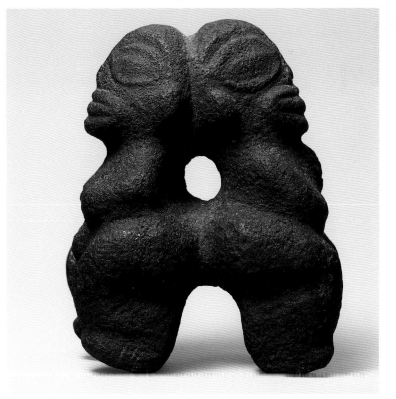

5

Bone Ornaments (*tiki ivi po'o*)

6. Bone Ornament

19th century
Bone
Height 2 in. (4.9 cm)
Indiana University Art Museum,
Bloomington, Raymond and Laura
Wielgus Collection

7. Bone Ornament

19th century
Bone
Height 1 ⅞ in. (4.7 cm)
The University of Pennsylvania
Museum of Archaeology and
Anthropology, Philadelphia

8. Bone Ornament

19th century
Bone
Height 1 ⅝ in. (4 cm)
Collection of Mark and Carolyn
Blackburn, Kamuela, Hawai'i
Collected by Adm. Abel du Petit-
Thouars

9. Bone Ornament

19th century
Bone
Height 1 ½ in. (3.8 cm)
Collection of Mark and Carolyn
Blackburn, Kamuela, Hawai'i

10. Bone Ornament

19th century
Bone
Height 1 ¾ in. (4.4 cm)
Collection of Mark and Carolyn
Blackburn, Kamuela, Hawai'i

11. Bone Ornament

19th century
Bone
Height 1 ½ in. (3.8 cm)
Collection of Monah and Alan Gettner

12. Bone Ornament

19th century
Bone
Height 2 in. (5.1 cm)
Peabody Essex Museum, Salem,
Massachusetts

13. Bone Ornament (?)

19th century
Bone
Height 4 in. (10.2 cm)
Collection of Mark and Carolyn
Blackburn, Kamuela, Hawai'i

1. Porter (1815) 1986: 338.
2. Krusenstern 1813: 162, 180.

The human body is the most important theme in Marquesan art. The primary motif in Marquesan designs, the body was also a major focus for artistic expression and materials derived from it served as artistic media. To adorn both themselves and the objects they used, Marquesans fashioned beadlike cylinders of bone called *ivi po'o* ("bone pieces") from the arm and leg bones of their enemies. Those carved in human form, such as the present works, were referred to as *tiki ivi po'o*.

Ivi po'o were employed widely as personal ornaments and as decorative accents to larger works. Porter described the diverse uses of *ivi po'o* among the Marquesans, noting, "their smaller bones are formed into ornaments to be hung round their necks, representing figures of their gods: they are also converted into fan-handles . . . and in fact compose a part of every description of ornament where they can possibly be applied."[1] Krusenstern noted that the Marquesans attached *ivi po'o* to "almost all their household furniture."[2] These included items such as shell trumpets (cat. no. 63), suspended bowls (cat. no. 77), drums, slings, and personal accessories. An unusually

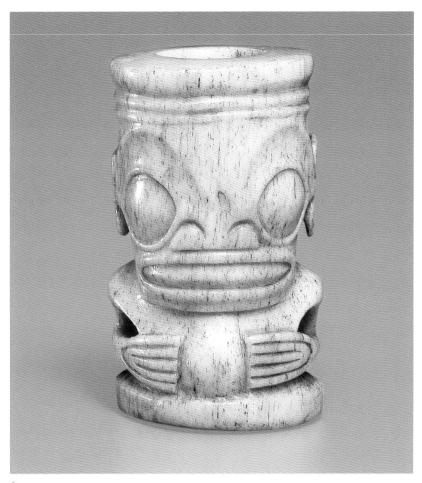

6

tall example from the Blackburn collection (cat. no. 13) may also have
been employed in this manner. Carved cylinders of human bone were
used, as Porter notes, as decorative sleeves for Marquesan fan handles
(cat. nos. 50, 51).

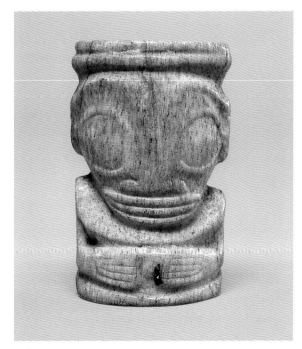

7, front

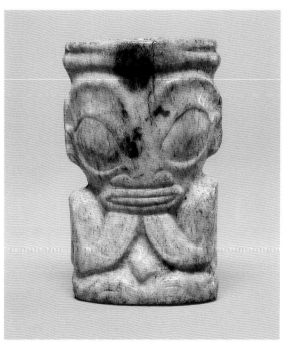

7, reverse

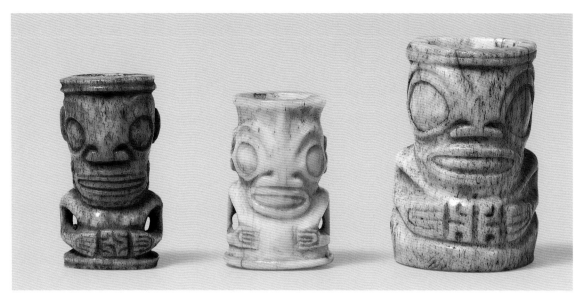

8–10, front

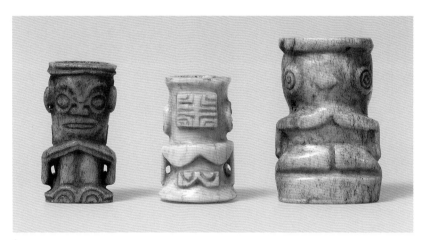

8–10, reverse

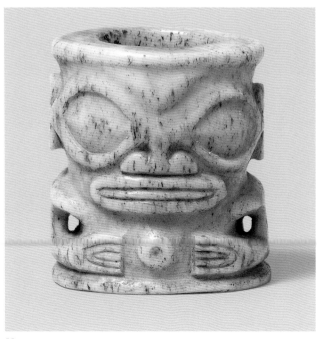

Ivi po'o were also worn around the neck or in the hair, and men incorporated them into the elaborate coiffures popular in the early contact period. To attach the carving, the cylinder was strung on a lock of hair like a bead and worn either hanging down or twisted into the overall hairstyle. An *ivi po'o* worn in the hair was said to be a sign that the wearer had a vendetta yet to be fulfilled.[3]

Large numbers of *tiki ivi po'o* survive in museum collections, either singly or attached to other objects. Although they at first appear similar to one another, especially when seen from the front, the imagery on each is unique. The front typically depicts the upper half of a *tiki* figure, which lacks legs. A greatly enlarged head occupies nearly half the total height. The hands rest on the stomach, which is sometimes marked with a navel indicated by a circle (cat. no. 11) or tattoo motif

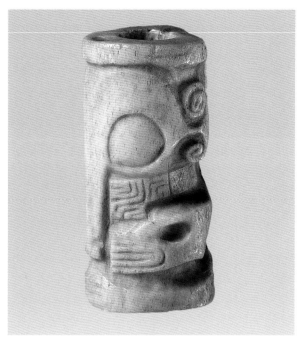

12

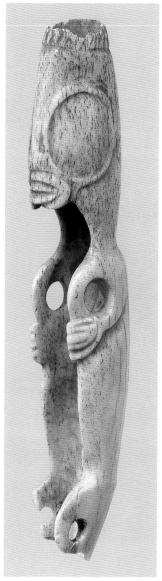

13

(cat. nos. 8, 10). The tops of the heads are flat, with a narrow decorative band accenting the upper edge.

The facial features of the *ivi po'o* resemble those of stone *tiki*, with large eyes framed by arched brows, flattened noses, and wide mouths with elongated bandlike lips. An unusual treatment of the face is seen in an example from the Peabody Essex Museum (cat. no. 12). Steinen referred to this unusual imagery as "*tiki nasau*—the face extended to the knee"; it is also called the "long nose" motif. [4] Extremely rare in Marquesan art, the "long nose" image is known to appear elsewhere on three stilt steps, a war club (*'u'u*), and a wood bowl. The faces of the *tiki* on the coconut-shell bowl in this catalogue (cat. no. 75) are also similar to *tiki nasau*.

The collection dates for the surviving *tiki nasau* images indicate that several were acquired before the middle of the nineteenth century. Steinen likened the motif to a bear's muzzle or an elephant trunk. It seems more probable, however, that the elongated noses of *tiki nasau* may represent the snouts of pigs, or *pua'a,* which were important sacred and sacrificial animals in Marquesan culture.

The imagery on the reverse sides of *tiki ivi po'o* varies widely. Some have tattoo motifs, while others show a second face (cat. no. 8) or even a second complete *tiki* figure (cat. no. 7). As with all Marquesan *tiki,* the *tiki ivi po'o* represent deified ancestors, beings who were honored and propitiated to ensure their assistance in important tasks and in sustaining the abundance of food, especially breadfruit, the staple of the Marquesan diet. These powerful ancestral images may also have served, in part, as supernatural guardians for the individuals who wore them or used the objects they adorned.

CSI/EK

3. Panoff et al. 1995: 114.
4. Steinen 1925–28, vol. 2: 131–34; Ivory 1993: 71–72.

14

14. Barkcloth Effigy

19th century
Wood, barkcloth, pigment, fiber
Height 23 ⅝ in. (60 cm)
Bernice P. Bishop Museum, Honolulu

The rarest of all Marquesan sculptures are boldly painted images made from wood overlaid with a skinlike covering of painted barkcloth, or *tapa*. Only three examples survive, all of which depict highly stylized anthropomorphic figures with prismatic heads and thin, plank-like bodies.[1] Their barkcloth skins are decorated with complex geometric patterns similar to Marquesan tattoo motifs applied freehand in red and black pigments. Virtually nothing is known about the imagery or function of these remarkable objects. The long rectangular bodies are adorned on both sides. The backs of the heads, by contrast, are roughly finished, lack the barkcloth covering, and have small sticks attached with fiber lashing. The unfinished nature of the reverse sides of the heads, together with the presence of the sticks, which possibly served as mounting brackets, has led some scholars to suggest that the images were once affixed to larger objects in such a way that the back of the head was not visible. Barkcloth-covered bird effigies (of which no examples survive) were reportedly used to adorn the ridgepole of one *me'ae* at Puama'u on the island of Hiva Oa, and one researcher speculated that the anthropomorphic barkcloth effigies may have been attached to the beams of ceremonial structures in a similar manner.[2]

The overall proportions of the barkcloth effigies, in which the head comprises roughly one-third the total height, are similar to those of other Marquesan images. But the figures otherwise represent a radical departure from the normal artistic conventions of Marquesan sculpture. The pronounced angularity of the wedge-shaped heads and flat, rectangular bodies stands in stark contrast to the flowing curves and rounded bodies of other Marquesan images. The goggle-like eyes typical of other sculpture in the round are here replaced by wide, staring eyes formed from concentric pointed ovals. While the bodies of other images were typically unadorned, the barkcloth effigies, like the Marquesans themselves, were completely covered with intricate geometric motifs.

In their construction and decoration, the effigies are similar to the bark-cloth-covered skulls also made by Marquesan artists. Consisting of the heads of slain enemies or, in some instances, those of *tupuna* (ancestors), the skulls, or *ipu o'o*, like the effigies, were overlaid with barkcloth, which was painted

1. Panoff et al. 1995: 131. The two other extant examples are in the Museum of New Zealand–Te Papa Tongarewa, Wellington, and the Musée de l'Homme, Paris.
2. Linton 1923: 441.

to record the facial tattoo patterns of the deceased.[3] Although direct histori-
cal evidence is lacking, it is possible that the effigies, like the skulls, also pre-
served the tattoo designs of specific individuals. E K

3. Panoff et al. 1995: 129.

Leg Images

15. Leg Image

Nuku Hiva
Early 1880s
Wood
Height 20 ½ in. (52.1 cm)
Bernice P. Bishop Museum, Honolulu

16. Leg Image

Nuku Hiva
Early 1880s
Wood
Height 20 ¾ in. (52.8 cm)
Bernice P. Bishop Museum, Honolulu

Among the most enigmatic Marquesan sculptures are images representing
individual human limbs. Only thirteen examples are known, all of which are
adorned with intricately detailed tattoo patterns carved in low relief, which

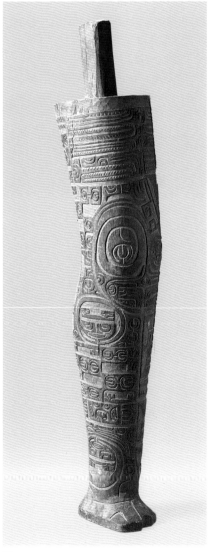

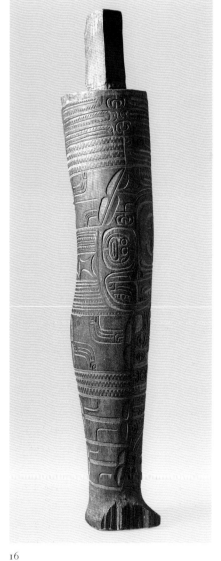

15

16

1. The limb images consist of five carved arms (one in the Peabody Essex Museum, Salem [fig. 7], two in the Ethnologisches Museum, Berlin-Dahlem, and two in the Milwaukee Public Museum) and eight carved legs (four, including cat. nos. 15 and 16, in the Bernice P. Bishop Museum, Honolulu; one in the Denver Art Museum; one in the Milwaukee Public Museum; one in the Ethnologisches Museum, Berlin-Dahlem; and one in the Musée de l'Hôpital de la Marine, Brest, France).

2. Steinen 1925–28, vol. 1: 124–25. When photographed in 1884, the legs, if they had been attached to a larger object, were separated from it and, apparently, only three examples could be located (see ibid: 124, pl. 70). At that time, they belonged to the French Resident, whom Steinen referred to only as Robert. Steinen described these legs as "lost." However, at some point, the complete set of four came into the possession of Oahu College in Hawai'i and were later acquired by the Bernice P. Bishop Museum, Honolulu (George Ulrich, personal communication, 2004).

are similar, in their overall appearance, to those on the limbs of fully tattooed Marquesan men (cat. nos. 19–22, 24).[1] The carvings, which represent both legs, as here, and arms, were first recorded in the late nineteenth century. Why Marquesan artists chose to make images of single limbs rather than full figures is not known. Many limb images, including several arms (see fig. 7), appear to have been intended as freestanding works of sculpture. However, some, such as with the present examples, which are the best preserved of an original set of four, seem to have formed supports for larger objects. Steinen documents and illustrates these particular leg images, which were photographed on the island of Nuku Hiva in 1884, and states that they were commissioned from a local *tuhuka* by a French official.[2] The prominent, protruding tenons suggest that the works likely served as furniture legs. If so, these legs are certainly of postcontact origin as legged articles of furniture—such as tables, chairs, and beds—did not form part of precontact Marquesan culture.

The form of the leg images, whether freestanding or elements of larger objects, represents a postcontact artistic development. Compared with the schematic, flattened, and unadorned limbs of earlier Marquesan images, such as those of the wood (cat. no. 1) and stone *tiki* and bone ornaments (cat. nos. 6–13), the relative naturalism of the limb images, with their rounded contours and indications of musculature, argues that the carvers were influenced by Western sculptural traditions. If so, *tuhuka* may have chosen to modify their traditional manner of depicting human limbs in order to suit Western tastes as part of the emerging market for Marquesan curiosities that developed in the mid- to late nineteenth century. It is conceivable that the designs on the images record the tattoo patterns of specific individuals. However, the elaborate tattoo motifs may simply reflect the general tendency toward greater surface ornamentation seen on canoe models (cat. no. 68), clubs, and other curiosities fashioned during the same period.

EK

WILLIAM HODGES'S PORTRAIT OF HONU

ATTRIBUTED TO
WILLIAM HODGES
British, 1744–1797

17. *A Chief of Santa Christina*

1774 (?)[1]
Red chalk on paper
8⅞ x 7 in. (22.5 x 17.9 cm)
Peabody Essex Museum, Salem,
Massachusetts

WILLIAM HODGES
British, 1744–1797
Engraved by J. Hall[2]

18. *The Chief at Sta. Christina*

1777
Copperplate engraving
13⅛ x 9½ in. (33.3 x 24.1 cm)
Rare Book Division, The New York
Public Library, Astor, Lenox, and
Tilden Foundations

Probably drawn from life on April 9, 1774, this small sketch by William Hodges of Honu (cat. no. 17), a chief from the island of Tahuata (then known as Santa Christina), is almost certainly the first European portrait of

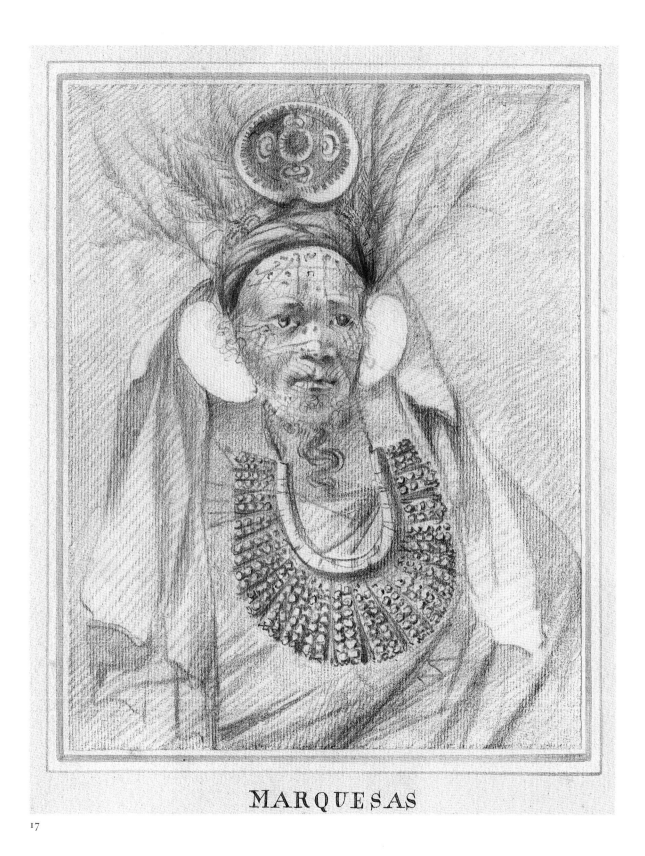

MARQUESAS

17

a Marquesan ever made.[3] A noted painter of landscapes and theatrical scenery,
Hodges served as the official artist on Capt. James Cook's (1728–1779) second
voyage to the Pacific from 1772 to 1775.[4] Only the second Western expedition

1. Joppien and Smith (1985–88, vol. 2: 206) give the date of this work as "1775?" but later state that it is "probably a preliminary sketch." If so, it seems more logical that Hodges made the drawing from life at the time of Cook's visit to the islands in April 1774, as Forster's account of the expedition's encounter with the sitter clearly implies; see the body of the text and Forster (1777) 2000, vol. 1: 334.

2. J. Hall is possibly the British painter and engraver John Hall (1739–1797).

3. The members of the Spanish navigator Alvaro de Mendaña's expedition in 1595 are not known to have made any images of the peoples they encountered, either in the Marquesas or elsewhere. The original sketch for Hodges's only other Marquesan portrait, that of an unidentified woman from Tahuata, was made on April 10, 1774, the day after his sketch of Honu (see Forster [1777] 2000, vol. 1: 339), and has since been lost. It survives only in the form of a later engraving from 1777 (Joppien and Smith 1985–88, vol. 2: 207). Small and undetailed depictions of Marquesans also appear in Hodges's Marquesan seascapes (see Joppien and Smith 1985–88, vol. 2: 202–4).

4. See Quilley et al. 2004.

5. See Beaglehole 1961, vol. 2: 363–76; Forster (1777) 2000, vol. 1: 326–43.

6. The name Honu means "turtle." Turtles were important animals in Marquesan religion.

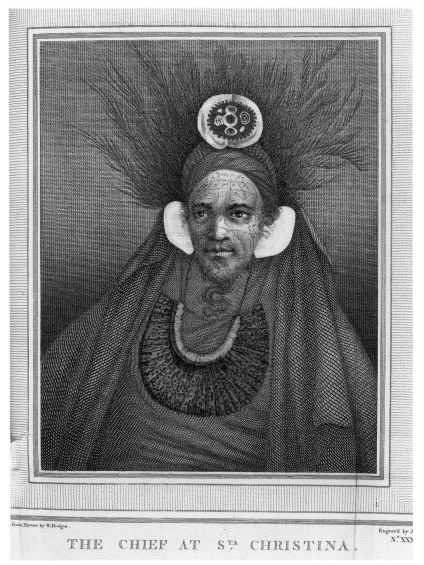

from Nature by W.Hodges .

Engrav'd by J

N.º XXX

THE CHIEF AT Sᵀᴬ CHRISTINA.

18

to reach the islands, which had not been visited since they were encountered by the Spanish nearly two centuries earlier, members of Cook's party produced the earliest known images of Marquesans and assembled the first collections of their objects. Cook's ships anchored at Vaitahu, on Tahuata, from April 8 through 12, 1774, when the crew made several forays ashore to obtain provisions and document the islands and their inhabitants.[5] On April 9, Honu, together with other residents of the valley, came down to the beach to greet Cook and his men.[6] The most extensive account of the meeting, which records what is in all probability the creation of the present work, is provided by George Forster (1754–1794), the son of the expedition's naturalist:

We went on shore after breakfast, and found our friendly natives assembled on the beach. Among them was a chief, who was dressed in a cloak manufactured of the paper-mulberry bark . . . and who wore the diadem, the gorget, the ear-pendants, and bunches of hair. We learnt that this man was the king of the whole island,[7] though he had not great respect shewn him. . . . He acquainted us that his name was Hònoo [Honu], and that he was he-ka-aï [haka'iki]. . . . He seemed to be a very good-natured, intelligent man, a character so prevalent in his countenance, that Mr. Hodges, who drew his picture, could not fail of expressing it, as may be seen in the print of him, in captain Cook's account of this voyage.[8]

As Forster also notes, Hodges's original sketch was subsequently engraved as one of the illustrations that accompanied Cook's official account of the expedition, which was first published in 1777 (cat. no. 18).[9] Comparing the image of Honu in the initial drawing with that of the later engraving, it is evident that the engraver, identified only as "J. Hall," made significant modifications to the appearance of the Marquesan chief. In Hodges's sketch, the subject appears middle-aged, and his face bears a plaintive and somewhat careworn expression. His tattoos, beard, headdress, and barkcloth robes are subtly rendered and somewhat indistinct. By contrast, Hall's engraving gives the sitter a livelier, more youthful appearance, and the details of his features and adornments are sharply defined. The wispy feather headdress of the sketch appears in the engraving as a robust, bushy form whose elements appear more like leafy branches than feathers. Despite these artistic liberties, the form and imagery of Honu's ornaments, the "diadem," "gorget," and "ear-pendants" described by Forster, remain remarkably accurate. The diadem, a headdress of the type known as *uhikana* (cat. nos. 28, 29), shows the characteristic cross-shaped arrangement of four concentric *ipu* (container) motifs in the openwork turtleshell overlay seen on *uhikana* from the late eighteenth and early nineteenth centuries (see fig. 16).[10] The gorget, or *tahi poniu*, formed from multiple wedge-shaped wood elements encrusted with *poniu* (a type of red and black seed), is also typical of the early contact period.[11] Honu's large crescentic wood ear ornaments, known as *kouhau*, are similar to those in Shillibeer's later portrait of Patuki, a chief from Nuku Hiva (cat. no. 22), indicating that these distinctive ornaments were in fashion in both the northern and southern Marquesas. E K

7. Although Forster here extends Honu's authority over all of Tahuata, it is more probable that he was actually a high-ranking chief from Vaitahu whose political power did not extend beyond the valley. Forster's misidentification later in the same passage of "Waitahoo" [Vaitahu] as the name for the entire island (as opposed to a specific valley) appears to reinforce this conclusion.

8. Forster (1777) 2000, vol. 1: 334.

9. Cook 1777, vol. 1, pl. 36.

10. An *uhikana* collected on Cook's voyage with *ipu* designs similar to those in Hodges's sketch is in the collection of the Etnografiska Museet, Stockholm; see Kaeppler 1978: 166, fig. 309. A rare double *uhikana* collected by Forster, whose two disks also bear *ipu* motifs, is in the Pitt Rivers Museum, University of Oxford; ibid.: 165, fig. 307.

11. Four *tahi poniu* are known to have been collected on Cook's voyage; ibid. 166–67.

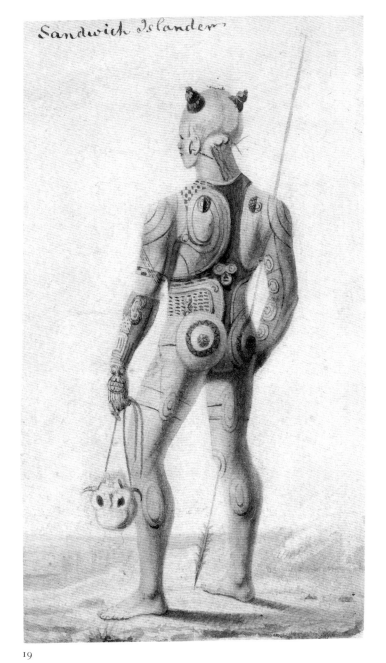

Sandwich Islander

19

TILENAU'S NUKU HIVAN PORTRAITS

POSSIBLY WILHELM GOTTLIEB
TILESIUS VON TILENAU
German, 1769–1857

19. *Sandwich Islander*

1804 (?)
Watercolor on paper
3 ⅝ x 2 in. (9.2 x 5.2 cm)
Collection of Mark and Carolyn Blackburn,
Kamuela, Hawai'i

WILHELM GOTTLIEB TILESIUS
VON TILENAU
German, 1769–1857
Engraver unknown

20. *A Young Nukahiwan Not Completely Tattoed*

1813
Copperplate engraving
10 ⅜ x 7 ⅞ in. (26.4 x 20 cm)
Department of Library Services, American
Museum of Natural History, New York

It is possible that this small watercolor (cat. no. 19), although it lacks specific provenance, is the work of the German naturalist Wilhelm Gottlieb Tilesius von Tilenau, who served as the primary expedition artist for explorer Adam Johann von Krusenstern (1770–1846) from 1803 to 1807. When Krusenstern's ships visited the Marquesas in 1804, Tilenau made sketches of a number of Marquesan subjects, which formed the basis of a series of engravings that appear as illustrations in Langsdorff's published account of the voyage.[1]

One of Tilenau's best-known Marquesan images is the engraving entitled *A Young Nukahiwan Not Completely Tattoed* (cat. no. 20), for which the watercolor may have served as a preliminary study. It depicts a young Marquesan warrior, or *toa,* from the back, his muscular body elaborately, though as yet only partially, tattooed.[2] The tattooing of the right arm and torso appears nearly complete, while only the broad outlines of the major motifs on the legs and upper left arm have been laid out and the visible portion of the face remains unadorned.

1. See Langsdorff 1813.
2. In what is likely a later inscription, the subject is incorrectly identified in the watercolor as a "Sandwich [Hawaiian] Islander."
3. While the use of pig tusks might appear to be intended to make the skull more frightening, such adornments were added to further humiliate a defeated enemy. One nineteenth-century explorer noted: "These [trophy] skulls decorated the houses of all the

renowned warriors, who, in derision put on them pearl-shell eyes, a wooden nose, and pigs' teeth." Vincendon-Dumoulin in Vincendon-Dumoulin and Decraz 1843: 257, quoted in E. Handy 1923: 140.

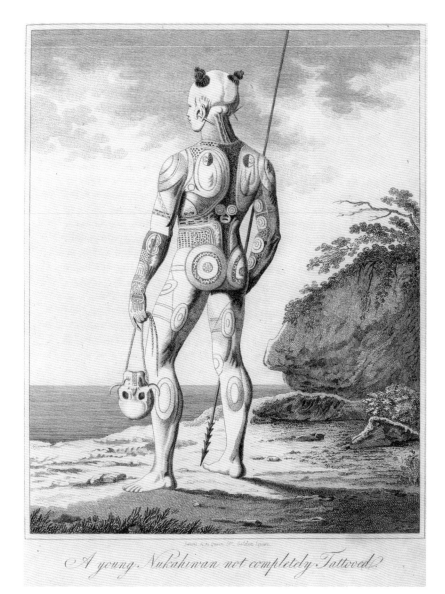

A young Nukahiwan not completely Tattooed

20

Gazing out to sea from the shore of Taioha'e bay, the finest harbor on Nuku Hiva, the subject wears ear ornaments and sports the partially shaved head and paired conical topknots fashionable among Marquesan men in the early nineteenth century. He holds a spear as well as the decorated skull, or *ipu o'o*, of a slain enemy. Such trophy skulls were at times adorned, as here, with the sharp curving tusks of boars and worn or carried as evidence of a warrior's achievements in battle.[3] Tilenau's portrait depicts a Marquesan *toa* early in his career, accompanied by the fearsome symbols of his martial prowess, his accomplishments, like his tattoos, already impressive but as yet incomplete. E K

WILHELM GOTTLIEB TILESIUS VON TILENAU
German, 1769–1857
Engraved by J. Storer[1]

21. *An Inhabitant of the Island of Nukahiwa*

1813
Copperplate engraving
10 ⅜ x 7 ⅞ in. (26.4 x 20 cm)
General Research Libraries, The New York Public Library, Astor, Lenox,
and Tilden Foundations

1. J. Storer is possibly the British artist James Storer (1781?–1852).
2. Ivory 1990: 187.
3. Langsdorff 1813, vol. 1: 117.

In its complexity, extent, and aesthetic sophistication, Marquesan tattooing was the finest in the Pacific. If Tilenau's *A Young Nukahiwan Not Completely Tattoed* (cat. no. 20) shows what is a work in progress, his *An Inhabitant of the Island of Nukahiwa* represents the completed masterwork, depicting a Marquesan man fully tattooed from head to toe. The subject's stance is somewhat unnatural, suggesting that he may have posed in this manner at the artist's request in order to better display his lavish bodily adornment. His identity is unknown, but his personal accessories indicate that he is a person of rank, probably a *haka'iki* (chief). In his right hand he holds a fan, or *tahi'i* (cat. nos. 50–53), while in his left he grasps a chief's staff, or *tokotoko pio'o* (cat. nos. 57, 58), both of which are prestige objects.[2] He also wears ear ornaments, which may be small *hakakai* (cat. no. 41). Only one of these is visible, held in place by a long stick that appears behind the ear. The ensemble is completed by a modest *hami,* or loincloth, secured around the waist.

Even without these accessories, his exquisitely tattooed body reveals the subject to be a member of the elite. Although almost naked, he is effectively clad in the finest raiment a Marquesan man could possess. Virtually every adult Marquesan had some tattoos. However, only high-ranking men could afford the time and expense required to have themselves fully tattooed in the manner seen here. An individual's tattoos thus served, quite literally, as marks of social status, as Langsdorff, in whose work Tilenau's portraits first appeared, described:

> *The regular designs with which the bodies of the men of Nukahiwa [Nuku Hiva] are punctured from head to foot supplies in some sort the absence of clothing; for, under so warm a heaven, clothing would be insupportable to them. Many people here seek as much to obtain distinction by the symmetry and regularity with which they are tattooed, as among us by the elegant manner in which they are dressed; and although no real elevation of rank is designated by the greater superiority of these decorations, yet as only persons of rank can afford to be at the expense attendant upon any refinement in the ornaments, it does become in fact a badge of distinction.[3]*

Visible within the intricate tattoo patterns are several motifs that also appear widely in other forms of Marquesan decorative art. These include the concentric *ipu,* or "container" motif, which lines the inner arms. *Ipu* appear on *'u'u* clubs (cat. nos. 54–56) and barkcloth effigies (cat. no. 14) and are commonly seen on the intricately carved surfaces of late-nineteenth-century wood objects such as bowls (cat. no. 76) and limb images (cat. nos. 15, 16). The designs on the mid-thighs are examples of the face motif, or *mata komoe,* modified versions of which also appear on *'u'u* and the carved wood covers, or *tiha* (cat. no. 78), used to seal coconut or gourd containers.

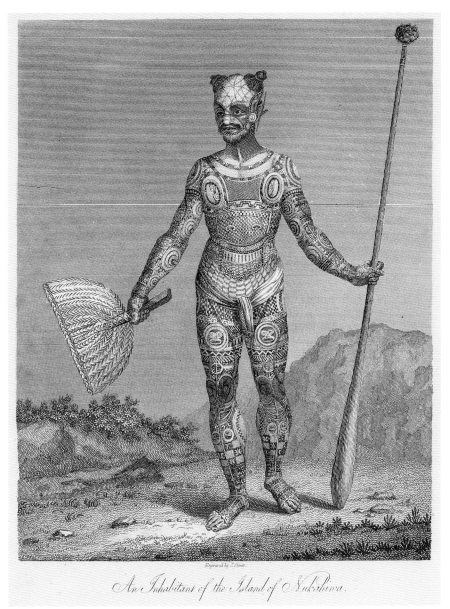

An Inhabitant of the Island of Nukahiwa.

21

Beyond his richly tattooed body, the subject's appearance is further enhanced by an elaborately prepared coiffure. Like Tilenau's "Young Nukahiwan," he wears his hair in two hornlike topknots, a hairstyle known as *tautike*. To create the *tautike,* much of the head was shaved with shells or shark teeth so as to leave two patches of hair, one on either side of the crown.[4] The hair was then gathered to form a pair of conical topknots, which were held together with strips of *tapa* (barkcloth). Porter, who evidently admired the *tautike,* noted that the whole was accomplished with "a degree of neatness and taste which might defy the art of our best head dressers to equal."[5] First observed by members of Cook's crew in 1774,[6] these distinctive paired top-knots remained popular throughout the early nineteenth century and can be seen in numerous early portraits of Marquesans, including those of Shillibeer, Armstrong, and Le Breton (cat. nos. 22, 23, 25, 27).

<div align="right">E K</div>

4. Porter (1815) 1986: 421.
5. Ibid.
6. Beaglehole 1961: 833.

JOHN SHILLIBEER
English, 1792–1860

22. *Patookee, a Friendly Chief in the Island of Nooaheevah*

1817
Etching
8⅞ x 5¼ in. (22.5 x 13.3 cm)
Rare Books Division, The New York Public Library, Astor, Lenox,
and Tilden Foundations

1. Shillibeer 1817: frontis.,
 61–62. Shillibeer's early-
 nineteenth-century render-
 ings of the name of the sitter
 and his island have been
 updated here to conform
 with modern spellings.

2. Dening 1980: 31.

3. Shillibeer 1817. Although he
 chose his etching of Patuki
 for the frontispiece, Shillibeer
 is best known for his por-
 trait of Thursday October
 Christian, the half-Tahitian
 son of *Bounty* mutineer
 Fletcher Christian, which
 appears later in the same vol-
 ume. Shillibeer sketched
 Christian when the *Briton*
 called at Pitcairn Island,
 where the descendants of the
 Bounty mutineers lived.

4. In the southern dialect: *o inoa*.

5. Shillibeer 1817: 42.

6. Crook 1800: 119. Despite their
 extreme fragility, at least four
 examples of Marquesan
 coconut-frond headdresses
 are preserved in museum col-
 lections; Ivory 1990: 153; for
 an illustration, see Panoff et
 al. 1995: 52.

7. Shillibeer 1817: 42.

8. Crook 1800: 119. There is
 nothing in Shillibeer's account
 to indicate that Patuki was a
 priest, so it is likely the palm-
 leaf headdress here was sim-
 ply an element of chiefly
 regalia.

9. Crook 1800: 22. Although
 their existence is frequently
 recorded by early European
 visitors to the Marquesas,
 examples of *kouhau* are rare
 in museum collections.

One of the most intriguing early European images of a Marquesan is John Shillibeer's portrait of Patuki, a chief from Taioha'e valley on the island of Nuku Hiva.[1] An officer serving aboard the HMS *Briton* under the command of Sir Thomas Staines, Lt. John Shillibeer was part of a British naval expedition dispatched to the Marquesas in 1814.[2] An amateur artist, Shillibeer drew and subsequently etched this extraordinary depiction of an early-nineteenth-century Marquesan *haka'iki* in full regalia as the frontispiece for his published account of the voyage.[3] In his book Shillibeer describes Patuki—with whom he performed the ritual of *o ikoa* ("name exchange"),[4] a gesture of friendship and alliance—as "a chief of great celebrity." Patuki's lavish tattooing and personal ornaments are eloquent testimony to his status.[5]

Portrayed leaning on a horizontal element, perhaps the ship's rail of the *Briton,* Patuki holds a war club, or *'u'u* (cat. nos. 54–56), in the crook of his right arm. Although Shillibeer accurately records the club's overall shape and decoration, it is not to scale with the figure. Shown far smaller than any known example, it is likely that Shillibeer reduced the size of the *'u'u* so as to make it fit more neatly within the overall composition. On his forehead the sitter wears an unusual headdress, made from the frond of a coconut palm whose central ridge forms a prominent crest with the individual leaflets drawn tightly around the head and secured at the back.[6]

Following the name exchange ritual (and presumably after Shillibeer completed his preliminary sketch), Patuki presented the headdress to the artist, who observed, "[he] placed on my head his own hat as a token of friendship. It is of a simple structure made from the leaf of the palm tree, but I shall ever hold it in the greatest estimation."[7] Restricted to priests on the island of Tahuata, on Nuku Hiva such coconut-frond headdresses could also be worn by other (presumably high-status) individuals at important ceremonies.[8] The knoblike projections that protrude above the headdress itself represent the tufts of *tautike*, the paired topknots often worn by Marquesan men during the early historic period (cat. nos. 21–23, 25, 27). The resplendent ensemble of headgear is completed by *kouhau,* large crescentic ear ornaments made from lightweight wood and painted a brilliant white with lime or clay.[9]

Patuki's most outstanding feature, however, are the intricate tattoos that cover his face and body. Requiring an enormous investment of time, pain, and expense, such detailed and extensive tattooing was usually performed only on high-ranking men.[10] The extent of Patuki's tattooing, with virtually no visible area of the body left unadorned, combined with his youthful appearance, suggests that he was likely about thirty when he sat for the portrait, since the full coverage of the body was not generally completed before

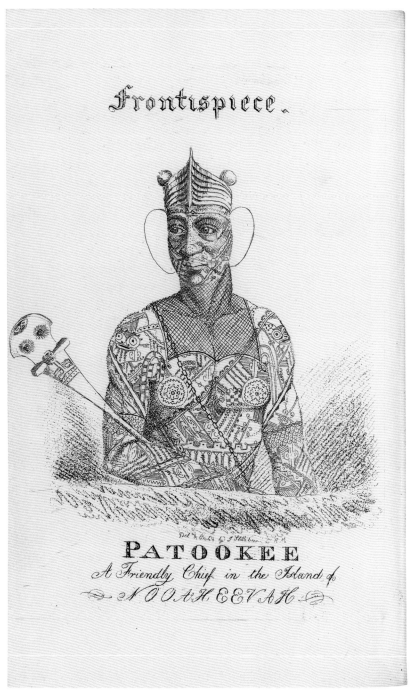

Frontispiece.

PATOOKEE
A Friendly Chief in the Island of
NOOAHEEVAH

22

this age.[11] Even when the body was completely covered, tattooing continued throughout life. The chainlike bands of motifs that crisscross the chest and appear to be superimposed on the designs already present indicate that portions of Patuki's body may already have begun to be tattooed over the earlier patterns as part of the ongoing tattooing process. Although his tattoos are somewhat schematically rendered, their overall layout is typically Marquesan and includes a number of recognizable motifs, such as the stylized faces, or *mata komoe,* that adorn the shoulders. EK

10. W. Handy 1922: 3–4;
 Lisiansky (1814) 1968: 66, 85;
 Porter (1815) 1986: 421–22.
11. Langsdorff 1813, vol. I: XIV.

CLARISSA CHAPMAN ARMSTRONG'S NUKU HIVAN PORTRAITS

CLARISSA CHAPMAN ARMSTRONG
American, 1805–1891

23. *Vokaima*

1833
Watercolor on paper
9 ⅜ x 6 ¾ in. (23.7 x 17.1 cm)
Hawaiian Mission Children's Society
Library, Mission Houses Museum,
Honolulu

24. *Tamahitu*

1833
Watercolor on paper
7 ½ x 5 ⅝ in. (19.2 x 14.4 cm)
Hawaiian Mission Children's Society
Library, Mission Houses Museum,
Honolulu

25. *Koko*

1833
Watercolor on paper
5 x 4 ¾ in. (12.7 x 11.9 cm)
Hawaiian Mission Children's Society
Library, Mission Houses Museum,
Honolulu

26. *Titihuta*

1833–34
Watercolor on paper
5 ⅜ x 5 in. (13.5 x 12.7 cm)
Hawaiian Mission Children's Society
Library, Mission Houses Museum,
Honolulu

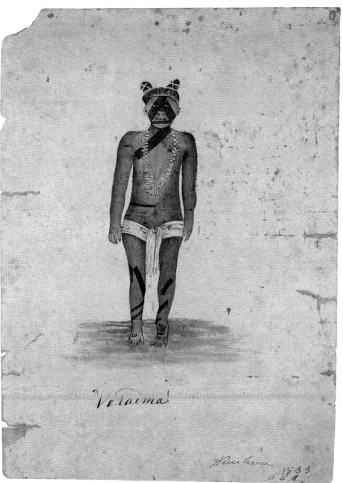

Missionary activity in the Marquesas began in the late eighteenth century but initially met with little success. Responding to a request from the American Board of Commissioners for Foreign Missions, based in Boston, the Hawaiian Board of Missions sent a delegation of three families, those of Richard and Clarissa Chapman Armstrong, Benjamin and Mary Elizabeth Parker, and W. P. and Mary Ann Alexander, to the Marquesas in 1833. On August 12 of that year, Clarissa Armstrong and Mary Parker became the first foreign women to set foot in the Marquesas.[1]

Disappointed at their failure to attract converts and discouraged by the challenging conditions they faced, the group left the islands eight months later, in April 1834.

During her time in the Marquesas, Clarissa Armstrong painted four small watercolor portraits.[2] They show details of tattoo and personal adornment, and though somewhat naïve in their rendering of the human body nevertheless capture the dignity, humanity, and individuality of their subjects.

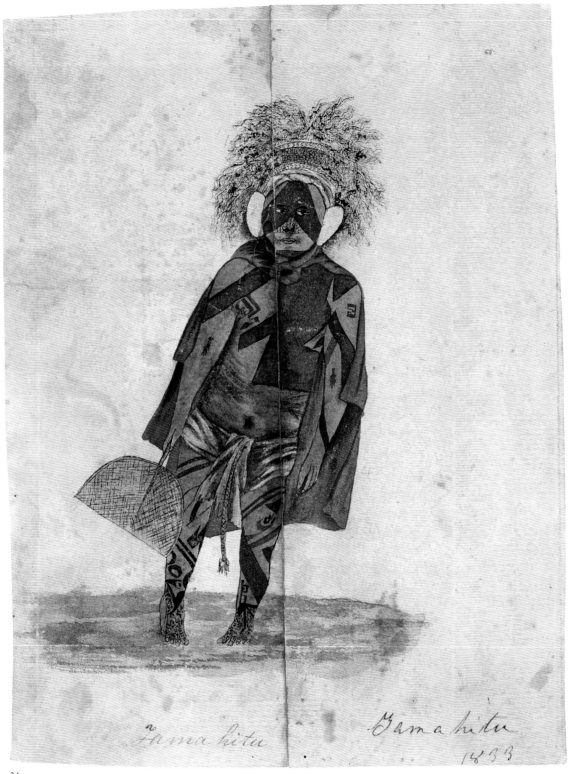

Jamahitu

Jamahitu
1833

24

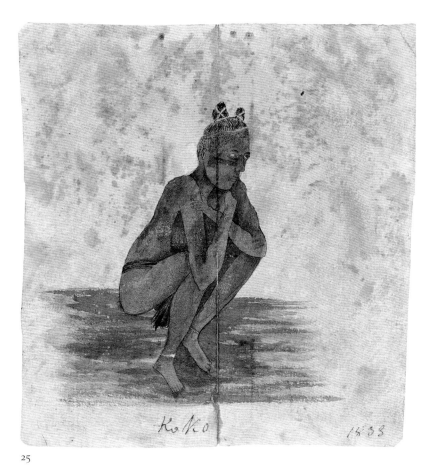

Ko Ko 1833

25

On the back of her painting of Vokaima (cat. no. 23), the artist notes that he was the son of Hape, an important *haka'iki* (chief) in Taioha'e valley who served as the group's main protector during their stay on Nuku Hiva.[3] She describes him as a warrior with black tattoos and wearing "whales' teeth about the neck, [and] white *kapa* [barkcloth] about the loins." In precontact Marquesan society, whale teeth had been rare and important status markers, reserved for high-ranking men, but by 1833 European and American whalers had long since devalued their worth by introducing them in large numbers through trade. Nevertheless, the lavish use of whale teeth on Vokaima's neck ornament is an indication of wealth and prestige. His hair is arranged in the *tautike* style, with two topknots bound with strips of *tapa*.

Tamahitu (cat. no. 24) must also be a member of the elite, since he is shown bearing numerous marks of rank and is elaborately tattooed. He wears a loincloth, or *hami,* and a red cape, or *kahu ku'a*, which at this time probably would have been made of trade cloth. A sacred color in the Marquesas, red was reserved for men of high status and for demarcating important sites. Tamahitu carries a fan, or *tahi'i* (cat. nos. 50–53), one of the most important Marquesan prestige objects.

On his head Tamahitu wears ear ornaments and an elaborate headdress. The ear ornaments are of a type called *kouhau,* described by early visitors as being made of a lightweight wood, either hibiscus or breadfruit, whitened with lime or clay.[4] The headdress is of white *tapa* over which is placed a crescent-shaped ornament studded with *poniu*, a red seed with a distinctive black spot. Although the other materials in the headdress are difficult to identify, they appear to be either feathers

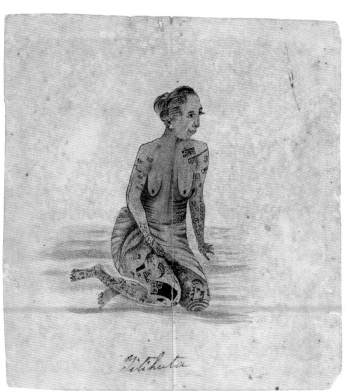

Titihuti

26

or *pavahina,* the most precious of all ornaments, made from the gray beards of male elders.

The artist's portrait of Koko (cat. no. 25) shows the subject squatting on the ground, in a position still commonly seen in the Marquesas today. He has few tattoos and wears a black *hami.* This is an unusual color for a loincloth and may be inaccurate because on the back is the notation, "The color is not good."

The fourth portrait is of a woman, Titihuta (cat. no. 26), identified only as "one of my scholars." Titihuta is densely tattooed for a woman, an indication that she was an individual of importance. Tattooing typically began for young girls around the age of ten, starting with the hands. Women were also commonly tattooed on the lips, behind the ears, and on the feet and ankles. They often wore flowers in their ears and, for important occasions, *pu taiana,* ear ornaments of human bone (cat. nos. 42–48). Titihuta's skirt would have been made of white *tapa* dyed yellow with *'eka* (turmeric). Yellow had associations with beauty, sexual attractiveness, prestige, and wealth.

Armstrong's watercolors provide a rare view of the Marquesan people in the early nineteenth century. According to her husband's journal, their sojourn was a difficult one, both physically demanding and emotionally taxing. While his descriptions of the Marquesans are often harsh, these sensitive renditions suggest that Clarissa had made a more positive connection with the individuals she portrayed. CSI

1. Armstrong 1831–34: 28.
2. We wish to thank Mission Houses Museum and Library, especially Kimberlee Kihleng, executive director, and Marilyn Reppun, head librarian, Hawaiian Mission Children's Society Library, for providing information about the mission's history, including Clarissa Armstrong's notes.
3. Armstrong 1831–34: 27–40. It was Hape who requested that missionaries be sent. However, he was very ill when they arrived and died December 4, 1833.
4. Panoff et al. 1995: 110. For early descriptions, see Forster (1777) 2000, vol. 1: 332; Crook 1800: 22; Krusenstern 1813; 157–58; Langsdorff 1813: vol 1: 170–71.

LOUIS LE BRETON
French, 1818–1866
Engraved by Émile Lassalle (1813–1871), 1843

27. *Naturel de Nouka-Hiva*

1846
Engraving
13 ½ x 20⅝ in. (34.3 x 52.4 cm)
Department of Library Services, American Museum of Natural History, New York

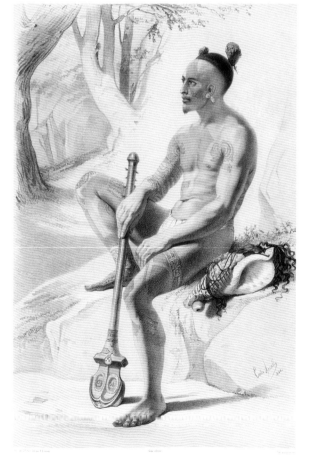

27

Among the most refined of the early European images of the Marquesas is a group of thirteen large engravings, published in the *Atlas pittoresque,* that accompanies the multivolume account of the voyages of the French explorer Jules-Sébastien-César Dumont d'Urville (1790–1842).[1] As part of his broader exploration of the South Pacific, Dumont d'Urville, commander of the vessels *Astrolabe* and *Zélée,* visited the Marquesas from August 25 to September 3, 1838, spending the majority of his time anchored at Taioha'e on the island of Nuku Hiva.[2] During their stay, members of the expedition made a number of trips ashore to obtain provisions, sketch the land and its inhabitants, and collect artifacts and scientific specimens. Louis Le Breton, one of three artists attached to the expedition, was responsible for a number of the images published in the *Atlas pittoresque.*

1. Dumont d'Urville 1846.
2. Lavondès and Jacquemin 1995: 28.
3. This image appears as plate 58 in the first volume of the *Atlas pittoresque* (Dumont d'Urville 1846).
4. Lavondès and Jacquemin 1995: 28.
5. Roquefeuil 1823: 71.

Perhaps the finest of the Dumont d'Urville engravings is Le Breton's *Naturel de Nouka-Hiva,* engraved for the *Atlas* in 1843 by Émile Lassalle, whose signature appears at the lower right.[3] Although not explicitly identified as such, the ornamentation and accessories of the subject are those of a Marquesan warrior, or *toa*. He sits in casual repose atop a large boulder, gazing attentively at a person or object outside the composition. Wearing the traditional men's *hami* (loincloth), he is adorned with extensive, though as yet incomplete, facial and body tattoos. He holds an *'u'u*, the highly polished club that was the mark of a warrior (cat. nos. 54–56). Beside him is a shell trumpet, or *putoka* (cat. no. 63), a musical instrument often employed to coordinate the assembly or movements of combatants in war. The subject wears small *hakakai* (ivory ear ornaments; cat. nos. 40, 41) and sports a goatee and carefully prepared coiffure in which the lower portion of the head is shaved and the remaining hair gathered into two tufted topknots in the style known as *tautike*. The figure's classical physique and Arcadian setting likely reflect the European perception of Marquesans and other Polynesian peoples as Noble Savages, which first emerged in the eighteenth century with the works of Jean-Jacques Rousseau (1712–1778).

By the time Dumont d'Urville arrived in 1838, however, the lives of Nuku Hivans, particularly the residents of Taioha'e, a popular anchorage for European and American vessels, had already undergone significant changes as a result of Western contact.[4] In fact, well before that date, imported firearms had replaced clubs as the favored weapons. One visitor in 1817 described this dramatic new development: "With comparatively trifling exceptions, the natives take nothing in exchange [for sandalwood] but muskets, powder, or other ammunition."[5] Clubs, however, likely remained in use as prestige items. By the time of Dumont d'Urville's visit, many, though not all, Marquesans had also begun to wear Western clothing. It is thus likely that, even at this early date, Le Breton's picture represents a historical reconstruction, for which the sitter was asked to pose with the traditional accoutrements of a warrior, rather than a depiction of the subject as he was actually encountered by the artist.

E K

Headdresses (*uhikana*)

28. Headdress

Late 19th century
Pearlshell, turtleshell, fiber
Length 18 in. (45.7 cm)
The Metropolitan Museum of Art,
New York, The Michael C. Rockefeller
Memorial Collection, Purchase, Nelson
A. Rockefeller Gift, 1964
1978.412.832

29. Headdress

Late 19th century
Pearlshell, turtleshell, fiber
Length 19⅜ in. (49 cm)
Collection of Raymond and
Laura Wielgus

In the southern Marquesas, important chiefs wore headdresses called *uhikana*. As in the *pa'e kaha* headdresses (cat. nos. 30, 31), the headband is made of woven coconut fiber. Attached to the band is a disk of pearlshell, or *uhi*, overlaid with an openwork carving of turtleshell. The ends of each band are decorated with pearl- and turtleshell plaques shaped to conform to the outline of the tapered band.

There are two styles of *uhikana*, which are distinguished by the design of the turtleshell overlay. Steinen described these as the tracery style and the *tiki*

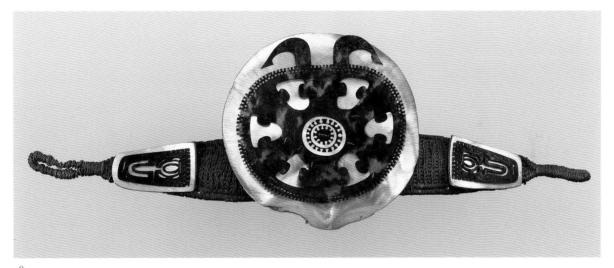

28

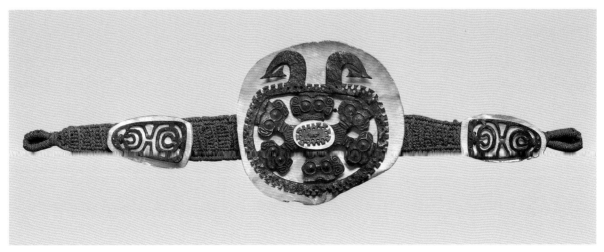

29

1. Steinen 1925–28, vol. 2: 167–72; see also Ivory 1990: 166–68.
2. E. Handy 1923: 237, 241. For an example of a ceremonial fishhook, see Panoff et al. 1995: 131, no. 155.
3. Heetoua Epetahui, personal communication, June 1999.
4. See Ivory 1995.

star style.[1] An example of an *uhikana* in the tracery style can be seen in William Hodges's portrait of Honu (cat. nos. 17, 18) and in figure 16. Without exception, all *uhikana* collected before the 1830s are of this type. The openwork is delicate, and the design is dominated by four *ipu,* or container, motifs that surround a central disk.

The *uhikana* shown here are in the *tiki* star style, in which six *tiki* faces radiate from the central disk. As in the tracery style, an openwork band encircles the group, but in this case two hooklike forms extend from the top. These motifs closely resemble the ceremonial fishhooks from which sacrificial victims, or *heana*, were hung at the *me'ae*.[2]

Whether the configuration of six faces had a specific meaning when these headdresses were made is not known. Contemporary Marquesans, however, maintain that they symbolize the six inhabited islands of the archipelago.[3] The *tiki* star image also appears on wood clubs made for sale during the last decades of the nineteenth century, suggesting that this type of *uhikana* dates to the same period.[4] The *tiki* star is one of several Marquesan designs that appear in the work of Paul Gauguin (fig. 9). C S I

Headdresses (*pa'e kaha*)

30. Headdress

19th century
Shell, turtleshell, fiber
Diameter 8⅞ in. (22.5 cm)
Indiana University Art Museum, Bloomington, Raymond and Laura Wielgus Collection, Evan F. Lilly Memorial

31. Headdress

Ho'oumi Valley, Nuku Hiva Island
19th century
Shell, turtleshell, fiber
Diameter 8 in. (20.3 cm)
The Metropolitan Museum of Art, New York, The Michael C. Rockefeller Memorial Collection, Bequest of Nelson A. Rockefeller, 1979
1978.206.1484
Collected by Karl von den Steinen, 1897

1. Crook, Greatheed, and Te'ite'i (1799) 1998: 28, 39–40.
2. Panoff et al. 1995: 53, no. 56.
3. Chaulet 1873, cited in Ottino-Garanger 2001: 70 n. 26.

For special occasions, Marquesans donned a variety of ornaments, including many worn on the head, the most *tapu,* or sacred, part of the body. The general term for a hat, cap, or other head ornament is *pa'e,* and when these take the form of bands made of woven coconut-husk fiber, or *keikaha,* they are called *pa'e kaha*.[1] This term is also used to denote headdresses of the type seen here, in which the fiber bands have alternating panels of dark brown turtleshell and white shell attached to them. The ends of the fiber band are ornamented with tapered shell plaques overlaid with openwork carving in turtleshell similar to those on *uhikana* (cat. nos. 28, 29). Some *pa'e kaha* also have numerous small mother-of-pearl disks sewn onto the band.[2]

The turtleshell panels were shaped by wrapping them in *noni* leaves and heating them in a fire.[3] The turtleshell plaques are carved in low relief and

depict *tiki* arranged in a variety of configurations. Some have a large central *tiki* flanked by smaller figures. Others depict multiple faces similar to the tattoo and rock art motif known as *mata komoe,* or show half *tiki* similar to *tiki ivi po'o* bone ornaments (cat. nos. 3, 6–13).

Handy attributed the *pa'e kaha* specifically to the island of Hiva Oa and stated that they were typically part of festival attire.[4] Owned by families rather than individuals, they were passed down as heirlooms. *Pa'e kaha* were used by warriors and *haka'iki* and also by male dancers, especially in the southern Marquesas.

There is some debate about whether *pa'e kaha* were worn with the panels facing down, like a visor, or standing upright, like a crown. In nineteenth-century illustrations they are shown with the panels down (see fig. 20). But in his journal,

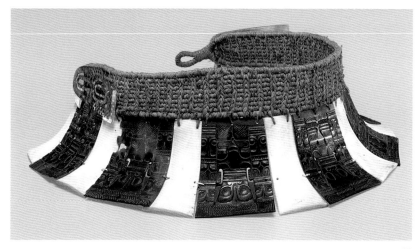

30

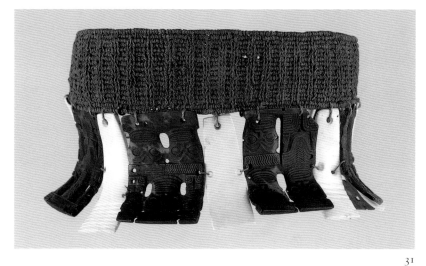

31

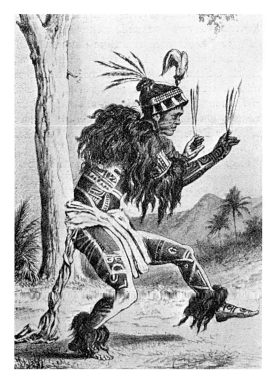

Crook described the panels as "joined lengthways, and fastened upright upon a bandange [*sic*] of coconut fibers to be tied round the head."[5]

C S I

4. The term given by Handy (1923: 283) was *pa'e kea* (*kea* is the word for "turtleshell"), which is used on the island of Hiva Oa. The word *pa'e kaha* is used on Nuku Hiva.
5. Crook 1800: 18.

Figure 20. Dancer wearing a *pa'e kaha* headdress and a cape and anklets of human hair performing at Atuona on Hiva Oa in 1881. His fingers are adorned with rings made from the tail feathers of tropicbirds.

FEATHER HEADDRESSES

32. Composite Feather Headdress

Early 19th century
Feathers, fiber, wood, seeds, hair
Height 17 ¾ in. (45 cm)
Peabody Essex Museum, Salem, Massachusetts
All components acquired in 1823 or earlier.

33. Feather Headdress

19th century
Feathers, fiber
Height 11 in. (29.7 cm)
Bernice P. Bishop Museum, Honolulu

34. Feather Headdress (*pa'e ku'a*)

19th century
Feathers, coconut fiber, bark
Height 8 ¼ in. (21 cm)
Bernice P. Bishop Museum, Honolulu

The most spectacular of all Marquesan head ornaments were the elaborate feather headdresses worn at *koina* (feasts), festivals, and other important events. Constructed from highly perishable materials, few of these remarkable headdresses survive today, and the present examples are among the finest known. Obtained from indigenous birds as well as from roosters, or *moa vahana*, which were brought to the islands by the original Polynesian settlers, feathers in the Marquesas were highly prized luxury items. Indeed, despite the fact that no European vessel had touched at the islands in nearly two centuries, Cook observed that, on learning that some of his crew had red feathers to exchange, the Marquesans lost interest in all other trade goods.[1]

Marquesan *tuhuka* made several distinct types of feathered headgear, which were often combined with separate, smaller ornaments to form large composite headdresses. These dramatic headdresses were frequently described and depicted in early Western accounts and illustrations, including Clarissa Armstrong's portrait of Tamahitu (cat. no. 24). However, today the individual components of these headdresses lie scattered and forgotten in museum collections.

Re-created for the first time in more than a century, the composite headdress seen here (cat. no. 32) has been assembled from components now in the Peabody Essex Museum based on an example that appears in an 1842 illustration by French artist Maximilien René Radiguet

Figure 21. A prominent Marquesan warrior (*toa*) in full regalia wearing an elaborate composite headdress as portrayed by the artist Maximilien René Radiguet (1816–1899) in 1842. The headdress in Radiguet's portrait served as the basis for the reconstruction of the example seen here (cat. no. 32).

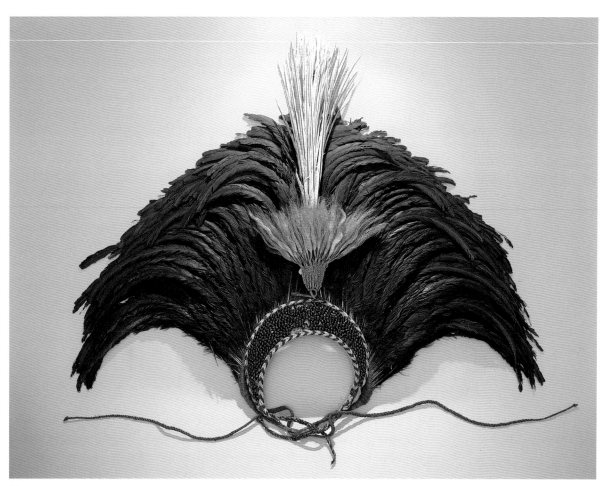

32

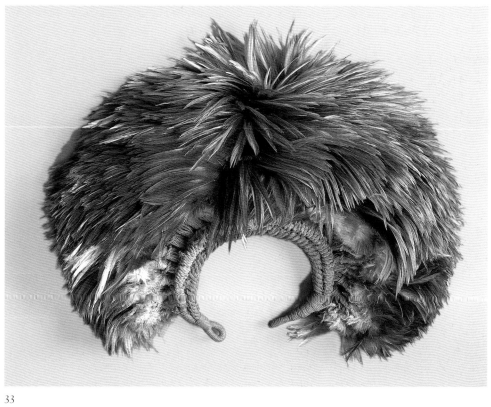

33

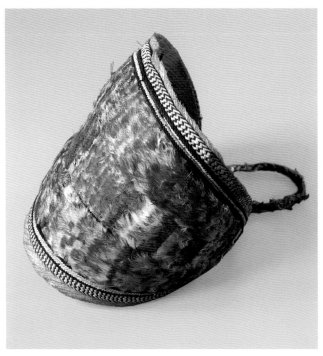

34

1. Beaglehole 1961: 369.
2. Linton 1923: 432–33.
3. Ibid.
4. Stewart 1832: 223–25.
5. E. Handy 1923: 284. Handy noted that *pa'e ku'a* also occurred on Hiva Oa, but that residents of Hiva Oa stated that they were made of red rooster neck feathers (ibid.). Thus, it is possible that, on Hiva Oa, the term *pa'e ku'a* referred to the type of headdress seen in cat. no. 33 rather than to the flatter, bandlike ornaments of the same name on Nuku Hiva.
6. Ibid.: 284.

(1816–1899; fig. 21). Both visually and physically, the headdress is anchored by a crescentic forehead ornament, or *tete poniu,* adorned with brilliant red seeds. A tassel, or *pavahina,* fashioned from the gray beards of male elders, is inserted behind the crescent, together with a bold vertical plume, or *tu'a,* made from the long slender tail feathers of tropicbirds. These smaller elements form the frontlet for an immense semicircular head ornament known as a *ta'avaha* made from the tail feathers, or *pea*, of roosters. As each rooster produced only one or two tail feathers of suitable length, several hundred birds were required to produce a single *ta'avaha.*[2]

Worn primarily by men but also, on some occasions, by women, the *ta'avaha* towered above the wearer's head, undulating with his or her every movement.[3] Charles Samuel Stewart (1795–1870), who visited Nuku Hiva in 1829, described the striking visual impact of *ta'avaha* in motion:

This plumage consisted of the long, black, burnished tail-feathers of the cock, the finest I ever saw, those in the center being more than two feet in length. . . . The ends, falling from the highest point above the forehead one over another in a regularly defined curve on either side, played in the air with the gracefulness of an ostrich plume, and imparted to the whole an appearance of richness and taste we had not been led to expect from any of the decorations of the country previously seen.[4]

In addition to the tail plumes employed in *ta'avaha,* artists collected the neck feathers of roosters to create dense, luxurious headdresses (cat. no. 33) that crowned the head in a similar fashion. Red was a sacred color, and the reddish cast of the neck feathers made them highly desirable.

The most colorful of all Marquesan feather headdresses were the *pa'e ku'a* (cat. no. 34), broad, bandlike ornaments adorned with the brilliant red and green body feathers of wild birds. Found primarily on Nuku Hiva, *pa'e ku'a* formed part of the festive attire of male and female *haka'iki* (chiefs).[5] As shown in Armstrong's portrait of Tamahitu (cat. no. 24), which depicts a similar, though unidentified, ornament in use, *pa'e ku'a* were worn on or slightly above the forehead as decorative headbands. The bright green feathers are those of the *kuku,* the white-capped fruit dove, while the more valuable red feathers were said to have come from a bird known as the *manu ku'a.* On Nuku Hiva, the *manu ku'a* was said to be an extinct species that had once lived in high arid regions on the western side of the island. On Hiva Oa, however, Marquesans in the early twentieth century asserted that the feathers of the *manu ku'a* could be obtained only by voyaging to a distant land called A'o Tona (possibly the island of Raratonga in the Cook Islands).[6] Their sacred color, combined with their rarity and semi-legendary origins, made these feathers among the most precious materials in all Marquesan art, which would explain why the Marquesans were so eager to acquire the red feathers offered by the sailors of Cook's expedition.

E K

35. Feather Headdress (*peue kavii* or *tuetue*)

19th century
Feathers, fiber, whale teeth
Height 27 ⅛ in. (69 cm)
The Field Museum, Chicago

One of only a small number of surviving examples of its type, this remarkable headdress incorporates two of the most precious materials in the Marquesas, feathers and ivory. Known as a *peue kavii* or *tuetue,* it is composed of a crescent of plaited fiber covered in delicately trimmed feathers to create a soft, luxuriant accent for the head.[1] An item of festive attire in both the northern and southern Marquesas, *peue kavii* were worn on the temples or the top of the head, with the free ends tied below the chin so that the whale-tooth pendants draped over the chest.[2] The visual impact of the *peue kavii,* like that of larger feather headdresses (cat. nos. 32, 33), was often enhanced by the addition of other ornaments such as *pavahina* (tassels of gray beard) or *tu'a* (plumes of tropicbird feathers). Whether use of the *peue kavii* was restricted to members of one sex or if this headdress could be worn by both men and women is not known.

Embellished with some thirty-five small whale teeth, this *peue kavii* would have been a treasured object. Like other prestige ornaments that incorporated whale ivory, such as *hakakai* (cat. nos. 40, 41), the *peue kavii* would have been reserved for important occasions including festivals, dances, and feasts.[3] With its feathers glistening softly in the sun or firelight and ivory pendants displayed conspicuously on the chest, this headdress would have been a striking symbol of its wearer's wealth and status. The abundance of ivory indicates that this work almost certainly dates to the early decades of the nineteenth century, after whale teeth, originally obtained solely from stranded whales, became widely available as the result of barter with European and American whalers and sandalwood traders.[4] E K

1. Ottino-Garanger 2001: 56.
2. Panoff et al. 1995: 113;
 Ottino-Garanger 2001: 56;
 E. Handy 1923: 286.
3. Panoff et al. 1995: 113.
4. Dening 1980: 121–22; Ivory
 1990: 171.

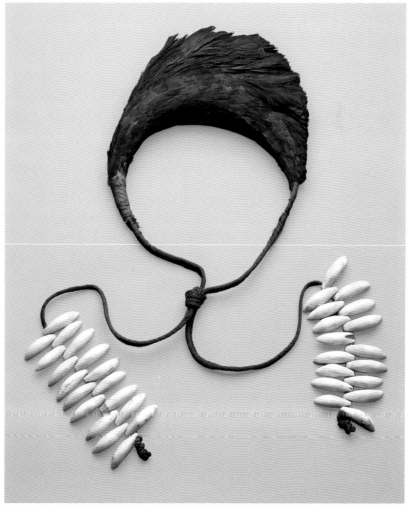

35

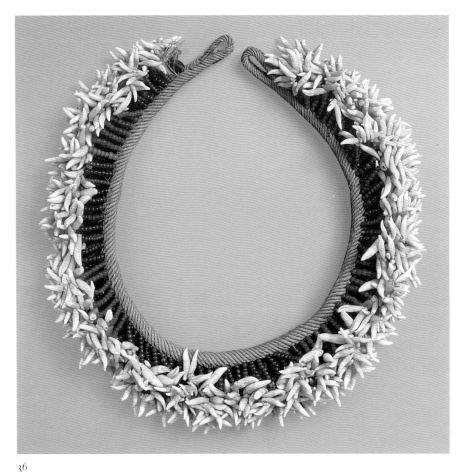

36

PORPOISE-TOOTH CROWNS (*peue 'ei* or *peue koi'o*)

36. Porpoise-Tooth Crown

19th century
Porpoise teeth, glass trade beads, fiber
Width 8⅝ in. (22 cm)
Peabody Museum of Archaeology and Ethnology, Harvard University, Cambridge, Massachusetts

37. Porpoise-Tooth Crown

19th century
Porpoise teeth, glass trade beads, fiber
Width 8¾ in. (22.2 cm)
Collection of Mark and Carolyn Blackburn, Kamuela, Hawai'i
Collected by Adm. Abel du Petit-Thouars

These two headdresses are fine examples of *peue 'ei,* crowns made from porpoise teeth and worn by women. *Peue 'ei* appear to have been made exclusively on Ua Pou, where porpoises were particularly abundant, and traded from there to other islands.[1] Porter described a porpoise hunt in his journals:

The manner of catching [porpoises] is truly surprising. When a shoal comes in, they get outside of them with their canoes and forming a semi-circle, by splashing with their paddles, hallooing, and jumping over board, so alarm the fish, that they push for shoal water and thence to the beach, where the natives pursue and take them. In this manner whole shoals are caught.[2]

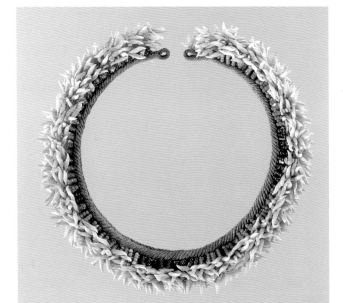

37

1. E. Handy 1923: 284.
2. Porter (1815) 1986: 434.

The hundreds of individual teeth required for each headdress were pierced and strung on *keikaha* (coconut-husk fiber) along with European glass beads obtained through trade. *Peue 'ei* were first collected in the 1830s, and all of the surviving examples incorporate such beads. CSI/EK

Ear Piercers (*ta'a puaika/ta'a puaina*)[1]

38. Ear Piercer

19th century
Bone
Height 3 ⅞ in. (9.9 cm)
The University of Pennsylvania
Museum of Archaeology and
Anthropology, Philadelphia

39. Ear Piercer

19th century
Bone
Height 2 ¾ in. (7.1 cm)
The University of Pennsylvania
Museum of Archaeology and
Anthropology, Philadelphia

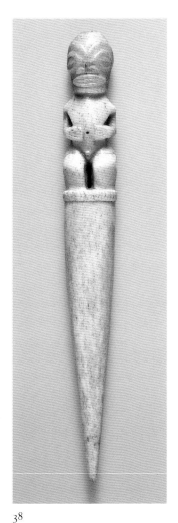

38

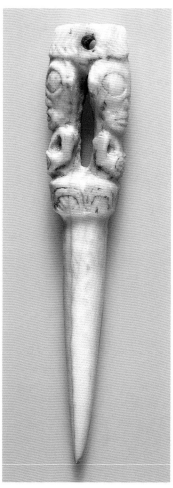

39

Marquesan body art found perhaps its most diverse expression in the adornment of the human ear. Over the course of their lives, men and women wore a variety of ear ornaments ranging from ephemeral forms, such as flowers, to more durable examples in bone, ivory, shell, and porpoise teeth (cat. nos. 40–49). All of these ornaments were worn inserted through a large hole in the earlobe. Ear-piercing was a signal event in the life of every Marquesan child. The ear-piercing ceremony, known as *tui i te puaina* or *oka,* was performed when a child was six to ten years of age.[2] Because it involved the spilling of human blood, the *tui i te puaina* was performed in a sacred place.[3] For the sons or daughters of prominent chiefs, the ritual was held on a *paepae* (stone platform) located near the village *tohua* (public ceremonial ground).[4] According to one source, for the children of the most powerful chiefs the *tui i te puaina* was accompanied by the offering of a *heana* (human sacrifice).[5]

The actual piercing of the ears was performed by a *tuhuka* skilled in the procedure who employed a specialized ear-piercing implement, the *ta'a puaika*.[6] Passed down within individual families, *ta'a puaika* were usually carved from the bones of ancestors, although some are also made from bird bone or turtleshell.[7] In nearly all surviving examples, the upper portion is adorned with a carved finial, which takes the form of a *tiki* image.[8] These occur both as single figures (cat. no. 38) and double images in which two *tiki* are joined at the head and lower body (cat. no. 39). Although similar in material and scale to the *ivi po'o* (bone ornaments; cat. nos. 6–13), the *tiki* on the ear piercers are more fully modeled and show greater stylistic affinities with larger examples of Marquesan sculpture such as the *tiki ke'a* (stone figures; cat. nos. 2–5). Like all Marquesan *tiki*, the images on the *ta'a puaika*

1. The Marquesan language has both a northern and a southern dialect. Where there are variants of the same name for a particular object, the northern version is given first with the southern after the slash mark.
2. E. Handy 1923: 91, 286.
3. Ibid.: 91.
4. Lavondès 1995: 34.
5. Graçia 1843: 166.

6. E. Handy 1923: 91.
7. Linton 1923: 418; E. Handy 1923: 91.
8. Linton 1923: 418.

depict deified ancestors and might possibly have been intended as conventionalized representations of the specific ancestors from whose bones they were fashioned.

EK

Ivory Ear Ornaments (*hakakai/ha'akai*)

40. Ear Ornaments

19th century
Whale ivory
Length of each 2¾ in. (7 cm)
The Metropolitan Museum of Art,
New York, The Michael C. Rockefeller
Memorial Collection, Bequest of
Nelson A. Rockefeller, 1979
1979.206.1639a,b

41. Ear Ornament

19th century
Pig tusk (?)
Length 2⅜ in. (6 cm)
Collection of Mark and Carolyn
Blackburn, Kamuela, Hawai'i

1. Langsdorff 1813, vol. 1: 171.
2. Porter (1815) 1986: 309.
3. E. Handy 1923: 286–87.
4. Ivory 1990: 240.

According to early visitors, men and women in the Marquesas typically wore few ornaments in their daily lives. Women might wear flowers in their ears, or men, "iron nails, a little wooden stick . . . and various other trifles."[1] But for special occasions, such as feasts and ceremonies, individuals dressed in all their finery and adorned themselves with ear ornaments of a variety of types, some large and imposing, others small and finely carved.

Ivory ear ornaments, or *hakakai,* made from whale teeth or, in smaller examples, pig tusks were worn by both sexes. Obtained, in precontact times, solely from chance strandings, whale teeth were among the rarest and most precious objects in the Marquesas. Describing Marquesan ornaments, Porter observed: "No jewel, however valuable, is half so much esteemed in Europe or America, as is a whale's tooth here."[2] Ear ornaments of whale ivory may have existed in the precontact period. However, they became far more abundant in the early nineteenth century, when European and American whalers and sandalwood traders brought large numbers of whale teeth to the islands to exchange for food and other commodities.

Carved in one piece from the massive teeth of sperm whales, larger *hakakai,* such as the pair seen here (cat. no. 40), were worn by men. In form, *hakakai* consist of a large disk worn in front of the ear and a curved spur inserted through the earlobe, which projected behind the ear. A stick placed through a hole in the spur held each ornament in place, and a length of cordage attached to the spurs of the two ornaments was passed over the head to support their weight.[3] Tilenau's engraving *An Inhabitant of the Island of Nukahiwa* (cat. no. 21) depicts a similar ear ornament in use. The stick securing it is visible behind the subject's ear. In both men's and women's *hakakai,* the spurs were frequently adorned, as here, with small *tiki.* However, until the time of Porter's visit in 1813, no examples of ear ornaments with such carved figures were either described or collected, suggesting that this more ornate form may have developed in the early nineteenth century.[4]

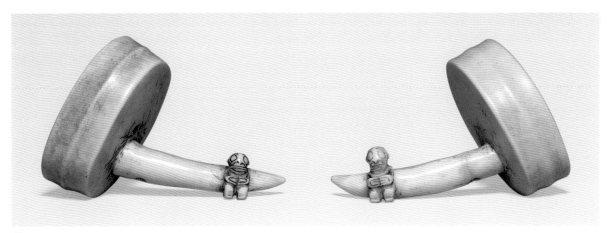

40

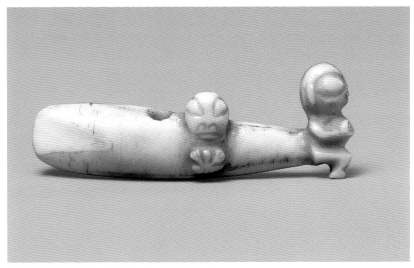

41

In smaller *hakakai*, the disk and spur were carved as separate elements, the disk being made from shell and the spur from ivory. In the single example seen here (cat. no. 41), only the spur, which appears to have been carved from a pig tusk, survives. Although *hakakai* of this size are said to have been women's ornaments, a number of early illustrations, including those of Tilenau and Le Breton (cat. nos. 21, 27 and fig. 3), also show men wearing what may be small *hakakai*. However, the precise nature of these ornaments is difficult to determine from the images. CSI/EK

BONE EAR ORNAMENTS (*pu taiana/pu taiata*)

42. Ear Ornaments

19th century
Bone, shell, wood, glass trade beads
Length of each 1¾ in. (4.5 cm)
American Museum of Natural History,
New York

43. Ear Ornament

19th century
Bone
Length 1⅝ in. (4.1 cm)
The University of Pennsylvania
Museum of Archaeology and
Anthropology, Philadelphia

44. Ear Ornaments

19th century
Bone, shell, glass trade beads, fiber
Length of each 2 in. (5.2 cm)
Collection of Mark and Carolyn
Blackburn, Kamuela, Hawai'i

45. Ear Ornaments

19th century
Bone
Length: left, 2 in. (5 cm); right, 1¾ in.
(4.5 cm)
The University of Pennsylvania
Museum of Archaeology and
Anthropology, Philadelphia

46. Ear Ornaments

19th century
Bone, shell
Length of each 2 in. (5.1 cm)
Collection of Mark and Carolyn
Blackburn, Kamuela, Hawai'i
Collected by Adm. Abel du
Petit-Thouars

47. Ear Ornaments

19th century
Bone, shell
Length of each 1¾ in. (4.4 cm)
Collection of Mark and Carolyn
Blackburn, Kamuela, Hawai'i
Collected by Adm. Abel du
Petit-Thouars

48. Ear Ornament

19th century
Bone, shell
Length 2⅜ in. (6 cm)
Collection of Mark and Carolyn
Blackburn, Kamuela, Hawai'i
Collected by Adm. Abel du
Petit-Thouars

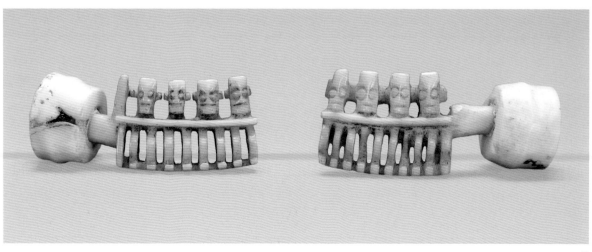

42

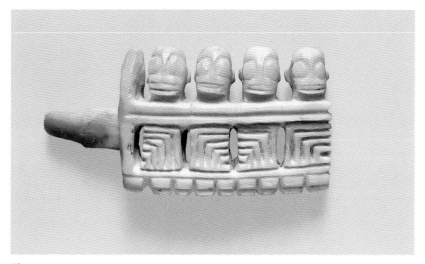

43

Perhaps the most beautiful type of Marquesan jewelry are the ear ornaments known as *pu taiana*. According to Handy, *pu taiana* were worn only by women and passed down through the female line.[1] However, the missionary Gérauld Chaulet, who lived in the Marquesas between 1858 and 1912, stated that they were also worn by men.[2] *Pu taiana* first begin to appear in museum collections around 1840, suggesting that they may have been a postcontact development, carved with metal tools introduced by Westerners.

Pu taiana consist of a caplike cylinder of shell into which is inserted an elaborately carved spur. The distinctive openwork spurs were carved from the leg or arm bone of an ancestor. As in the *hakakai* (cat. nos. 40, 41), *pu taiana* were worn with the spur projecting behind the ear. However, *pu taiana* are more intricately carved than *hakakai,* and their spurs are thinner,

1. E. Handy 1923: 289.
2. Quoted in Ottino-Garanger 2001: 61. Toti Te'ikiehu'upoko, who lives on Ua Pou, also states that they were worn by both men and women (personal communication, July 2004).

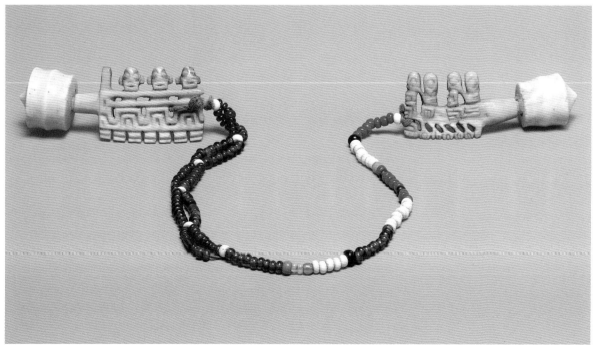

44

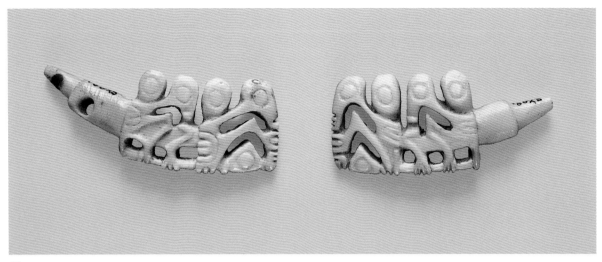

45

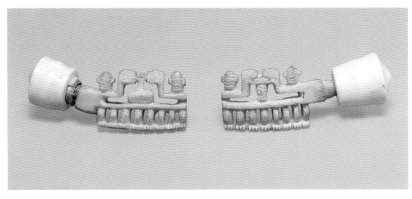

46

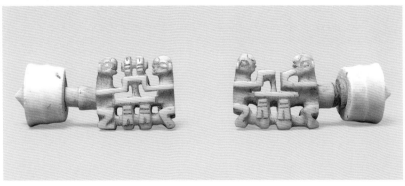

47

3. Steinen 1925–28, vol. 2: 136–48.
4. Dordillon (1904) 1999: 120.
5. Langridge and Terrell 1988: 77.
6. Ibid.: 32–35.

flatter, and more rectangular in shape.

Steinen, who made an in-depth study of *pu taiana*, found that the majority depict one of four themes or subjects.[3] The first he called "indifferent comrades," which shows several human figures arranged side by side along the length of the spur (cat. nos. 42, 43, 44 left).

Steinen's second category was *fanaua,* which he referred to as *vehine fanaua*—women who died in childbirth.[4] Steinen related this theme to a Marquesan oral tradition that told of women who knew how to give birth only by cutting the infant out of the womb, killing the mother in the process. In the story the women were taught how to give birth through the body, so that the mother might live.[5] The *fanaua* motif shows two pairs of overlapping, highly abstracted human figures that Steinen described as representing a woman and those assisting her in giving birth (cat. nos. 44 right, 45).

The third theme Steinen called "young girls in a swing" (cat. nos. 46, 47). Steinen related this motif to a story he collected in which two young girls seated on a swing played a prank on a visitor named Akaui. In revenge, Akaui dispatched two *toa* (warriors) to find stone balls. When the girls tried the prank again, the warriors threw the stones at the branch supporting the swing. The branch broke, and the girls fell to their deaths.[6] In the two *pu taiana* seen here, the figures at either end, which Steinen interpreted as slaves or

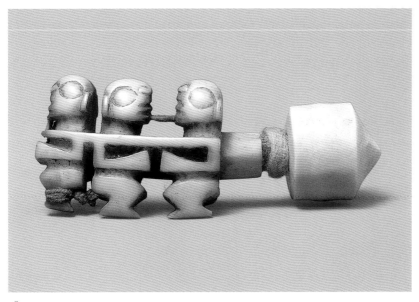

48

servants, are depicted facing each other. Between them is the swing on which the girls sit, which serves as the crossbar. In both pairs there are four sets of legs, those of the two servants and those of the two girls. The central scenes, however, vary from showing the two girls upright (cat. no. 47) to depicting one or both of them fallen over (cat. no. 46).

The final theme, of which a particularly refined example is seen in catalogue number 48, is the type Steinen referred to as the "loving couple." Oddly, however, this type always includes three figures. While the couple on the spur face each other, a third figure on the end faces outward.

<div style="text-align: right">C S I</div>

49. Porpoise-Tooth Ear Ornaments (*uuhe*)

19th century
Porpoise teeth, turtleshell, glass trade beads, fiber
Height of each 4 in. (10 cm)
The Field Museum, Chicago

Of the ear ornaments worn by women, the *uuhe* are among the most distinctive. *Uuhe* consist of an S-shaped support of turtleshell adorned with porpoise teeth and glass trade beads. The turtleshell was shaped by heating it in a fire until it became malleable and then bending it into the desired form.[1] In some cases, other materials were used for the support, including pigskin and possibly coconut shell.[2]

Glass beads were introduced to the Marquesas through trade, first by explorers in the late eighteenth century and later by European and American sandalwood traders and whalers beginning in the early nineteenth century. Marquesans had a taste for colorful attire and were always eager to acquire new trade goods that they could incorporate into their regalia. A similar

1. Chaulet 1873, cited in Ottino-Garanger 2001: 61.
2. Ibid., see also p. 71 n. 44.

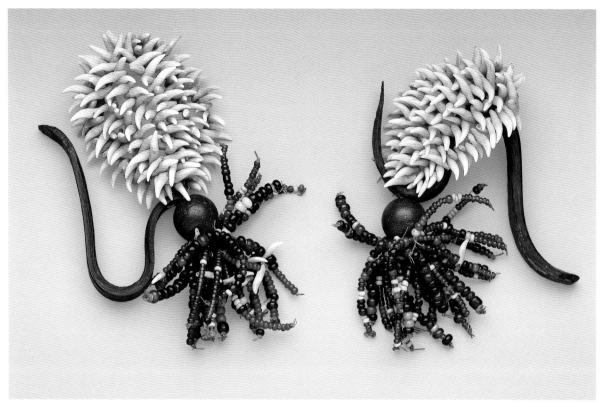

49. The configuration of the components of the ornament on the left represents an early, inaccurate restoration.

3. Crook 1800: 22.
4. Porter (1815) 1986: 356, 416 (ill.).
5. Peabody Essex Museum, Salem, E5292.

combination of porpoise teeth and trade beads can also be seen in women's *peue 'ei* crowns (cat. nos. 36, 37).

There are few early references to *uuhe,* though some form of the ornament seems to have been in evidence in the late eighteenth century. Crook described a man's ear ornament made of a "piece of thick tortoise [turtle] shell, or coconut shell, cut into a crooked form, like the handle of a grind stone, sometimes stuck through the ear, . . . with the appendage of several porpoise teeth attached to it."[3] When he was in Taioha'e on Nuku Hiva, in 1813, Porter described a woman wearing an ear ornament "tastily formed of a dark kind of wood, which receives a high polish; it is fashioned something in the form of the letter *Z,* has its ends tipped with the mother of pearl, and is otherwise ornamented with beads and small teeth," and later published the earliest known illustration of an *uuhe* in the account of his voyage.[4] Ornaments of this type were first collected around the same date by Capt. Nathaniel Page, who gave a pair to the Salem East India Marine Society (now the Peabody Essex Museum) in 1817.[5] CSI

Fans (*tahi'i*)

50. Fan (*tahi'i*)

19th century
Wood, bone, fiber
Height 18½ in. (47 cm)
The Metropolitan Museum of Art,
New York, The Michael C. Rockefeller
Memorial Collection, Bequest of
Nelson A. Rockefeller, 1979
1979.206.1757

51. Fan (*tahi'i*)

18th century
Wood, bone, fiber
Height 17½ in. (44.5 cm)
Peabody Essex Museum, Salem,
Massachusetts
Gift of Capt. Clifford Crowinshield
and Capt. Mayhew Folger, 1802

52. Fan Handle (*ke'e*)

1820–50
Wood
Height 14 in. (35.6 cm)
The Metropolitan Museum of Art,
New York, The Michael C. Rockefeller
Memorial Collection, Bequest of
Nelson A. Rockefeller, 1979
1979.206.1601
Ex coll.: Harry G. Beasley, Chiselhurst,
United Kingdom, 1850–70

53. Fan (*tahi'i*)

1820–50
Wood, fiber
Height 17⅝ in. (44.8 cm)
Collection of Mark and Carolyn
Blackburn, Kamuela, Hawai'i

Distinctively shaped fans, or *tahi'i,* were carried by *toa* (warriors), *tau'a* (ritual specialists), and other high-ranking men and women as status markers. Displayed on important occasions, especially feasts, their visual impact was enhanced by the elegant manner with which they were carried, particularly by women (see fig. 3).

Fans were described by many early visitors to the Marquesas, beginning with Cook in 1774. Tahuata has been singled out as having a reputation for finely made fans and many have been collected from that island, including four on Cook's voyage.[1] Porter, however, reported them to be widespread throughout the archipelago, and himself saw many on Nuku Hiva and Ua Huka.[2]

The blades of the *tahi'i* are tightly woven around a long wood handle, or *ke'e,* which sometimes had a sleeve of human bone slipped over it. Plant species used in weaving the blades included stiff grass, pandanus leaves, and the leaves and midribs of the coconut palm. Once completed, the blades were whitened with lime or crushed coral, which was periodically reapplied.[3]

The earliest fans described and collected in the late eighteenth century had smooth wood handles that flared slightly to echo the shape of the blade. Shortly after 1800, however, the handles became more ornate and were carved in the form of human figures, shown back-to-back and stacked one on top of the other.[4] The *tahi'i* from the Metropolitan Museum (cat. no. 50) has such a handle, carved from bone. The *tiki* are shown in the conventional Marquesan style, with large heads and oversize, deeply incised eyes. The lower pair are shown with the hands resting on the stomach, while the upper pair have one hand to the chin. The handle terminates in

1. Panoff et al. 1995: 118.
2. Porter (1815) 1986: 427.
3. Forster (1777) 2000, vol. 1: 336; Porter (1815) 1986: 427; Panoff et al. 1995: 118.
4. Ivory 1990: 182.

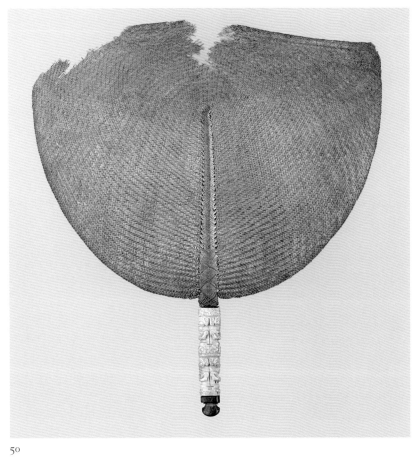

50

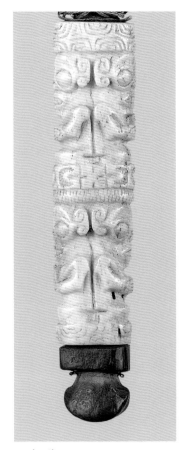

50, detail

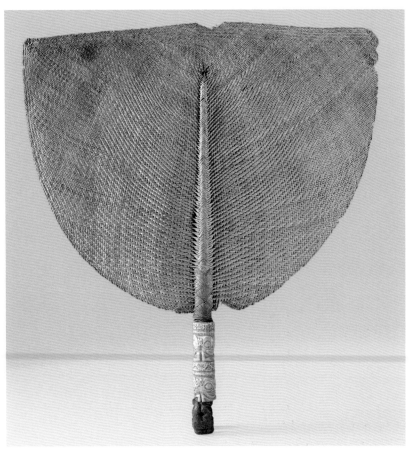

51

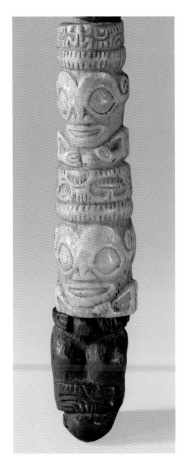

51, detail

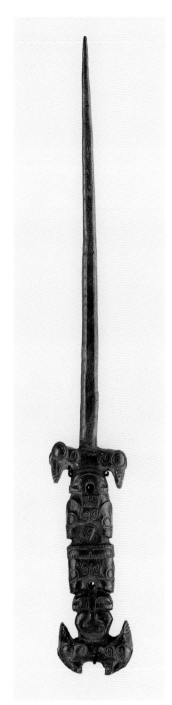

52

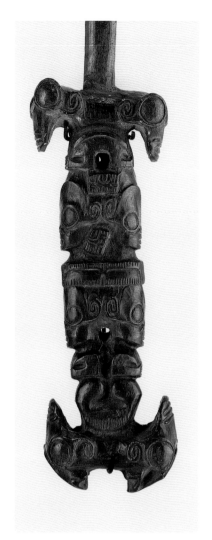

52, detail

a simple, slightly curved knob similar to those on fans from the late eighteenth century.

The handle of the fan from the Peabody Essex Museum (cat. no. 51) is slightly different. Here, the upper *tiki* are half figures carved in human bone, while the *tiki* in the lower register are full figures made partly of bone and partly of wood. On the underside of the wood section is a fifth, very small human figure.

The wood fan handles from the Metropolitan Museum (cat. no. 52) and the Blackburn collection (cat. no. 53) are more complex than the bone examples. The *tiki* on the upper register of the Metropolitan's handle consist

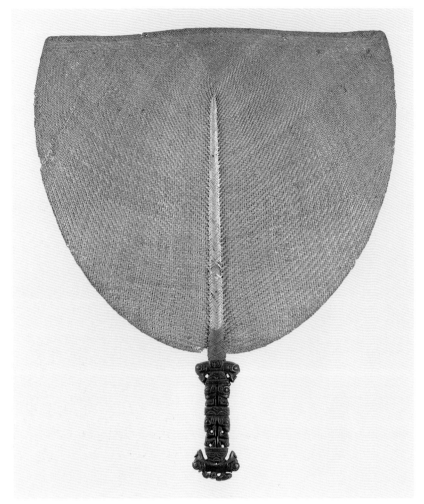

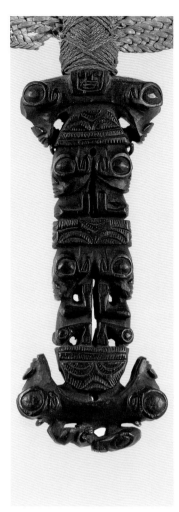

53

53, detail

5. Panoff et al. 1995: 118–19.

only of heads, while the lower pair are full figures. There is no open space between them. By contrast, on the Blackburn handle, the upper pair are half figures, similar to *tiki ivi poʻo* (cat. nos. 6–12), while the lower pair are shown as complete figures. The overall composition has more openwork and includes additional motifs in low relief that suggest faces or eyes. On both handles, the central *tiki* figures are bracketed by four elongated *tiki* heads shown in profile. These stylistic attributes suggest that the two fans were made between 1820 and 1850.[5] CSI

War Clubs ('*u'u*)

54. War Club

Early 19th century
Wood
Height 54⅝ in. (138.6 cm)
Collection of Mark and Carolyn
Blackburn, Kamuela, Hawai'i
Ex coll.: James Hooper, United
Kingdom

55. War Club

Early 19th century
Wood
Height 57¼ in. (145.5 cm)
The Metropolitan Museum of Art,
New York, Gift of Michael D. and
Sophie D. Coe, 1992
1992.223

56. War Club

Early 19th century
Wood
Height 53¾ in. (136.5 cm)
Private collection
Ex coll.: James Hooper, United
Kingdom

Warfare was an integral part of Marquesan life. Weapons included slings, spears, and war clubs made of ironwood, a heavy, dense wood the Marquesans called *toa,* which was also the word for "warrior." One type of club, the '*u'u,* an effective weapon in hand-to-hand combat, also served as a symbol of prestige for chiefs and warriors.

'*U'u* are the most numerous Marquesan objects in museum collections. They are carved in both high and low relief. The designs on each side are slightly different, and no two are identical. The heads of '*u'u* resemble human faces composed of smaller faces and pairs of eyes, creating a series of visual puns. The eyes and nose, for example, consist of diminutive human heads. Each eye is surrounded by a low-relief aureole on a slightly concave surface. The two aureoles meet at a central ridge that runs vertically between the eyes and continues as an arching brow line. Above the brow line is a beveled band which always includes a carved small face in low relief.

A projecting crossbar extends horizontally below the large eyes, while another head at the middle of the bar

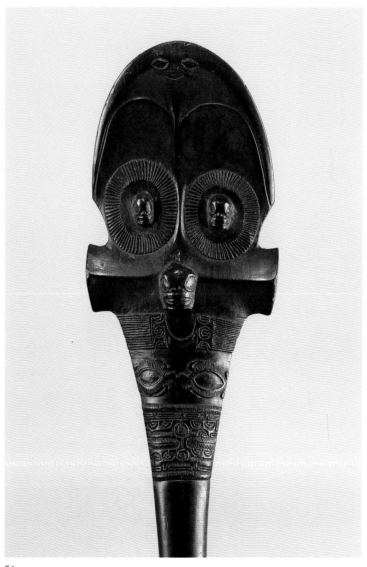

54

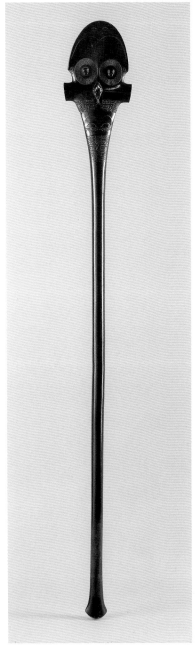

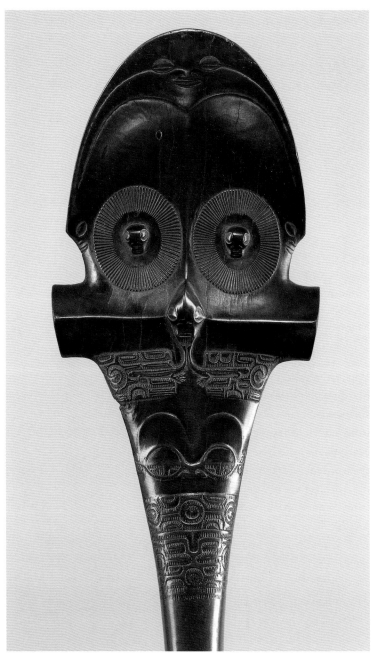

55

55, detail

serves as the nose. There are typically three bands of low-relief carving below the crossbar. The upper band usually consists of two separated rectangular panels joined by thin, armlike shapes. A pair of eyes and a nose in low relief appear between the upper and lower bands. The lower band is continuous and generally filled with geometric motifs, especially the *ipu* (containers), which are similar to tattoo designs. After they were carved, the clubs were buried in taro fields, where the soil darkened the wood to produce a deep brown color. They were then polished with coconut oil to give them a rich patina. In some cases, the lower portion of the shaft was wrapped in coconut fiber, adorned with tufts of human hair.

The *'u'u* made before the mid-nineteenth century fall into two main stylistic groups.[1] The first is exemplified by the club from the Blackburn collection

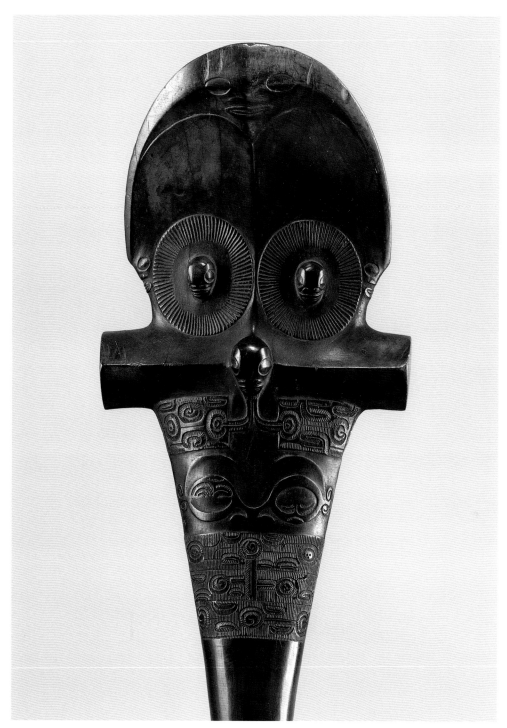

56

(cat. no. 54), and the second by the other two (cat. nos. 55, 56). The greatest differences between the two styles appear in the bands below the crossbar. On the Blackburn *'u'u,* the panels in the uppermost band consist primarily of plain horizontal lines and have a well-defined rectangular space between them from which thin arms extend upward in a U shape toward the nose above. The lower band is arranged along both horizontal and vertical axes that include *ipu* and other geometric motifs. The eyes between the

1. For an extended analysis of club styles, see Ivory 1994. See also Steinen 1925–28, vol. 2: 55, 162–64, 196–216, 265–89.

two bands in this example take the form of turtles, or *honu,* which is very unusual.

The second style is distinguished by high, wide, arching brow lines that dip into a U shape between the eyes, and there is greater variation in the designs of both the upper and lower bands. Small faces also appear on the edges of the club above the crossbar. CSI

1. Steinen 1925–28, vol. 3: αQ, no. 2.
2. Langsdorff 1813, vol. 1: xiv. The conch trumpet in this catalogue (cat. no. 63) is also adorned with artificially curled hair.
3. E. Handy 1923: 283.

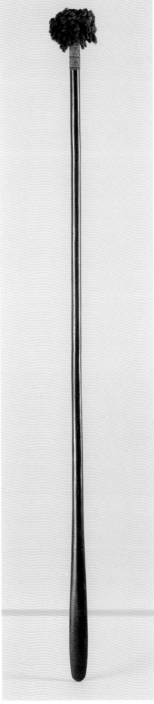

57

CHIEFS' STAFFS (*tokotoko pio'o/to'oto'o pio'o*)

57. Chief's Staff

Early 19th century
Wood, fiber, hair
Height 69 in. (175.3 cm)
Collection of Mark and Carolyn Blackburn, Kamuela, Hawai'i

58. Chief's Staff

19th century
Wood, fiber, hair
Height 58⅞ in. (149.5 cm)
The University of Pennsylvania Museum of Archaeology and Anthropology, Philadelphia

As part of their accoutrements, Marquesan *haka'iki* (chiefs) carried *tokotoko pio'o,* long wood staffs surmounted by pom-poms of human hair. The subject of Tilenau's engraving *An Inhabitant of the Island of Nukahiwa* (cat. no. 21) holds such a staff in his left hand. *Tokotoko pio'o* are made from ironwood, or *toa,* which was also used for weapons. In form, they are similar to the war clubs called *parahua.*[1] The clubs, however, are larger in size and lack the pom-pom of hair.

According to Langsdorff, the hair on *tokotoko pio'o* was obtained from slain enemies.[2] Naturally straight, it was treated by winding it around small sticks that were then wrapped in leaves and baked in an earth oven to produce the distinctive tight curls.[3]

Below the hair the upper portion of the staff is sheathed in a wide band of tightly

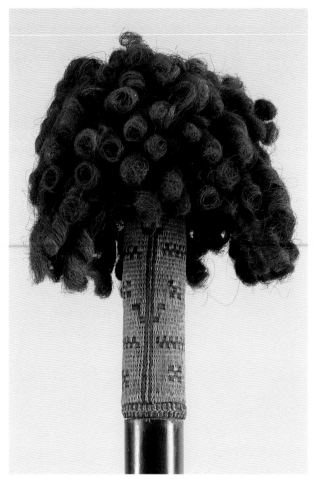
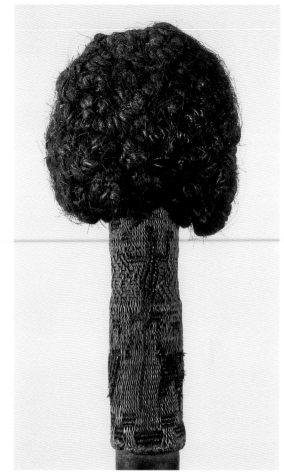

57, detail 58

woven coconut-husk fiber (*keikaha*) adorned with figural and geometric designs. One of the most common motifs is often interpreted as a stylized lizard (*moko*),[4] and the staffs seen here both have lizard images. Lizards occur throughout Polynesia, where they are often associated with ancestors, the ancestral world, and death. Some are endowed with supernatural powers, as among the Māori people of New Zealand, where they are both omens and agents of death. In the Marquesas, the lizard commonly appears as a tattoo motif, though its meaning is unclear.[5]

Tokotoko pio'o were used by both male and female *haka'iki*, and it was the owner's prerogative to carry them on ceremonial occasions.[6] According to Chaulet, chiefs also took the staffs with them when they traveled.[7] Rather than serving as emblems of secular authority, however, *tokotoko pio'o* may instead have indicated the *tapu* status of the bearer.[8]

<div style="text-align:right">CSI</div>

4. Panoff et al. 1995: 118.
5. See Ottino-Garanger and Ottino-Garanger 1998 and Steinen 1925–28, vol. 2, for discussions of lizard motifs.
6. Rollin 1929: 146.
7. Chaulet 1873: 134–35.
8. Ottino-Garanger 2001: 63. Ottino-Garanger notes that in the Marquesas today the Catholic bishop carries an ancient *tokotoko pio'o* rather than the traditional bishop's staff.

Tobacco Pipes (*epaepa* or *pioro*)

59. Pipe Bowl

Early 19th century
Whale ivory
Height 2⅜ in. (6 cm)
The Metropolitan Museum of Art,
New York, Gift of Mrs. Evelyn A. J.
Hall, 1986
1986.476.5

60. Pipe

Mid- to late 19th century
Wood
Length 5⅞ in. (14.9 cm)
Collection of Mark and Carolyn
Blackburn, Kamuela, Hawai'i

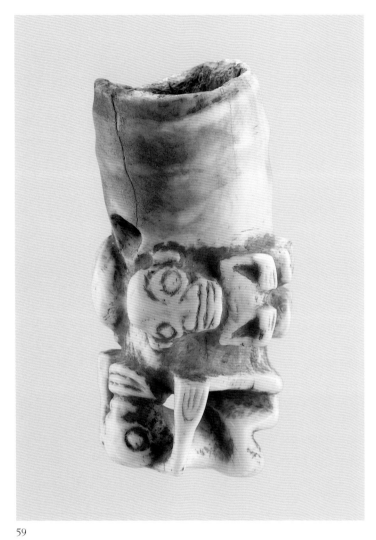

59

1. Dordillon (1904) 1999: 190.
2. Linton 1923: 334.
3. Dordillon (1904) 1999: 154.
 Steinen (1925–28, vol. 2: 58)
 also gives the name as *paepa*
 or *paipa,* while Panoff et al.
 1995: 120, lists *puoro* as
 another variant.
4. Graçia 1843: 149, cited in
 Linton 1923: 268.

Among the first Western practices to be adopted in the Marquesas were the cultivation and smoking of tobacco, known as *maimai* or *pake*.[1] Archaeological surveys reveal the presence of clay trade pipes in burial caves that otherwise show no evidence of outside contact, indicating that pipes, and presumably tobacco, were among the earliest foreign goods to gain wide acceptance.[2] By the early nineteenth century, the Marquesans had already begun to cultivate tobacco and to make their own distinctive smoking pipes, which they called *epaepa* or *pioro*.[3] At least some *tuhuka* seem to have specialized in pipe making. In 1843, the French missionary Mathias Graçia reported that one Marquesan *haka'iki* earned most of his livelihood from carving *epaepa*.[4]

Soon in general use, pipes remained valued objects that, along with tobacco containers made from bamboo or small coconuts (cat nos. 61, 62), were occasionally buried with their owners.[5] Others were preserved as heirlooms and by the early twentieth century had already been passed down for several generations.[6] Used by individuals of both sexes, pipes and tobacco, like many other aspects of Marquesan culture, were governed by gender-specific *tapu*. Men and women were not permitted to smoke together, and in some localities a woman could not smoke a pipe belonging to a man, while a man could smoke a pipe belonging to a woman.[7]

Although direct historical evidence remains scant, the earliest *epaepa* appear to have been composite objects consisting of a carved stone pipe bowl with a hole in the side into which a separate hollow-reed stem was inserted.[8] Pipe bowls of whale ivory, such as the present example (cat. no. 59), likely gained popularity beginning in the 1810s, as whale teeth became increasingly

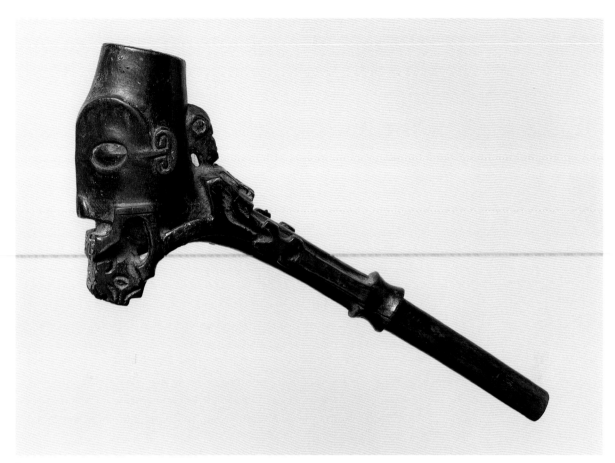

60

available through trade with European and American sailors.[9] This example is adorned with three small *tiki* in high relief whose poses and features resemble those on ivory ear ornaments, or *hakakai* (cat. nos. 40, 41), dating to the same period.

In the latter part of the nineteenth century, artists began to make *epaepa* in which the stem and bowl were carved from a single piece of wood. The intricately detailed pipe seen here (cat. no. 60) is an outstanding example of this second type. Carved in the form of a single large *tiki* head against which a smaller *tiki* reclines, the bowl is adorned at the base with a geometric design flanked by a stylized lizard, or *moko*. E K

5. Panoff et al. 1995: 120.
6. Linton 1923: 335.
7. E. Handy 1923: 261.
8. For examples, see Linton 1923, pl. 49c, d.
9. Dening 1980: 121–22.

Tobacco Containers (*putui* or *tui maimai*)

61. Tobacco Container

Ua Pou
Mid- to late 19th century
Coconut shell
Height 5 ⅛ in. (13 cm)
The University of Pennsylvania
Museum of Archaeology and
Anthropology, Philadelphia

62. Tobacco Container

Mid- to late 19th century
Coconut shell
Height 5 ⅛ in. (13 cm)
Collection of Mark and Carolyn
Blackburn, Kamuela, Hawai'i

1. Steinen 1925–28, vol. 2: 58.

Among the most lavishly ornamented of all Marquesan objects are containers fashioned from the shells of small coconuts. Designed to fit pleasingly into the palm of the hand, these small vessels are said to have served as tobacco containers and were referred to variously as *putui* or *tui maimai*.[1] The interior is accessible only through a small hole pierced through one of the three "eyes" at the top of the coconut and plugged with a wood stopper. The diameter of the hole is generally so small that, assuming the vessels were indeed used for storing tobacco, the leaves would have to have been very finely cut.

Together with locally carved smoking pipes (cat. nos. 59, 60), *tui maimai* constituted a distinctive ensemble of Marquesan smoking equipment that developed following the introduction of tobacco in the early contact period.

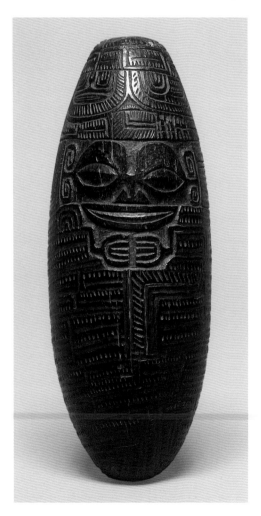

61

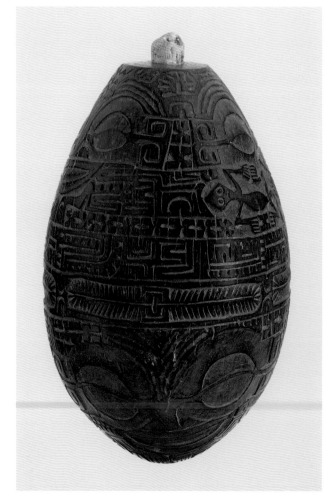

62

Pipes and tobacco containers were highly prized possessions that were occasionally buried with their owners.[2]

The elaborately decorated surfaces of these tobacco containers form part of a broader tradition of ornamental low-relief carving on coconut-shell vessels, such as bowls (cat. no. 75). As in other relief carvings, such as those on the turtleshell plaques of *pa'e kaha* headdresses (cat. nos. 30, 31), the primary design element is the *tiki*, in some cases reduced to only the face and hands. Unlike the *pa'e kaha,* however, the *tiki* on the tobacco containers, while prominent, do not dominate the composition. Instead, they are incorporated, at times almost subsumed, into a complex matrix of geometric designs and figurative images, including *moko* (lizards), which covers the entire surface.

EK

2. Panoff et al. 1995: 120.

63. Shell Trumpet (*putoka/putona*)

19th century
Shell, barkcloth, fiber, hair, bone, pearlshell, breadfruit sap
Length 20 in. (50.8 cm)
Collection of Mark and Carolyn Blackburn, Kamuela, Hawai'i

The large shell trumpets known as *putoka* were the most versatile of Marquesan musical instruments. In contrast to other instruments, such as drums or flutes (cat. no. 64), whose use was restricted primarily to musical performances, shell trumpets also played a vital role in communication

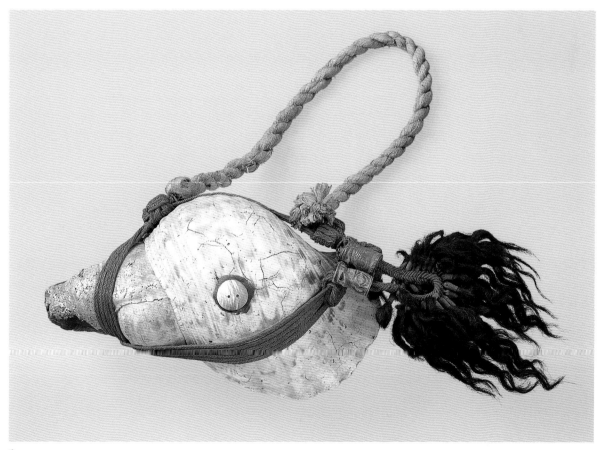

63

1. Panoff et al. 1995: 125;
 E. Handy 1923: 313.
2. E. Handy 1923: 77, 183, 313;
 Linton 1923: 406; Panoff et al.
 1995: 125.
3. E. Handy 1923: 125; Langs-
 dorff 1813, vol. 1: 164.
4. Porter (1815) 1986: 385.
5. Linton 1923: 406.
6. Ibid.: 405.
7. Ibid.; E. Handy 1923: 313.

both within and, at times, between the archipelago's isolated valleys. Producing a rich, sonorous tone that carried over great distances across the mountainous and often densely forested landscape, *putoka* served to call the population to assembly or signal important events.[1] In peaceful times, the sound of the *putoka* might proclaim the birth of a *haka'iki*'s first child, summon people to assist in the breadfruit harvest, announce the arrival of a prominent personage in a canoe, or accompany funerary rites.[2] In war, *putoka* played roles similar to those of trumpets in traditional European warfare, being variously employed to rally forces, warn of attacks, and urge fighters into battle.[3] They were also used to help coordinate the movements of war canoes at sea.[4]

Putoka were fashioned from the shells of large marine snails. In some cases referred to as *vehine na te mano* ("wife of the shark"), shells of a size suitable for making trumpets were highly prized.[5] In many instances, the choicest specimens lived at considerable depths, where they could be obtained only by diving to the bottom of the bay and swimming back to the surface laden with the heavy mollusk.[6] After the shell was procured and the snail removed, a hole for blowing was ground into one of the wide spiral whorls near the apex and a separate mouthpiece of gourd or, occasionally, bamboo was attached using the resinous sap of the breadfruit tree.[7]

The *putoka* was blown in the manner of a Western trumpet, with the sound produced by the vibration of the player's lips and amplified by the shell. It was frequently embellished, as here, with precious ornaments, which marked and enhanced its value.

This exquisitely appointed *putoka* is an outstanding expression of the trumpet maker's art. Bound with finely plaited fiber cordage attached to a spiral shoulder strap of twisted *tapa* (barkcloth), the body of the trumpet is adorned with a lustrous disk of pearlshell affixed with breadfruit sap. The lower end of the instrument (whose mouth, in the present view, is on the underside) is hung with a large tassel made from locks of human hair and accented by the addition of two *tiki ivi po'o* (bone ornaments). The result is a complex composite work that is at once a functional musical instrument and a notable demonstration of the diversity of materials and techniques employed by Marquesan artists. EK

64. Nose Flute (*pu ihu*)

Mid- to late 19th century
Bamboo
Length 17½ in. (44.5 cm)
Peabody Essex Museum, Salem, Massachusetts

Marquesans had very few musical instruments. Drums were used for ceremonies on *tohua* and for religious rites on the *me'ae*. Shell trumpets, or *putoka* (cat. no. 63), served to call the people together and to rally warriors in battle. Flutes, by contrast, were played in more intimate settings. Marquesans made two types of flutes: nose flutes (*pu ihu*) and mouth flutes (*pu kohe*),

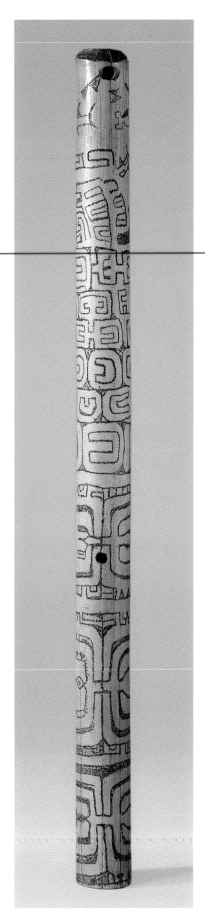

both of which were fashioned from bamboo. Handy noted that nose flutes, such as the present example, were played by both sexes, but were used especially by young men in courting:

> It is said that those who knew the art of playing this instrument could talk through its tones. A girl's lover would go behind her house at night and thus talk to her as she lay on the family bed space, luring her to come out to him — and it was not only unmarried girls that were "talked to" in this way! The nose flute was the instrument of the Marquesas islander's most subtle mode of love making.[1]

Pu ihu were played by holding the instrument to the nose with one hand while closing one nostril with a finger. The sound was produced by blowing with the other nostril through a small hole at the end of the flute. The fingers of the free hand were used to play the notes.

Although Marquesans used bamboo flutes in precontact times, the practice of burning designs into the surface with a piece of hot metal, known as pyrograving, appeared after European contact. Originally developed in New Caledonia, also a French colony, pyrograving may have been introduced to the Marquesas in the 1840s by the French garrison stationed on Nuku Hiva.[2]

The designs engraved on bamboo flutes are derived from Marquesan tattooing. The primary motif seen on this flute is the *ipu*, a concentric C-shaped form, examples of which cover nearly the entire surface. The word *ipu* refers to containers of almost any kind: cups, bowls, skulls, shells, turtleshells, and so forth. It indicates something hard that protects or shields. In Marquesan tattoo, the *ipu* was most frequently applied to the inner arm (cat. no. 21 and fig. 7), a vulnerable spot, especially when the arm was raised in battle. The *ipu* may

1. E. Handy 1923: 312.
2. Ottino-Garanger and Ottino-Garanger 1998: 60. By the late twentieth century, the practice of pyrograving bamboo had died out but was revived by Christian and Catherine Kervella, a French couple living on Ua Pou, who researched its history and learned the technique.

thus have afforded a measure of supernatural protection to the people or object it adorned. In addition to the *ipu,* various designs appear on this flute, including fish, rays, and other marine life. csi/ek

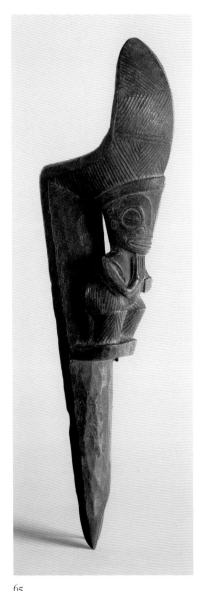

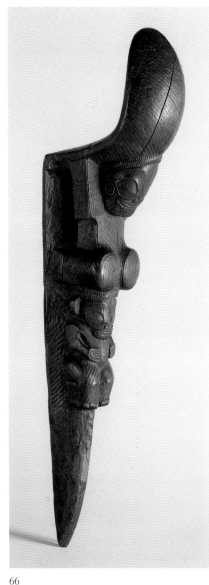

65

66

Stilt Steps (*tapuvae*)

65. Stilt Step

19th century
Wood
Height 14 in. (35.6 cm)
Collection of Mark and Carolyn
Blackburn, Kamuela, Hawai'i

66. Stilt Step

19th century
Wood
Height 15⅝ in. (39.7 cm)
Collection of Mark and Carolyn
Blackburn, Kamuela, Hawai'i

67. Stilt Step

19th century
Wood
Height 17¾ in. (45 cm)
Collection of Raymond and Laura
Wielgus

The Marquesans used stilts in special competitions held as part of funeral rites for important people. These took the form of races or one-on-one contests in which participants attempted to knock each other to the ground. Langsdorff described Marquesan stilt walking:

> *The best runners on stilts, who perform at the public dancing festivals, are tabooed for three days before; they do not, in consequence, go out, are well fed, and have no intercourse with their wives. This is probably with a view to increasing their strength.*[1]

He later added:

> *At their great public festivals they run in this way for wagers, in which each tries to cross the other, and throw him down; if this be accomplished, the person thrown*

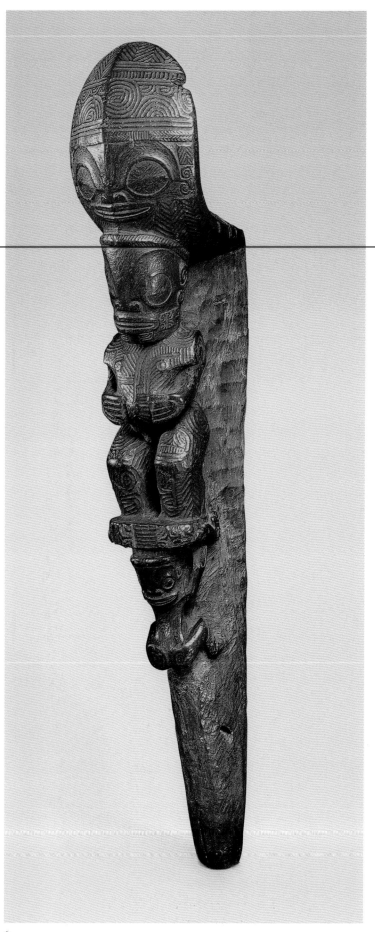

1. Langsdorff 1813, vol. 1: 136, 168–69. See also Porter (1815) 1986: 427–29.
2. Langsdorff 1813, vol. 1: 168–69.
3. Pascal Erhel Hatuuku of Ua Pou (personal communication, July 2004) states that *vaeake* refers to the entire stilt, while *totoko* is the word for "pole" and *tapuvae,* the word for "stilt step." Dordillon ([1904] 1999: 288) defines *vaeake* as "the god of those who walk on stilts."
4. E. Handy 1923: 297.
5. Dening 1980: 235.
6. Ivory 1999: 318.
7. Porter (1815) 1986: 328.

becomes the laughing-stock of the whole company. We were the more astonished at the dexterity shewn by them as they run on the dancing-place [tohua], which, being paved with smooth stones, must greatly increase the difficulty. . . .[2]

Elaborately carved stilt steps, or *tapuvae,* fashioned from ironwood were attached to poles of a lighter wood to form the completed stilt, or *vaeake.*[3] Stilt steps were one of the most distinctive Marquesan art forms, and like other important objects, were made by specialists known, in this instance, as *tuhuka vaeake.*[4] Although *tapuvae* were one of the most common items collected by European and American visitors, they are rarely described in the early literature. Dening has suggested that this may indicate that stilt racing was among the first traditions to fall out of practice following Western contact.[5] However, the portability of *tapuvae,* combined with their unusual function and style, may have made them particularly desirable to visitors, encouraging their continued production and making them perhaps the first Marquesan art form to be made specifically for sale.[6]

Tapuvae are decorated with *tiki* in the typical Marquesan style, with large heads and prominent eyes. Catalogue number 65 has a single *tiki,* with one hand on the stomach and the other raised to the chin. Shallow striated lines cover the body, suggesting tattooing, and the curved section above the figure recalls the shape of a feather headdress.

The other stilt steps show two figures, one above the other. In each case, one figure faces forward, while the other presents its backside to the viewer and looks over its shoulder. This position may represent an insult or a challenge to a competitor. Porter, who illustrated a stilt step similar to catalogue number 66 (see fig. 5), described an incident during a battle on the island of Nuka Hiva in which his opponents "scoffed at our men, and exposed their posteriors to them, and treated them with the utmost contempt and derision."[7]

CSI

68. Canoe Model (*vaka*)

Late 19th century
Wood, fiber
Length 47 ¼ in. (120 cm)
The Israel Museum, Jerusalem, Gift of the Faith-dorian and Martin Wright Family to the American Friends of The Israel Museum

1. Haddon and Hornell (1936–38) 1975: 31; Panoff et al. 1995: 125.
2. Haddon and Hornell (1936–38) 1975: 29.
3. Porter (1815) 1986: 367–69, 410; Haddon and Hornell (1936–38) 1975: 32–37, 41–42.
4. See Joppien and Smith 1985, vol. 2: 202–5; Porter (1815) 1986: 370 (ill.).
5. Two much eroded hull fragments from a large double

The ornamentation of canoes represents a highly significant tradition within Marquesan art. Early historical accounts describe a variety of watercraft used for fishing, warfare, and transportation between the numerous valleys and islands of the archipelago.[1] With the exception of large double-hulled vessels, all Marquesan canoes, as seen in this model, were equipped with an outrigger—a long narrow float attached to the hull by horizontal booms.[2] The outrigger greatly increased a canoe's stability. Ranging from small personal vessels to massive war canoes up to fifty feet long, Marquesan canoes were adorned with carved prows, sterns, and other components accented by more ephemeral ornaments of fiber, hair, palm fronds, and even human skulls.[3] Such canoes often appear, with varying degrees of detail, in

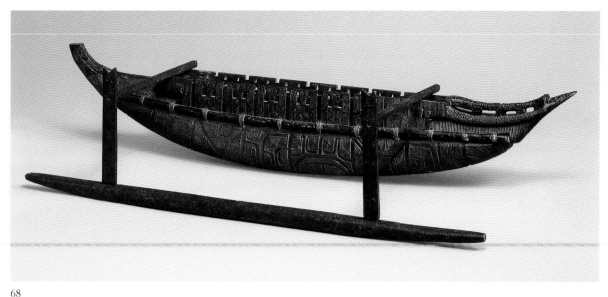

68

the seascapes of artists who accompanied eighteenth- and early-nineteenth-
century exploring expeditions.[4] However, apart from a few decorative carv-
ings (cat. nos. 69, 70) and fragments of hulls, no vestiges of these magnificent
vessels survive.[5] It is possible, however, to gain some impression of the grandeur
of Marquesan canoes from the smaller models created by artists in the nine-
teenth and early twentieth centuries.

Although there are indications that miniature canoes may once have
played a role in religious ceremonies, the majority of Marquesan canoe mod-
els were made as curiosities.[6] The oldest well-documented example was col-
lected in 1817.[7] Most, however, are considerably later and, as in the present
work, reflect the taste for elaborate surface ornamentation, which developed
in the late nineteenth century and is also seen on bowls (cat. no. 76), limb
images (cat. nos. 15, 16), and other objects from the period.[8] Production of
these ornate and often superbly crafted models was centered on the island
of Fatuiva, although they were made on Nuku Hiva as well (fig. 22).[9] A promi-
nent feature of canoe models, which is corroborated by early descriptions of

canoe from Hakaui valley on
Nuku Hiva are in the British
Museum, London; Haddon
and Hornell (1936–38) 1975:
45–46, fig. 29.

6. Linton 1923: 316.
7. See Haddon and Hornell
 (1936–38) 1975: 36–37, fig. 22.
8. Another feature that indicates
 a late-nineteenth-century date
 for this model is the use of a
 single flat plank (as opposed
 to a series of smaller struts) in
 attaching the outrigger float
 to the boom. This construction
 technique was introduced to
 the islands around the 1880s by
 an African or mulatto sailor
 who had settled on Hiva Oa
 and was subsequently adopted

Figure 22. Marquesan woman with an
elaborately carved canoe model similar
to the one seen above photographed by
Rollo H. Beck of the Whitney South Seas
Expedition in 1923. The woman holds
the canoe's outrigger in her left hand.

by the Marquesans in making canoes and canoe models. See ibid.: 39, 43.

9. Linton 1923: 316; Haddon and Hornell (1936–38) 1975: 34.

10. Haddon and Hornell (1936–38) 1975: 34.

11. Ibid.: 42.

12. Linton 1923: 316; Haddon and Hornell (1936–38) 1975: 42. Such carvings on the hull of an actual canoe would greatly increase its resistance and reduce its speed.

full-sized canoes, is the presence of a carved prow ornament (cat. nos. 69, 70). Prow carvings incorporated a variety of *tiki* images, terminating, as here, with an upturned human face in low relief.[10] Another aspect of canoe ornamentation described in historical accounts are decorated washstrakes (planks attached to the upper sides of the hull that served to increase the overall depth of the vessel). The washstrakes of full-sized canoes were reportedly decorated with geometric motifs.[11] However, those of late-nineteenth- and early-twentieth-century canoe models are frequently adorned, as here, with a row of *tiki* similar to those on the turtleshell plaques of *pa'e kaha* headdresses (cat. nos. 30, 31). While the hulls of actual canoes and early canoe models were plain, those of later models, by contrast, are richly decorated with intricate curvilinear designs.[12] EK

Canoe Prow Ornaments (*'au'au* or *pihao*)

69. Canoe Prow Ornament

19th century
Wood
Length 19⅜ in. (49.2 cm)
Leo and Lillian Fortess Collection

70. Figure from a Canoe Prow Ornament

19th century
Wood
Height 7⅞ in. (20 cm)
The University of Pennsylvania Museum of Archaeology and Anthropology, Philadelphia

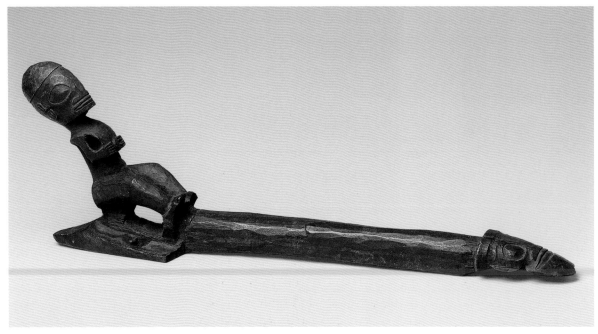

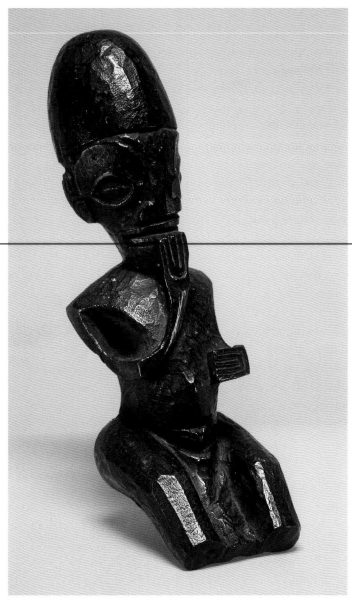

70

The *tiki* images that adorned the prows of Marquesan canoes constitute a distinct category within Marquesan sculpture. They consist of dynamic, seated figures shown with their legs extended forward to the base of a long projection that terminates in an upturned human face. In contrast to the more static, frontal orientation of freestanding wood (cat. no. 1) and stone *tiki* (cat. nos. 2–5), those of the prow ornaments convey a sense of movement and activity. Carved as part of separate prow pieces, known as *'au'au* or *pihao,* which were attached to the bows of canoes, these *tiki* were intended primarily to be viewed in profile as the vessels sped through the water, their bodies portrayed as though thrown backward by the acceleration of the canoe. Unlike the majority of Marquesan *tiki*, in which the head occupies a third or more of the body height, the proportions of the *'au'au* figures are more naturalistic, although the head remains somewhat enlarged. The legs,

1. Haddon and Hornell (1936–38) 1975: 32. A lashing hole, which was used to attached the prow ornament to the body of the canoe, is visible on the base of catalogue number 69.
2. Porter (1815) 1986: 367; Haddon and Hornell (1936–38) 1975: 40.
3. Haddon and Hornell (1936–38) 1975: 32.
4. Ibid.: 34; Stewart 1831, vol. 1: 243.
5. Haddon and Hornell (1936–38) 1975: 41.
6. The Marquesan section of Haddon and Hornell's encyclopedic study of Pacific Island canoes also makes no mention of prow ornaments with seated *tiki*.
7. Panoff et al. 1995: 126.

reduced or absent in many *tiki*, are shown full-scale and fully modeled. The arms, by contrast, are stylized, and their treatment and positions are similar to those on the wood and stone figures or stilt steps (cat. nos. 65–67).

Marquesan canoes were constructed of a number of separate components that were lashed together with cordage made from *keikaha* (coconut-husk fiber).[1] In the case of large war canoes, each part was owned by a different individual and stored in the house of its owner when not in use.[2] The prow pieces of the largest canoes were immense, attaining lengths of up to sixteen feet.[3] Hewn from massive logs, they were typically embellished with a variety of *tiki* images and geometric motifs. Based on historical descriptions and early models, the tips of nearly all Marquesan canoe prows were adorned with a flattened upturned human face carved in low relief (cat. no. 69).[4] Apart from this feature, however, the ornamentation of the prows appears to have been variable.

A number of canoe models have prows in which a row of recumbent *tiki* figures is arranged along the midline.[5] Prows with seated *tiki* figures, such as the present examples, are preserved in museum and private collections but are not described or depicted in historical sources. Many, however, show evidence of considerable use, indicating that they were actually mounted on canoes rather than carved as curiosities.[6] It is likely that these seated *tiki* ornaments—too small to have served as the prows of large war canoes— adorned smaller vessels intended for fishing or local travel. Depicting important ancestors or *tupuna*, the *tiki* on prow ornaments might have served to indicate that the owner of the canoe belonged to a prominent family.[7] If so, it is possible these unusual seated figures represent a specific image type, created to identify the personal watercraft of *haka'iki* (chiefs) or other high-status individuals.

EK

71. Paddle Finial

Early 19th century
Wood
Height 2 ⅝ in. (6.8 cm)
American Museum of Natural History, New York

1. Haddon and Hornell (1936–38) 1975: 47; Linton 1923: 311.
2. Haddon and Hornell (1936–38) 1975: 48. Early-twentieth-century studies state that both the grips (presumably including finials) and blades of Marquesan paddles were ornamented in "pre-European times"; see ibid.: 48; Linton 1923: 315. However, no reliably dated early examples with decorated blades have yet been located in museum collections. Thus, it is possible that the authors may have been making extrapolations

While sails were used under certain circumstances, especially when traveling long distances, Marquesan canoes were more typically propelled by paddling. In smaller vessels, such as fishing canoes, the paddlers sat one behind the other, but in larger craft, such as war canoes, they were seated side by side, with one paddling on either side of the hull.[1] Many Marquesan paddles, which were known as *hoe* or *tohua,* were undecorated. However, those associated with the war canoes of powerful chiefs were reportedly richly adorned with *tiki* and other motifs.[2] The size and imagery of the present work, previously identified as a fragmentary fan handle, indicate that it is actually a far rarer example of a carved paddle finial. It was likely cut from the full paddle by a Western collector, perhaps to make it more easily portable.

The overall composition, which depicts two *tiki* figures situated between thin serrated bands and surmounted by two smaller recumbent *tiki* who share a common torso, is similar to that of a paddle finial now in the British

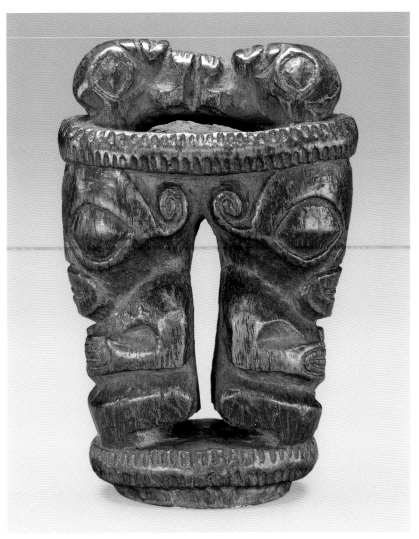

71

Museum, London.[3] These strong visual affinities, combined with the scale of the carving (the diameter of which is significantly greater than that of any known fan handle), indicate that this work originally formed part of a paddle rather than a fan. While the carvings on paddle finials are larger and more robust, characteristics required for strength and durability, their distinctive double-*tiki* figures otherwise show close stylistic affinities with those of the fan handles (cat. nos. 50–53). Marquesan *tuhuka* typically specialized in making one type of object, but the arrangement of the figures on fan handles and paddle finials is so close that it is possible the same artists fashioned both these objects.

During the late nineteenth and early twentieth centuries, Marquesan wood-carvers produced large numbers of intricately decorated paddles for sale as curiosities.[4] However, the rich patina and subtle signs of wear on this example indicate that it probably formed part of an earlier, functional paddle dating to sometime in the early 1800s. If so, it may have been employed to propel the war canoe of a chief during raids on neighboring valleys or in battles at sea.

EK

about the appearance of paddles in earlier periods based on their observations of the ornate examples made in the late nineteenth and early twentieth centuries.
3. See Haddon and Hornell (1936–38) 1975, fig. 31.
4. Linton 1923: 315.

103

Popoi Pounders (*ke'a tuki popoi*)

72. *Popoi* Pounder

19th century
Stone
Height 7 ¾ in. (19.7 cm)
Collection of Mark and Carolyn
Blackburn, Kamuela, Hawai'i

73. *Popoi* Pounder

19th century
Stone
Height 5 ¾ in. (14.6 cm)
Collection of Mark and Carolyn
Blackburn, Kamuela, Hawai'i
Collected by Paul Gauguin. Ex colls.
Émile Gauguin, Bengt Danielsson,
Papeete, Tahiti

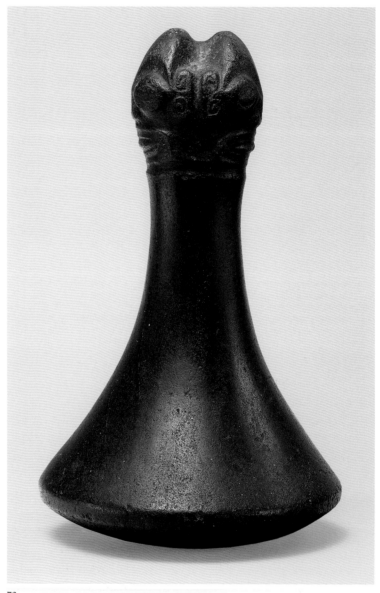

72

Figure 23: Early-twentieth-century photograph showing a Marquesan woman preparing *popoi* using a stone pounder (*ke'a tuki popoi*). Collection of Mark and Carolyn Blackburn, Kamuela, Hawai'i

One of the staples of the Marquesan diet is *popoi*, a starchy paste made from the flesh of the breadfruit, or *mei*. The production of *popoi* is a labor-intensive process in which chunks of breadfruit are placed on a large flat board and slowly pounded into a smooth paste (fig. 23) using a specialized stone pounder, the *ke'a tuki popoi* ("*popoi* pounding stone"). Like many activities in Marquesan culture, *popoi* making was at once a pragmatic process and a sacred act associated with specific *tapu*.

A central rite of passage for every Marquesan child was the ritual consecration of his or her hands to render them *tapu* for the task of pounding *popoi*. Known as *koina ha'ame 'ie i'ima,* the rite took place when the child was about ten years old. For the ceremony, the extended family would gather at the home of the initiate's father. During the ritual, the child's maternal uncles and paternal aunts lay on the ground and a *popoi* pounding board was placed across their prostrate bodies. The child then grasped the pounder and, with the father's guidance, ceremonially prepared his or her first batch of *popoi*. The act of preparing the paste atop the supernaturally charged bodies of relatives consecrated the child's hands, and he or she was then worthy of making *popoi*.[1]

Popoi pounders form part of the basic equipment of every Marquesan household. With their spare lines and robustly modeled grips that broaden into wide, flaring bases, they are at once ingeniously designed functional objects and striking works of art. In former times *popoi* pounders, fashioned from close-grained volcanic rock, were made by specialist carvers known as *tuhuka ke'a tuki popoi*.[2] The process of carving and smoothing the pounders was originally performed almost entirely with stone adzes, although some examples appear to have been finished by abrasion or pecking.[3] Pounders

1. E. Handy 1923: 91–92.
2. Ibid.: 144.
3. Linton 1923: 337–38.
4. Panoff et al. 1995: 122; Linton 1923: 338.

5. Linton 1923: 340; Panoff
 et al.1995: 122.
6. Among the earliest pounders
 with known collection dates
 is an example now in the
 University of Pennsylvania
 Museum of Archaeology and
 Anthropology, Philadelphia,
 collected about 1874. After
 this date, they begin to appear
 regularly in museum acces-
 sions. In the early twentieth
 century, carvers on the island
 of Ua Huka began to pro-
 duce pounders in substantial
 numbers for a German trad-
 ing company, which sold
 them both elsewhere in the
 Marquesas and in Tahiti.
 Once obtained, such pounders
 may have been further embel-
 lished by local carvers. See
 Linton 1923: 366.
7. Robert Suggs, personal com-
 munication, 2004.
8. Linton 1923: 340.

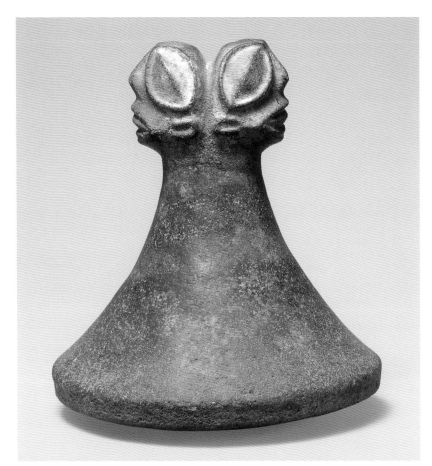

73

also commonly received a final polish in which a mildly abrasive paste made from charcoal and coconut oil was used to impart a dark lustrous sheen to the surface.[4]

The majority of *ke'a tuki popoi* are undecorated. In some cases, however, the finials are embellished with carvings in the form of bifacial *tiki* heads, whose elegantly stylized features are similar to those of other Marquesan sculpture in the round. Traditionally carved with chisel-like implements with blades made from rat or shark teeth, many of the surviving pounders show evidence of having been carved with metal tools.[5]

The dating of *popoi* pounders and other stone objects remains problem-atic. While *ke'a tuki popoi* were certainly used in the precontact period, few, if any, appear to have been collected before the late nineteenth century.[6] Some scholars suggest that the *tiki*-head type seen here represents a postcon-tact development, perhaps part of the general trend toward greater surface ornamentation that occurred in the late nineteenth century. The archaeolo-gist Robert Suggs, however, believes the earliest *tiki*-head pounders may date from the mid-eighteenth century.[7] According to information provided by Marquesans in the 1920s, the unusual bifacial *tiki* images on the pounders had no symbolic significance but served purely as adornment.[8]

EK

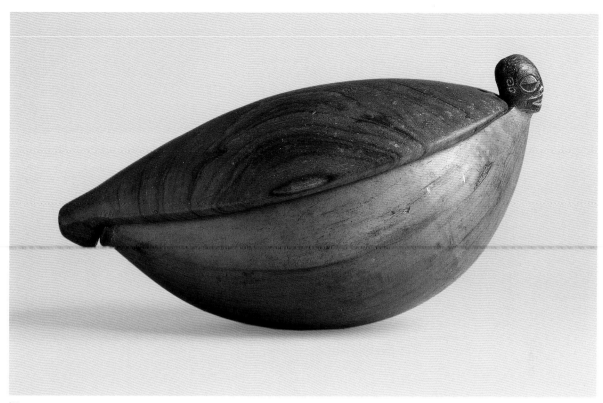

74

74. Lidded Bowl (*kotue / 'otue*)

Late 18th–early 19th century
Wood
Length 13½ in. (34.3 cm)
The Metropolitan Museum of Art, New York, Gift of Mrs. Evelyn A. J. Hall, 1986
1986.476.4a,b
Ex coll.: Musée d'Histoire Naturelle, La Rochelle, France

The graceful shape of this lidded bowl, or *kotue,* suggests the body of a bird. Only about a dozen *kotue* survive, all of which share the same distinctive form: a subtly curving body adorned at one end with a small, fully modeled human head and at the other with a rounded projection suggesting a tail. Despite their rarity, examples have been collected from almost every island in the Marquesan archipelago, indicating that the form may once have been widespread. In contrast to the elaborately decorated bowls of the late nineteenth century (cat. no. 76), the surfaces of *kotue* are smooth and polished.

Versatile as well as elegant, bird-shaped bowls were first observed in the late eighteenth century, and a number of different names and functions are attributed to them in the historical sources. The first description of *kotue* is that of Crook, who noted that they were used "to hold provisions" and that the bowls, which he called "*kepo*" (*kipo*), were adorned, as here, with a knob, carved in imitation of a mans [*sic*] head." Steinen, in 1897, was told that the term for such bowls was *kotue* and that the name referred to a species of black seabird. He stated that the bowls were used for storing a variety of items, including *popoi,* ornaments, and other valuables, and *'eka* (turmeric), a precious yellow powder used to adorn the skin.[2]

1. Crook 1800: 81. According to Dordillon ([1904] 1999: 159), in the northern Marquesas the term *kipo* refers to vessels used to serve *kava,* an intoxicating drink, while in the south it refers simply to a bowl with a cover. Crook (1800: 81), however, distinguishes *kipo* from *kava* bowls, which he called "*tannoa*" (*tanoa*). Toti Te'ikiehu'upoko (personal communication, 2004) stated that vessels known as *kotue* were created specifically to contain human skulls, while *kipo* held other items, including food and objects.
2. Steinen 1925–28, vol. 2: 262. Dordillon ([1904] 1999: 166) does not define *kotue* alone, but instead as *papa kotue*—a

dish with a cover for *popoi*.
He defines *'otue* as referring
to a large dish and also to a
species of bird (ibid.: 204).

3. E. Handy 1923: 114. Linton
(1923: 365, 369) also mentions
a small bird-shaped bowl
found in a burial cave.

4. Crook 1800: 38.

Kotue were also employed in funerary contexts. Handy, who worked mainly on Hiva Oa, described "a small oblong vessel with a bird's head carved at one end" that was used to carry the head of a deceased chief to the *me'ae*.[3] There is no doubt that special vessels were made to contain the skulls of chiefs and other important individuals during the early contact period. Crook observed that "sometimes a human skull is placed in a curious urn, & adorned with flowers."[4] The collections of the community museum on Ua Huka today include two bowls recovered from a burial cave that are similar in size and shape to the present example and that still contain human skulls.

CSI

BOWLS

75. Bowl (*ipu ehi*)

Early 19th century
Coconut shell
Diameter 6 ⅜ in. (16.2 cm)
*Collection of Mark and Carolyn
Blackburn, Kamuela, Hawai'i*
*Reportedly collected by Capt. David
Porter in 1813*

76. Bowl (*ko'oka*)

Mid- to late 19th century
Wood
Diameter 6 ½ in. (16.5 cm)
*American Museum of Natural History,
New York*

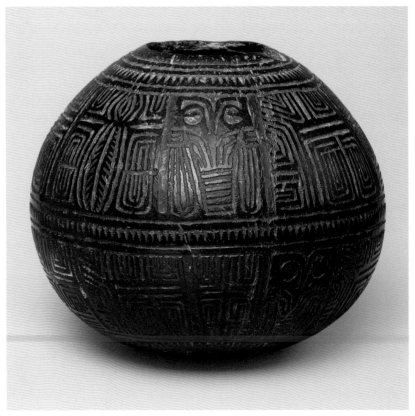

75

Marquesans made a variety of containers for storing and serving food, including several different types of bowls. The majority were round, lidless bowls carved from wood, known as *ko'oka*. The most common woods used in *ko'oka* were *tou* (false ebony), *temanu*, and *mi'o* (Pacific rosewood). Artists also made lidded wood bowls, or *kotue* (cat. no. 74), as well as deeper vessels fashioned from gourds or the shells of coconuts.

The first mention of decorative work on bowls was made by Fleurieu, who visited the archipelago in 1791 and described "various wooden vessels which they make use of for their food, and on which they amuse themselves in carving or engraving figures of men, fishes, and birds."[1] Langsdorff, in 1804, also referred to "dishes" with "little figures of human faces, of fish, and of birds."[2] The intricately carved coconut shell bowl seen here (cat. no. 75) was reportedly collected by Porter in 1813. If so, it is among the earliest documented bowls with extensive ornamentation. The surface is incised with *tiki* figures, which alternate with roughly rectangular zones of geometric motifs, while the underside is adorned with a striking radial pattern formed from triangular *tiki* images. The noses of the *tiki* appear to be elongated, indicating that they may be examples of the motif known as the *tiki nasau,* or "long nose" motif.[3]

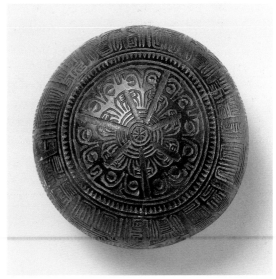

75, underside

1. Fleurieu 1801: 122.
2. Langsdorff 1813, vol. 1: 172.
3. Steinen 1925–28, vol. 2: 131–34. For a more extensive discussion of this motif, see cat. nos. 6–13.

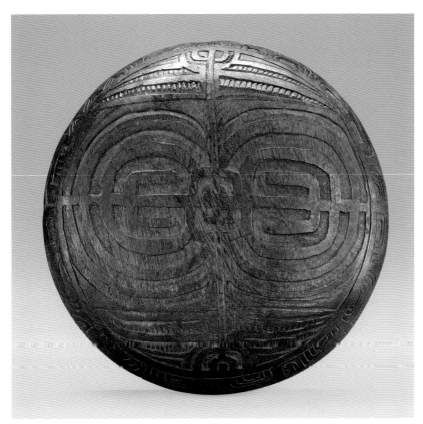

76

4. Ivory 2001: 315. See also the foreword to Steinen 1925–28, vol. 2.
5. Linton 1923: 355–76.
6. Ivory 1990; Ivory 1993.
7. W. Handy 1965: 111.

The overall low-relief surface decoration seen on the wood bowl, or *ko'oka* (cat. no. 76), reflects the more ornate carving style that developed in the late nineteenth century in which the entire surface is adorned with motifs and patterns similar to tattooing. Such decoration is also seen on clubs, paddles, limb images (cat. nos. 15, 16), and canoe models (cat. no. 68) made during the same period, primarily for sale to foreigners.[4] Linton, who considered decorated bowls the most important form of carved object, argued that the intricate designs on such bowls provided the original inspiration for Marquesan tattoo motifs.[5] But, given the late date of the bowls, it is far more probable that the reverse is true: that this later carving style drew primarily on tattoo patterns for its imagery.[6] In fact, by the late nineteenth century, virtually the only sources of traditional imagery remaining in the islands were the tattooed bodies of living people.

It is also possible, however, that tattooing and surface decoration employed separate, though similar, decorative conventions. Willowdean Handy quoted a Marquesan carver living on Fatuiva in 1921, who told her that there were different types of images for tattooing versus wood carving, and that "only fools put body images on food bowls" because it would be "very bad to eat from bowls covered with images meant for the body."[7] Nevertheless, bowls adorned with motifs that appear to derive from tattoo designs remain an important form of Marquesan decorative art to the present day.

CSI/EK

77. Suspended Bowl

Early to mid-19th century
Coconut shell, bone, seeds, fiber
Diameter 7 ¼ in. (18.4 cm)
The Metropolitan Museum of Art, New York, The Michael C. Rockefeller
Memorial Collection, Bequest of Nelson A. Rockefeller, 1979
1979.206.1607
Ex coll.: Harry G. Beasley, Chiselhurst, United Kingdom, 1850–70

1. Linton 1923: 293.
2. Crook 1800: 80–81; Robarts 1974: 279; Langsdorff 1813, vol. 1: 172.

The Marquesans used both coconuts and gourds to fashion containers, or *ipu*, in which they prepared, transported, and stored food or objects. *Ipu* were frequently suspended, as here, in finely woven nets, or *koko*, made from *keikaha* (coconut-husk fiber), allowing them to be easily carried or hung from the walls or ridgepoles of houses to protect the contents from rats and lizards.[1] The use of suspended containers was reported by a number of late-eighteenth- and early-nineteenth-century visitors to the archipelago, including Langsdorff, who described hanging calabashes enclosed in nets, adorned, as here, with ornaments of bone.[2]

The intricately crafted *koko* used to suspend the *ipu* were often works of art in their own right. In the present example, the body of the vessel, made from coconut shell, is enclosed in an elaborate decorative net woven into a series of bold interlocking diamond shapes. The suspension cord is embellished with ornaments made from black seeds and *ivi po'o,* ornaments made from human

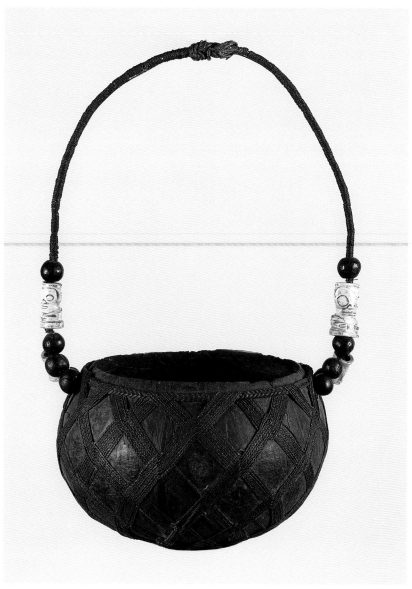

77

bone (cat. nos. 6–13). The seeds are those of the *koku'u* tree. *Koku'u* seeds are toxic, and their poison was (and still is) commonly used in fishing to stun or intoxicate the fish, making them easy to capture.[3]

 Fashioned from the limb bones of enemies, the *ivi po'o* on this work are of two types. The first consists of relatively plain cylinders adorned with raised ridges. The second, known as *tiki ivi po'o,* depict small *tiki* with enlarged heads and eyes. Probably representing deified ancestors, *tiki ivi po'o* appear widely in Marquesan art both as personal ornaments and as decorative accents for larger objects, where they may have served as supernatural protectors.

<div align="right">C S I</div>

3. Petard 1986: 39, 208.

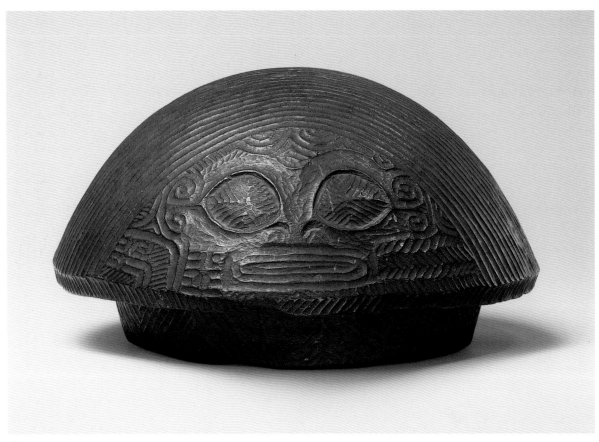

78

78. Vessel Cover (*tiha/tifa*)[1]

Early 19th century
Wood
Width 6 ½ in. (16.5 cm)
Collection of Mark and Carolyn Blackburn, Kamuela, Hawai'i

1. Dordillon ([1904] 1999: 262, 163) defines *tifa* as a "cover," but gives *kokomo* as the specific term for the cover of a calabash or gourd. Contemporary Marquesans state that they would use the word *tifa* for these objects.
2. Crook 1800: 80.
3. Robarts 1974: 261.

Wood covers, or *tiha,* were often used to seal the openings of *ipu* (containers) made from coconuts (*ehi*) or gourds (*hue mao'i*). The existence of *tiha* was noted by many late-eighteenth- and early-nineteenth-century observers, including Crook, who described them in his journal as "half globular, & likewise hollowed, with a narrow ledge, fitted to close the mouth of the gourd."[2]

Tiha were used throughout the Marquesas, although the finest examples were reportedly made in the southern part of the archipelago and traded to other islands. Robarts notes that during November and December, when the winds were favorable, residents of the northern island of Nuku Hiva sailed to the southern islands to exchange *'eka* (turmeric), the perfumed yellow powder for which Nuku Hiva was famous, for locally produced trade items including "large canoes, live hogs, stone adzes, [and] large calibashes with carved wooden covers."[3]

Tiha were frequently made from *toa* (ironwood), a hard, heavy timber that was also used for war clubs and stilt steps. The designs on this example are carved in very low relief and lack crisp edges, indicating that they were likely carved with stone tools, which were still in use in the early contact

period. Two faces, or *mata*, one on either side, are shown within well-defined semicircular areas surrounded by geometric motifs resembling Marquesan tattoos. The faces are separated by a series of parallel lines, which extend across the top of the cover. In form, the faces on the *tiha,* with their prominent eyes, broad arched brows, flat noses, wide oval mouths, and ears formed from spiral motifs, are similar to those on the lower portions of *'u'u* (cat. nos. 54–56). On *tiha*, such faces may have served to honor the *tupuna* (ancestors), whose powers ensured the safety of the food contained within the vessels they covered. C S I

GLOSSARY OF MARQUESAN TERMS

'a'akakai antiquity or curiosity, roughly equivalent to the term "art"

aoa banyan tree (*Ficus prolixa*), the inner bark of which is used to make *hiapo,* a type of barkcloth (*tapa*)

'au'au canoe prow ornament, also called *pihao*

ehi coconut (*Cocos nucifera*) used in making vessels and the source of coconut-husk fiber (*keikaha*), the Marquesans' primary cordage

'eka / 'ena turmeric, a yellow powder derived from the turmeric plant (*Curcuma longa*) used as a dye for barkcloth (*tapa*) and to adorn the skin

epaepa tobacco pipe, also called *pioro*

etua the primary supernatural beings in the Marquesas, mostly deified ancestors (*tupuna*)

ha'a kanahau beautifully made

haka'iki chief

hakakai / ha'akai ivory ear ornaments

hami man's loincloth

heana human sacrifice

hiapo reddish brown variety of barkcloth made from the bark of young banyan trees (*aoa*)

hoe canoe paddle, also called *tohua*

honu turtle

honu ipu shell of a turtle

hue mao'i *Lagenaria siceraria,* a species of gourd used to make bowls and other vessels

ipu general term for a container

ipu mata eye socket

ipu o'o / ipu oho skull

ite skillful, adroit

ivi po'o bone ornaments

ka'eu woman's barkcloth skirt

kahu ku'a red cape

ka'ioi society of semiprofessional performers composed of young men and women

kanahau beautiful

kava the kava plant (*Piper methysticum*) and the mildly narcotic beverage prepared from its roots

ke'a tuki popoi stone food pounder used to prepare breadfruit paste (*popoi*)

ke'e fan handle

keikaha coconut-husk fiber, the primary cordage used in Marquesan art and architecture

koina feast

koina ha'ame 'ie i'ima ritual in which a child's hands are consecrated through ceremonially preparing his or her first batch of breadfruit paste (*popoi*)

koko suspension net, used to hold bowls or other vessels

koku'u *Sapindus saponaria,* a species of tree that produces large black seeds used in Marquesan art

ko'oka round, lidless bowl

kotue / 'otue lidded bowl in the form of a bird

kouhau wood ear ornaments worn by men in the precontact and early contact periods

kuku white-capped fruit dove (*Ptilinopus dupetithouarsii*), whose bright green body feathers were used in headdresses

maimai tobacco, also called *pake*

mana supernatural power

manu ku'a unidentified species of bird, the source of red feathers used in some headdresses

mata face or eye

mata'eina'a / mata'einana 1. autonomous people of a valley or part of a valley 2. commoners, as opposed to chiefs (*haka'iki*)

mata 'enana 1. relatives, ancestors, or allies 2. the best of humanity

mata komoe design motif depicting the human face

matatetau recitation of a genealogy

me'ae sacred ceremonial sites

mei breadfruit (*Artocarpus altilis*), the staple food of the Marquesan diet

mi'o Pacific rosewood (*Thespesia populnea*), used in wood carving

moa vahana rooster

moko lizard

noni *Morinda citrifolia,* a plant whose leaves are used to wrap pieces of turtleshell prior to heating in the manufacture of *uhikana* headdresses and porpoise-tooth ear ornaments (*uuhe*)

oka ear-piercing ritual, also called *tui i te puaina*

pa'e general term for a headdress

pa'e kaha headdress of coconut-husk fiber adorned with alternating plaques of carved turtleshell and white shell

pa'e ku'a type of feather headdress

paepae stone platform; *paepae* served as foundations for houses and other structures

pake tobacco, also called *maimai*

parahua paddle-shaped war club

patu 'i te tiki or *patu 'i te ti'i* the process of tattooing

pavahina tassel-like ornaments made from the gray beards of male elders

pea tail feathers of a rooster, used in *ta'avaha* headdresses

peue 'ei or *peue koi'o* porpoise-tooth headdress

peue kavii crescentic feather headdress adorned with whale teeth, also called *tuetue*

pihao canoe prow ornament, also called *'au'au*

pioro tobacco pipe, also called *epaepa*

poniu *Abrus precatorius,* a red seed with a distinctive black spot used to adorn gorgets, head ornaments, and other objects

popoi breadfruit paste

pua'a pig

pu ihu nose flute

pu kohe mouth flute

pu taiana / pu taiata bone ear ornaments

putoka / putona shell trumpet

putui tobacco container, also called *tui maimai*

ta'a puaika / ta'a puaina ear piercer

ta'avaha type of headdress made from rooster tail feathers (*pea*)

tahi'i fan

tahi poniu crescentic gorget formed from wedge-shaped elements adorned with *Abrus precatorius* seeds (*poniu*)

tanoa a form of kava bowl

ta'o mata mnemonic device made from knotted coconut-husk fiber used in learning and reciting genealogies

tapa barkcloth, a paperlike textile typically made from the inner bark of the paper mulberry tree (*ute*) and occasionally from breadfruit (*mei*), banyan (*aoa*), Pacific rosewood (*mi'o*), and *pukatea* trees

tapu 1. sacred 2. forbidden, restricted

tapuvae stilt step

tau'a prophetic priests, the most important and powerful category of Marquesan religious specialists

tautike men's hairstyle consisting of two horn-like topknots

Te 'Enana / Te 'Enata "the People," the term Marquesans use to refer to themselves

Te Henua 'Enana / Te Fenua 'Enata "the Land of the People," the name used by contemporary Marquesans for the Marquesas Islands

temanu *Calophyllum inophyllum,* a species of tree used in wood carving

tetau to count or recite

tete poniu crescentic forehead ornament adorned with *Abrus precatorius* seeds (*poniu*)

tiha / tifa wood cover used on vessels made from gourds or coconut shells

tiki human image

tiki ivi po'o bone ornaments in the form of human figures

tiki ke'a human figure in stone

tiki nasau type of *tiki* image in which the nose is greatly elongated

toa 1. warrior 2. ironwood (*Casuarina equisetifolia*), a hardwood used for carving war clubs and other objects

tohua 1. public ceremonial ground or plaza 2. canoe paddle, also called *hoe*

tokotoko pio'o / to'oto'o pio'o chief's staff

totoko pole of a stilt (*vaeake*)

tou false ebony (*Cordia subcordata*), a tree used in wood carving

tu'a head ornament consisting of a plume of tropicbird (*Phaeton sp.*) feathers

tuetue crescentic feather headdress adorned with whale teeth, also called *peue kavii*

tuhuka / tuhuna artistic or ritual specialist; an individual who is recognized as skilled or gifted

tuhuka ke'a tuki popoi specialist carvers of stone food pounders

tuhuka o'oko / tuhuka o'ono religious specialists skilled in ritual protocol and keepers of oral traditions and genealogies

tuhuka patu tiki tattoo artist

tuhuka ta'ai tiki specialist in carving human figures

tuhuka vaeake specialist in making stilts

tui i te puaina ear-piercing ritual, also called *oka*

tui maimai tobacco container, also called *putui*

tupuna ancestor

uhi pearlshell

uhikana headdress of coconut-husk fiber adorned with a large disk (or disks) of pearlshell with openwork turtleshell overlay

ute paper mulberry tree (*Broussonetia papyrifera*), the inner bark of which is used to make barkcloth (*tapa*)

'u'u type of war club adorned with stylized faces and eyes as well as geometric designs

uuhe porpoise-tooth ear ornaments

vaeake stilts; *vaeake* consist of a stilt step (*tapuvae*) attached to a pole (*totoko*)

vaka canoe

vehine na te mano "wife of the shark"; name of a large species of marine snail whose shell is used for shell trumpets (*putoka*)

REFERENCES CITED

Armstrong, Richard
1831–34 "Journal, Marquesan Collection, 1830–
1900." Mission Houses Museum Library,
Honolulu.

Bailleul, Michel
2001 *Les îles Marquises, Histoire de la Terre des
Hommes, Fenua Enata, du XVIIIème siècle à
nos jours.* Papeete: Ministère de la Culture
de Polynésie Française, Tahiti.

Beaglehole, J. C., ed.
1961 *The Voyage of the Resolution and Adventure,
1772–1775.* The Journals of Captain James
Cook on His Voyages of Discovery, vol. 3.
Cambridge: University Press for the
Hakluyt Society.

Chaulet, Gérauld
1873 "Notices géographiques, ethnographiques
et religieuses sur les îles Marquises."
Manuscrit, Catholic diocese, Nuku Hiva;
Archives of the Congregation of the Sacred
Hearts of Jesus and Mary, Rome.

Cook, James
1777 *A Voyage towards the South Pole and round
the World, Performed in His Majesty's Ships
the Resolution and Adventure in the Years
1772, 1773, 1774, and 1775.* 2 vols. London:
W. Strahan and T. Cadell.

Crook, William Pascoe
1800 "An Account of the Marquesas Islands."
Journal, Mitchell Library, Sydney.

Crook, William Pascoe, Samuel Greatheed, and Tima'u
Te'ite'i
1998 *An Essay toward a Dictionary and Grammar
of the Lesser-Australian Language, According
to the Dialect Used at the Marquesas (1799).*
Edited by H. G. A. Hughes and S. R.
Fischer. Monograph Series of the Institute
of Polynesian Languages and Literatures, 1.
Auckland: Institute of Polynesian Languages
and Literature.

DeBoer, Warren R.
1991 "The Decorative Burden: Design, Medium,
and Change." In *Ceramic Ethnoarchaeology,*
edited by William A. Longacre: 144–61.
Tucson: University of Arizona Press.

Delmas, Siméon, comp.
1927 *La religion ou le paganisme des Marquisiens:
D'après les notes des anciens missionnaires.*
Braine-le-Comte, Belgium: Maison-mère
des Pères des Sacrés-coeurs de Picpus; Paris:
G. Beauchesne.

Dening, Greg
1974 "Introduction." In Robarts 1974: 1–29.
1980 *Islands and Beaches: Discourse on a Silent
Land, Marquesas, 1774–1880.* Honolulu:
University Press of Hawaii.

Dodge, Ernest Stanley
1939 *The Marquesas Islands Collection in the Peabody
Museum of Salem.* Salem: Peabody Museum.

Dordillon, Ildephonse-René
1999 *Grammaire et dictionnaire de la langue des îles
Marquises.* Tahiti: Société des Études
Océaniennes. Reprint of edition published
Paris: Imprimerie Belin Frères, 1904.

Dumont d'Urville, Jules-Sébastien-César
1846 *Voyage au Pole Sud et dans l'Océanie sur les
corvettes l'Astrolabe et la Zélée . . . pendant les
années 1837–1838–1839–1840, sous le com-
mandement de m. J. Dumont d'Urville, capi-
taine de vaisseau. . . . Atlas pittoresque.* Vol. 1.
Paris: Gide.

Fleurieu, Charles P. C.
1801 *A Voyage Round the World, 1790–1792,
Performed by Étienne Marchand.* 2 vols.
London: T. N. Longman and O. Rees, and
T. Cadell, Jun. and W. Davies.

Forster, George
2000 *A Voyage Round the World.* Edited by
Nichoas Thomas and Oliver Berghof;
assisted by Jennifer Newell. Honolulu:
University of Hawaii Press. Reprint of a
journal first published in 1777.

Gauguin, Paul
1978 *The Writings of a Savage.* Edited by Daniel
Guérin; translated by Eleanor Levieux.
New York: Viking Press.

Gell, Alfred
1993 *Wrapping in Images: Tattooing in Polynesia.*
Oxford: Clarendon Press; New York:
Oxford University Press.

Graçia, Mathias
1843 *Lettres sur les îles Marquises; ou, Mémoires pour servir à l'étude religieuse, morale, politique et statistique des îles Marquises et de l'Océanie orientale.* Paris: Gaume Frères.

Green, Roger C.
1979 "Early Lapita Art from Polynesia and Island Melanesia: Continuities in Ceramic, Barkcloth, and Tatoo Decorations." In *Exploring the Visual Art of Oceania,* edited by Sidney M. Mead: 13–31. Honolulu: University Press of Hawaii.

Haddon, Alfred C., and James Hornell
1975 *Canoes of Oceania.* Bernice P. Bishop Museum Special Publication, nos. 27–29. Honolulu: Bishop Museum Press. Combines and reprints James Hornell, *The Canoes of Polynesia, Fiji, and Micronesia;* A. C. Haddon, *The Canoes of Melanesia, Queensland, and New Guinea;* and A. C. Haddon and J. Hornell, *Definition of Terms, General Survey, and Conclusions,* first published 1936–38.

Handy, E. S. Craighill
1923 *The Native Culture in the Marquesas.* Bernice P. Bishop Museum Bulletin, no. 9. Honolulu: Bernice P. Bishop Museum.
1927 *Polynesian Religions.* Bernice P. Bishop Museum Bulletin, no. 34. Honolulu: Bernice P. Bishop Museum.
1930 *Marquesan Legends.* Bernice P. Bishop Museum Bulletin, no. 69. Honolulu: Bernice P. Bishop Museum.

Handy, Willowdean
1922 *Tattooing in the Marquesas.* Bernice P. Bishop Museum Bulletin, no. 1. Honolulu: Bernice P. Bishop Museum.
1938 *L'art des îles Marquises.* Paris: Éditions d'Art et d'Histoire.
1965 *Forever the Land of Men: An Account of a Visit to the Marquesas Islands.* New York: Dodd, Mead.

Hayford, Harrison
1964 "Afterword." In Melville 1964: 309–17.

Ives, Colta, and Susan Alyson Stein
2002 *The Lure of the Exotic: Gauguin in New York Collections.* Contributions by Charlotte Hale and Marjorie Shelley. Exh. cat. New York: The Metropolitan Museum of Art.

Ivory, Carol
1990 "Marquesan Art in the Early Contact Period, 1774–1821." Ph.D. diss., University of Washington, Seattle.
1993 "Reviewing Marquesan Art." In *Artistic Heritage in a Changing Pacific*, edited by Philip J. Dark and Roger G. Rose: 63–73. Honolulu: University of Hawaii Press.
1994 Marquesan 'U'u: A Stylistic and Historical Review." *Pacific Arts,* no. 9–10 (July): 53–63.
1995 "Late Nineteenth-Century Marquesan Clubs: A Preliminary Analysis." *Pacific Arts,* no. 11–12 (July): 20–28.
1999 "Art, Tourism, and Cultural Revival in the Marquesas Islands." In *Unpacking Culture: Art and Commodity in Colonial and Postcolonial Worlds,* edited by Ruth B. Phillips and Christopher B. Steiner: 316–33. Berkeley: University of California Press.
2000 "A Coconut Container from the Marquesas Islands." *Arts and Cultures* 1: 138–47.
2001 "Revisiting Late Nineteenth Century Sculpture in Te Henua 'Enana, the Marquesas Islands." In *Pacific 2000, Proceedings of the Fifth International Conference on Easter Island and the Pacific:* 313–19. Los Osos, Calif.: Easter Island Foundation.
2002 "Marquesan Art at the Millennium." In *Pacific Art: Persistence, Change, and Meaning,* edited by Anita Herle et al.: 394–403. Adelaide: Crawford House.
n.d. "Arts Festivals in the Marquesas Islands (Te Henua 'Enana / Te Fenua 'Enata): Identity, Pride, and Politics on Display." In *Proceedings of the Sixth International Conference on Easter Island and the Pacific, September 2004.* Santiago, Chile, and Los Osos, Calif.: Easter Island Foundation. Forthcoming.

Joppien, Rüdiger, and Bernard Smith
1985–88 *The Art of Captain Cook's Voyages.* 3 vols. in 4 parts. New Haven: Yale University Press for the Paul Mellon Centre for Studies in British Art.

Kaeppler, Adrienne L.
1978 *"Artificial Curiosities": Being an Exposition of Native Manufactures Collected on the Three Pacific Voyages of Captain James Cook, R.N.* Bernice P. Bishop Museum Special Publication, no. 65. Exh. cat. Honolulu: Bernice P. Bishop Museum.
1988 "Hawaiian Tattoo: A Conjunction of Genealogy and Aesthetics." In *Marks of Civilization: Artistic Transformations of the Human Body,* edited by Arnold Rubin: 157–70. Los Angeles: Museum of Cultural History, UCLA.
2001 "Rapa Nui Art and Aesthetics." In Eric Kjellgren, *Splendid Isolation: Art of Easter Island:* 32–41. Exh. cat. New York: The Metropolitan Museum of Art.

Kaiser, Michel, and Samuel Elbert
1989 "Ka'akai o Te Henua 'Enana: History of the Land of Men." *Journal of the Polynesian Society* 98: 77–83.

Kirch, Patrick V.
1997 *The Lapita Peoples: Ancestors of the Oceanic World.* Cambridge, Mass., and Oxford: Blackwell Publishers.
2000 *On the Road of the Winds: An Archaeological History of the Pacific Islands before European Contact.* Berkeley: University of California Press.

Kirsten, Sven A.
2003 *The Book of Tiki: The Cult of Polynesian Pop in Fifties America.* Cologne and Los Angeles: Taschen.

Krusenstern, Adam Johann von
1813 *Voyage round the World in the Years 1803, 1804, 1805, and 1806. . . .* Translated by Richard Belgrave Hoppner. 2 vols. in 1. London: J. Murray.
1814 *Reise um die Welt in den Jahren 1803, 1804, 1805 und 1806. . . . Atlas.* Saint Petersburg: Gedruckt in der Schnoorschen Buch-druckerey.

Langridge, Marta, trans., and Jennifer Terrell, ed.
1988 *Von den Steinen's Marquesan Myths.* Canberra: Target Oceania and the *Journal of Pacific History*.

Langsdorff, Georg Heinrich von
1813 *Voyage and Travels in Various Parts of the World during the Years 1803, 1804, 1805, 1806, and 1807.* Part 1. London: Henry Colburn.

Larousse
1993 *Concise French-English, English-French Dictionary.* Paris: Larousse.

Lavondès, Anne
1995 "La société traditionnelle." In Panoff et al. 1995: 31–39.

Lavondès, Anne, and Sylviane Jacquemin
1995 "Des premiers écrits aux collections d'objets." In Panoff et al. 1995: 26–30.

Le Cléac'h, Hervé
1997 *Pona Tekao Tapapa'ia, Lexique Marquisien-Français.* Papeete: Association Eo Enata.

Linton, Ralph
1923 *The Material Culture of the Marquesas Islands.* Memoirs of the Bernice P. Bishop Museum 8, no. 5; Bayard Dominick Expedition Publication, no. 5. Honolulu: Bishop Museum Press.

1925 *Archaeology of the Marquesas Islands.* Bernice P. Bishop Museum Bulletin, no. 23; Bayard Dominick Expedition Publication, no. 10. Honolulu: Bishop Museum Press.

Lisiansky, Urey
1814 *A Voyage round the World, in the Years 1803, 4, 5, and 6, Performed, by Order of His Imperial Majesty Alexander the First, Emperor of Russia in the Ship Neva.* Translated by the author. London: Printed for J. Booth.
1968 *Voyage round the World in the Years 1803, 1804, 1805, 1806.* Reprint of 1814 ed. Amsterdam: N. Israel; New York: Da Capo Press.

London, Jack
1911 *Cruise of the Snark.* New York: Macmillan.

Loti, Pierre [pseud.]
1878 *Le mariage de Loti.* Paris: Calmann-Lévy.

Marin, Aylic [pseud.]
1891 *Au loin: Souvenirs de l'Amérique du Sud et des îles Marquises.* Paris: Delhomme et Briguet.

Melville, Herman
1964 *Typee: A Peep at Polynesian Life during a Four Months' Residence in a Valley of the Marquesas.* New York: New American Library. First published London: H. J. Gibbs, 1846.

Millerstrom, Sidsel
1997 "Carved and Painted Rock Images in the Marquesas Islands, French Polynesia." *Archaeology in Oceania* 32: 181–96.

Millerstrom, Sidsel, and Edmundo Edwards
1998 "Stone Sculptures of the Marquesas Islands (French Polynesia)." In *Easter Island in Pacific Context: South Seas Symposium,* edited by F. J. Morin: 55–62. Los Osos, Calif.: Easter Island Foundation.

Ottino-Garanger, Marie-Noëlle.
2001 "'Être avant que de paraître': L'art de la parure dans un archipel océanien; les Marquises." In *Kannibals et Vahines, Les sources de l'imaginaire,* edited by Roger Boulay: 49–72. Chartres: Musée des Beaux-Arts.

Ottino-Garanger, Pierre, and Marie-Noëlle Ottino-Garanger
1995 "La préhistoire des îles Marquises." In Panoff et al. 1995: 15–25.
1998 *Te Patu Tiki: Le tatouage aux îles Marquises.* Papeete: Jean-Pierre Fourcade and Ch. Gleizal Editeur.

Panoff, Michel, ed., et al.

1995 *Trésors des îles Marquises.* Catalogue of objects by Jacqueline Guicciardi, Muriel Hutter, Anne Lavondès, Pierre Ottino, and Marie-Noëlle Ottino. Exh. cat. Musée de l'Homme. Paris: Réunion des Musées Nationaux.

Petard, Paul

1986 *Quelques plantes utiles de Polynésie française et Raau Tahiti.* [Papeete]: Éditions Haere Po No Tahiti.

Porter, David

1986 *Journal of a Cruise.* Edited and with notes by R. D. Madison and Karen Hamon. Reprint of the unexpurgated 1815 ed., with the preface to and chapters added to the 1822 ed. Annapolis: Naval Institute Press.

Quilley, Geoff, et al.

2004 *William Hodges, 1744–1797: The Art of Exploration.* Exh. cat. New Haven: Yale University Press for the National Maritime Museum, Greenwich, and the Yale Center for British Art.

Quirós, Pedro Fernandez

1904 *The Voyages of Pedro Fernandez de Quiros, 1595–1606.* Translated and edited by Sir Clements Markham. 2 vols. London: Hakluyt Society.

Rallu, Jean-Louis

1995 "Histoire d'une dépopulation." In Panoff et al. 1995: 75–82.

Robarts, Edward

1974 *The Marquesan Journal of Edward Robarts: 1797–1824.* Edited and with an introduction by Greg Dening. Honolulu: University Press of Hawaii.

Rolett, Barry V.

1986 "Turtles, Priests and the Afterworld: A Study in the Iconographic Interpretation of Polynesian Petroglyphs." In *Island Societies: Archaeological Approaches to Evolution and Transformation,* edited by Patrick V. Kirch: 78–87. Cambridge: Cambridge University Press.

Rollin, Louis

1929 *Les îles Marquises: Géographie — ethnographie — histoire, colonisation et mise en valeur.* Paris: Société d'Éditions Géographiques, Maritimes et Coloniales.

1974 *Moeurs et coutumes des anciens Maoris des îles Marquises.* Papeete: Stepolde.

Roquefeuil, Camille de

1823 *A Voyage round the World between the Years 1816–1819.* London: Sir Richard Phillips and Co.

Rotschi, Agnès

1995 "Paul Gauguin et l'art marquisien." In Panoff et al. 1995: 88–93.

Rubin, William

1984 "Picasso." In Rubin et al. 1984, vol. 1: 241–343.

Rubin, William, et al.

1984 *"Primitivism" in 20th Century Art: Affinity of the Tribal and the Modern.* 2 vols. Exh. cat. New York: Museum of Modern Art.

Sheahan, George M.

1952 "Marquesan Source Materials. Part I. Appendix I–II." In "A Study in Acculturation: The Marquesas Islands." Ph.D. diss., Emmanuel College, Cambridge University. Typescript, Bernice P. Bishop Museum, Honolulu.

Shillibeer, John

1817 *A Narrative of the Briton's Voyage to Pitcairn's Island.* Taunton: J. W. Marriott; London: Law and Whittaker.

Steinen, Karl von den

1925–28 *Die Marquesaner und Ihre Kunst.* 3 vols. Berlin: Dietrich Reimer.

Stevenson, Robert Louis

1986 *In the South Seas; Being an Account of Experiences and Observations in the Marquesas, Paumotus, and Gilbert Islands.* Reprint of the 1900 ed., with a new introduction. London and New York: KPI.

Stewart, Charles

1832 *A Visit to the South Seas in the United States' Ship Vincennes, during the Years 1829 and 1830; including scenes in Brazil, Peru, Manilla, the Cape of Good Hope, and St. Helena.* London: H. Colburn and R. Bentley.

Suggs, Robert

1961 *The Archaeology of Nuku Hiva, Marquesas Islands, French Polynesia.* Anthropological Papers of the American Museum of Natural History, vol. 49, part 1. New York.

1966 *Marquesan Sexual Behavior.* New York: Harcourt, Brace and World.

Thomson, Robert

1980 *The Marquesas Islands: Their Description and Early History* [1841]. Introduction and notes

by Robert D. Craig. 2nd ed. Publications of the Institute for Polynesian Studies, Monograph Series, no. 2. La'ie, Hawai'i: Institute for Polynesian Studies.

Varnedoe, Kirk
1984 "Gauguin." In Rubin et al. 1984, vol. 1: 179–209. Exh. cat. New York: Museum of Modern Art.

Vincendon-Dumoulin, Clément Adrien, and César Descraz
1843 *Îles Marquises, ou Nouka-Hiva: Histoire, géographie, moeurs et considérations générales; d'après les relations des navigateurs et les documents recueillis sur les lieux.* Paris: A. Bertrand.

PHOTOGRAPH CREDITS